THE ALL-IN-ONE CAMERA BOOK

Focal Press

is an imprint of the Butterworth Group

which has principal offices in

London, Sydney, Toronto, Wellington, Durban and Boston

First published 1939
Reprinted seventy-nine times
Eighty-first Revised & Enlarged Edition 1978
Reprinted, 1979, 1981

Spanish Edition
TODA LA FOTOGRAFICA EN UN SOLO LIBRO
Ediciones Omega, S.A., Barcelona

Italian Edition
NUOVA GUIDA PRATICA DEL FOTODILETTANTE
Edizioni del Castello, Milano

Portuguese Edition
GUIA PRATICO DE FOTOGRAFIA
Editorial Presença, Lisbon

British Library Cataloguing in Publication Data

Emanuel, Walter Daniel and Mannheim, L. Andrew
 The all-in-one camera book. 81st ed., revised and enlarged.
 1. Photography
 I. Title
 770'.28 TR146

 ISBN 0 240 51013 5

Printed in Great Britain by Clout & Baker Ltd, Maidstone
and bound by Whitefriars Press Ltd, London and Tonbridge

The All-in-One Camera Book

Photography made Easy

By W. D. Emanuel
and L. A. Mannheim

Eighty-first Edition
Revised and Enlarged

Focal Press

London & Boston

CONTENTS

7

8

PARTNERS INTRODUCE THEMSELVES

A brief description of some very important items

Essentials Of Every Camera

I AM THE LENS

My family goes back around a thousand years.

My ancester was a round glass bottle filled with water. Even in those far-off days people noticed that the sun's rays streaming through the water in the bottle formed an image of the world. True, this image is upside down. But everything is there all right: the brightly lit window frame, the blue sky, the trees and the houses on the other side of the street. And if somebody stands at the window and waves, his or her image and gesture are faithfully recorded.

But the image thrown by the bottle is very imperfect; the details are more than somewhat blurred. So clever men set to work and made countless experiments and immensely complicated calculations until at last they invented me.

Being composed of a number of carefully ground lenses — often of different kinds of glass — assembled together, I am able to produce a faultless image. I take the disorderly mass of light rays as they come rushing through me, the glare from the nearby roof all mixed up with the distant blue of the sky and rays from wood in the near distance, and I put them all in the proper place to form a clear bright image of the outside world.

Some of my modern brothers are not even made of glass, but of transparent plastic, which is less expensive if they are produced by the million in huge factories.

If the objects I have to reproduce are a long way away, their sharp outlines appear some 25 to 100 mm or more behind me, depending on my *focal length*, as it is called. The nearer objects come towards me, the further the images retreat. True, this is only

14

a question of millimetres and fractions of millimetres. But if you want me to produce a sharp picture you must be careful to capture the image at exactly the right spot. You must *focus* your camera. Otherwise you get a blurred picture and it's no use blaming me for it.

With some cameras it is easy to get the focus right: you can watch the pictures beforehand on a screen that shows whether it is sharp. In other cameras you can measure the distance by an optical device. This, too, ensures a sharp image of the object. And there are even cameras that measure the distance and set the lens all on their own by very clever and complicated electronic devices.

I AM THE VIEWFINDER

I am a kind of back-to-front telescope that helps you to point the camera in the right direction. What you see when you look through me — sometimes inside a luminous frame — is like the picture my cousin, the lens, produces. That way you know whether you have really got Bobby all in the picture, not forgetting his dog and without cutting off half his head.

On so-called reflex cameras I give you a really big and precise view on a screen where you can also focus it easily.

I AM THE FILM

I have an extremely senstivie skin compared with which the delicate epidermis of a young girl is like the toughest pigskin. A few fleeting beams of light are enough to make me sunburnt. That is why I am always wrapped up and kept light-tight. My skin must

15

only come into contact with the air in the dark interior of the camera. Photographers — cunning fellows — exploit my peculiarities to capture the fleeting image of the outside world cast on my skin by the lens of their camera.

This image must remain on my skin just long enough — neither too long nor too short. For my emulsion is highly sensitive to light. Otherwise you get pictures that are either *underexposed* or *overexposed*.

So if the picture does not come out right, it is not really my fault. I do my best and I know that the people in the film factory where I am made take a tremendous amount of trouble and use the best scientific brains and instruments to endow me with the very best qualities.

One of them is a consistent *sensitivity*, expressed in ASA or DIN values and printed on my packet. Some films have 80 ASA, others 400 ASA or more — the higher the figure the greater my sensitivity to light.

There are two of us, actually. One of us makes black-and-white pictures, the other reproduces things in their natural colours.

I AM THE SHUTTER

I am a kind of doorkeeper. I decide whether light is to pass into the camera, and for how long it is allowed to remain there.

My door is often one or more metal leaves between or just behind the lens components. Sometimes it is further back in the camera, just in front of the film. But in either case I must accurately control the light.

To allow me to time exposures so precisely, I have a mechanism as elaborate as a watch. Many of my more modern brothers also do it by involved electronic circuits.

I can move extremely fast, when necessary, for light rays are slippery customers. They dash through the gateway at 300 000 km per second. If I were not snappy, you would have more light in the house than you could use and the poor film's skin would be ruined.

At my fastest I let through light for just 1/500, 1/1000 or even 1/2000 second — not once, but as often as you like. Usually I do longer exposure times, such as 1/60 or 1/30 second. But when required, I can remain open for 10 seconds, 10 minutes or even 10 hours in exceptional circumstances.

If the subject is brightly lit, I need let light in for a short time only, because it requires only a fraction of a second to work on the skin of the film. But if the light is weak, for instance on a dull day, it has to remain longer on the film.

I AM THE IRIS DIAPHRAGM

I am made of thin steel plates cunningly set in a metal ring. When you turn the ring my plates close in and the opening in the middle gets very small. If you turn the ring in the opposite direction, my plates open out and the *aperture* gets bigger.

I live in the empty space between lens components. When I am wide open, a lot of light can get in and the image the lens throws on the film is bright. But if the steel plates close in, only a narrow bundle of rays can force its way through. The image then remains dim, because it is formed of so few light rays.

Like my colleague, the shutter, I control light. But while the shutter's is an all-or-nothing job, I am concerned with the number of incoming rays. The size of my aperture is expressed by certain numbers: 2, 2.8, 4, 5.6, 8 and so on. The lower the number, the larger the aperture of the diaphragm and the brighter the image within the camera. Aperture or stop 2 (also called f 2) indicates a wide opening — like a big window — while 16 means a small aperture and a correspondingly darker image.

There is rhyme and reason in this scale of numbers. First, at any aperture number I let throught the same amount of light, whatever the camera I am in. And secondly, when you move my control ring (or a lever attached to it) from one number to the next higher one, the image brightness on the film is halved. When you move to the next lower number, the brightness is doubled.

17

Strangely enough, the size of my aperture affects not only the picture's brightness but also the sharpness of its details. If my aperture is kept small, nearly all objects — from near to far — are sharply reproduced. As the plates open wider to increase the size of my aperture, the depth of this sharp definition shrinks. With a very wide aperture such as 2, and the camera focused on 1 or 2 metres, or 3 to 6 feet, this *depth of field* is reduced to a few cm. It then becomes difficult to get a person's nose and ears equally sharp — even though he may not be particularly thick-headed. Fortunately, you can generally use the smaller apertures and get correspondingly greater depth.

WE WORK TOGETHER

It is our job, diaphragm and shutter, to see to it that the film gets enough light. So we work hand in hand.

If you want a picture with great depth of field you must make my (the diaphragm's) opening fairly small. That means that the image inside the camera will be rather dark. This is where friend shutter comes to the rescue in allowing the image to remain for a longer time on the film's surface. That way it can leave an impression, despite its weakness.

On the other hand if you want a sharp picture of a quickly moving subject, the shutter must remain open for only a short time. This means that the image remains for a short time — 1/125 second or less — on the film. Now I, the diaphragm, must compensate for this by keeping my aperture wide so as to make the most of the light available.

So it is rather like a see-saw: when one of us shoots up into the air, the other one comes down with a bump. Shutter speed and aperture size are therefore complementary and in inverse ratio to each other. If the light is poor however, we must both of us go all out: I, the diaphragm, must provide the widest possible opening, and friend shutter must remain open a long time so that our combined efforts overcome the unfavourable lighting conditions. On some cameras we are mechanically connected, so

that when you alter one of us, the other adjusts itself automatically to keep the effective exposure the same.

One other thing is important: before we share out the work, we must know how much light is necessary to get the picture onto the film. Sometimes the sky is covered and at others the sun is shining; and some objects are brighter than others. The light that comes rushing towards the lens is therefore different in intensity every time. This is where another friend helps us: the exposure meter.

I AM THE EXPOSURE METER

I am a sort of electric eye with a cell that is just as sensitive to light as the film's skin. But unlike the film, I also have electric circuits. When light falls on my cell, my circuits measure how strong the light is. In a so-called automatic camera I tell the diaphragm and shutter how they must adjust themselves to make sure that the film gets the right amount of light for a correct picture. The diaphragm and shutter then look after the right exposure all on their own, once you point the camera — with me built into it — at the scene you want to photograph. In other cameras I control a pointer swinging through an arc. There you adjust the diaphragm ring or shutter speed until the pointer is in line with a special mark or with a second pointer; that at the same time sets the diaphragm and shutter again to a correct combination.

In my early days — nearly half a century ago — I was not even built into cameras but was bigger and all on my own. My needle told you what diaphragm aperture and shutter setting you needed in any light, and you then set that on the camera. Some of my brothers are still like that — in case you have a camera without me built in.

WE ARE FLASH UNITS

Indoors or when it's too dark for a correct exposure even with the diaphragm and shutter doing their best, you need a

convenient form of pocketable light to illuminate your object. That is where we come in.

Actually we are two kinds — electronic flash and flash bulb. We work differently, but do the same job, namely to throw light where there is not enough.

I, electronic flash, have a primeval ancestry: I am distantly related to lightning. But clever electrical engineers have scaled me down so small — without thunder — that I can sometimes even be built into a camera. Otherwise I usually sit on top and flash again and again every time you want to take a picture. All I need to keep me going is a battery or two.

Flash bulb is even smaller and produces its light by a miniature chemical explosion. But that takes place sealed inside a tiny strong glass bulb, so it is perfectly safe. Flash bulb is so small nowadays, that he is combined in a foursome in the flash cube or even an eight- or tensome in a bar or panel. For a flash bulb lives but for a single flash. When you fit the cube or bar into a socket on the camera, you then have enough flashes for anything from four to ten pictures.

I AM THE FLASH CONTACT

I am really an electrical switch wired to a socket on the camera body. I complete an electrical circuit when the shutter opens to fire electronic flash or a flash cube. For the flash is quite short

CAMERA AND SUBJECT A straightforward subject you could take on any camera. With average distance and average light the most inexpensive camera can cope quite easily. Photograph by *Colin Ramsay, Britain.*

and you want its light exactly when the shutter is open, for 1/30 second or less.

Some of my brothers are linked mechanically to the shutter to cope with non-electric flash cubes but their job is still the same: to make sure that the very brief flash lights up exactly at the same instant as the shutter works.

AND THESE ARE CAMERAS

They come in all shapes and sizes and incorporate most of the partners you have just met. They also vary a lot in what they can do, But within their capabilities they all can give good pictures.

Inexpensive cameras are simple in construction and also in use. Their shutter may have only one or two settings — perhaps 1/30 and 1/125 second — and the lens a small diaphragm opening of perhaps aperture *f*8. That means that such cameras cope with only a few restricted subject conditions — usually outdoor shots in fairly bright sunshine. For indoor pictures you can however normally use flash cubes or electronic flash. As the lens aperture is so small (such a lens costs much less to make) the depth of field is correspondingly great and such cameras need no focusing adjustment. Everything more than about 2 metres, or 6 feet, away is acceptably sharp in the picture.

The simple adjustable camera is rather more versatile, with several different shutter settings from perhaps 1/30 to 1/250 second, and several lens apertures up to reasonably large ones such as *f*4 or *f*2.8. It takes pictures not only in bright sunlight, but in duller weather, too — and of course indoors with flash. You can also shoot subjects with some movement. Sometimes the camera has a built-in exposure meter, or you use a separate meter to tell you what lens aperture and shutter speed settings to use.

The simple automatic camera looks after this job on its own. A built-in exposure meter selects the right aperture and shutter speed for you. That doesn't always give you any say if you want

CAMERA AND SUBJECT Subject requiring a more sophisticated camera and lens. The light is not good, the subject is distant and moving quickly. You need a wide aperture for the light, long focus lens to cope with the distance and a higher shutter speed to stop the action. Photograph by *Raymond Lea, Britain.*

to use a small stop and long exposure time instead of a large stop and short time — you have to take what you get. But the exposure at least will be right.

The advanced adjustable camera is more versatile still than the simple adjustable type. For one thing you have a wider range of shutter settings or shutter speeds ranging from as long as 1 second (sometimes several seconds) down to 1/500 or 1/1000 second. That way you can capture even very fast moving objects, in sports, for instance. And the lens can open up to really large apertures such as $f2$ or $f1.4$. Between them such a shutter and lens can shoot pictures in very unfavourable light conditions, even indoors in normal lamp light, for more natural effects than you would get with flash.

Lenses with such a large aperture need accurate focusing, so such cameras often have a reflex system which, on a large screen, shows you exactly how sharp the picture will be. You can see this when you look through an eyepiece at the back. Other advanced adjustable cameras may have a special optical system — a rangefinder — built in for precisely measuring the distance of the subject you are photographing. And with advanced camera you can often interchange lenses to cover either a very wide view of big scenes or, alternatively, get an enlarged view of distant things as if you were looking through binoculars. The big screen of reflex cameras is handy there, for it shows you the view with different lenses more accurately than would a simple viewfinder. Advanced adjustable cameras are usually precision instruments to give pictures of best possible quality, and are used by professional as well as amateur photographers.

The system camera is really like an almost universal tool set. In addition to having a wide range of adjustments and interchangeable lenses it can be used with numerous accessories to shoot, for example, very big pictures of tiny objects, or for photographing through a microscope. It may take a motor drive, useful for sports shots done in rapid succession — three or more pictures a second — and special attachments for many applications in scientific and other specialised photography.

The advanced automatic camera gives you the best of two worlds. On the one hand it is a versatile adjustable camera, while on the other you can set its built-in exposure meter to select the right exposure all on its own. You just choose what lens aperture you want and the automatic camera sets the corresponding correct shutter speed — or vice versa.

The exposure control system of such cameras can be very involved. Inside it you may have an integrated circuit as complex

as in a transistor radio or pocket calculator. Its purpose is to make the camera as straightforward and foolproof to use as the simplest inexpensive model.

In a way we have come a full circle: easy handling by automation, with sophisticated versatility. But all you have to do is to press a button – the camera does the rest. That, indeed, was the slogan of amateur photography nearly 100 years ago when simple popular cameras first appeared on the scene!

HOW BIG?

Cameras vary not only in what they can do but also in how big they are. For the everyday photographer they break down into a few fairly well defined size groups.

The pocket camera is today in very widespread use. Often no larger than a couple of packs of cigarettes, it literally goes into your pocket or handbag. It is also supremely convenient, for it takes film in cartridge form; you just drop the cartridge into the camera and you are ready to go. The pictures on the film are rather small – about 13 x 17 mm – but photofinishing laboratories that process the film give you album-sized enlarged prints measuring about 9 x 11.5 cm (3½ x 4½ inches).

Most simple inexpensive cameras are nowadays pocket models, but you also get simple automatic and sometimes even advanced adjustable and automatic models in this size. One drawback is that the picture sharpness and definition on the film is just good enough for enlarged prints up to about 13 x 18 cm or 5 x 7 inches – but not larger unless you have a really expensive precision model.

Small cameras of this kind have been around for a long time and used to be called ultra-miniatures. They became really popular with the introduction of the modern cartridge loading kind – also known as size No. 110.

Cartridge cameras also exist in a somewhat larger size – the No. 126 format yielding 26 x 26 mm images on the film. These No. 126 cartridge cameras are usually very simple and are being

superseded by the pocket camera whose technical improvements give just as good pictures with smaller bulk.

The 35 mm miniature camera uses perforated 35 mm film in special cartridges that are not quite as simple to load and unload as pocket camera cartridges. But you can buy many more types of film in this form. Such 35 mm cameras range from simple adjustable to advanced reflex and automatic cameras, right through to the most elaborate professional precision systems. Although the picture on the film itself is still fairly small — usually 24 x 36 mm or occasionally 18 x 24 mm — the image sharpness with the better types of this camera is so good that you can enlarge negatives to yield first class prints up to 30 x 40 cm (or 12 x 16 inches) and even larger without significant loss of quality.

The roll film camera was the first popular amateur camera some 80 or 90 years ago. For at least two generations the simplest inexpensive cameras — the so-called box cameras — were of this kind, before modern cartridge cameras took over that role. Nowadays the most usual roll film camera picture is about 6 x 6 cm (2¼ x 2¼ inches) large — but the 4.5 x 6 cm (1¾ x 2¼ inches) and 6 x 7 cm (2¼ x 2¾ inches) formats are also used. With the larger of these the picture is almost big enough to show around without enlarging, though professional photographers who nowadays mostly use such cameras do of course enlarge their negatives.

With a big film format you can get even bigger prints of top-most quality, though the cameras are rather bulkier. Today, roll film cameras are usually reflex models, often with highly advanced features including interchangeable film magazines. These permit almost as quick film changing as a pocket cartridge, for roll film on its own is a little cumbersome to load into a camera.

Some roll film reflex cameras have two lenses: one to take the picture and the other to show the image all the time on a viewing and focusing screen. Others are like the miniature reflex: you have a mirror between the film and the lens to throw the picture on a screen while you view and focus, and the mirror swings aside to take the picture. But during this instant you do not see it in the finder.

HOW MUCH AMMUNITION?

The film you put in your camera gives you a number of pictures per cartridge or roll. With a pocket camera that is usually 20 exposures, with a 35 mm camera up to 36 shots and with roll film 8 to 16 pictures (most frequently 12), depending on the image format. There are also cartridges with shorter film loads —

12 exposures in pocket cameras and 24 or 12 exposures in 35 mm.

In terms of price, 35 mm film is most economical per exposure. Roll film costs about 50 to 80 per cent more — as does cartridge film for pocket cameras. In cost per square mm of film area cartridge film is actually the most expensive. That is because of the packaging cost. But generally the number of pictures matters more than their size.

IF YOU ARE GETTING A CAMERA

Maybe you already have a camera. This book will then help you to make the most of it. And if your ambitions outgrow the capabilities of the instrument, you can switch to something more versatile.

But what should you choose if you are getting your first camera? It depends of course both on what you want it for and what you intend (or can afford) to pay.

For holiday snapshots, pictures of people out of doors (not too near) and other outdoor scenes in sunshine a simple inexpensive camera is quite adequate. If you do not want to carry much weight and are satisfied with standard prints about 9 x 11.5 cm large, a pocket camera will do admirably.

If you want to take near shots down to about 1 metre, or 3

feet, and to be able to take pictures when the light is not just brilliant sunshine, a simple adjustable camera will do the job, And if you are attracted by the convenience of not having to worry over exposure settings, get a simple automatic model. But should you need bigger sharp prints than 9 x 11.5 cm or if you want to take colour transparencies for projection, go for a 35 mm rather than a pocket model.

A simple inexpensive or simple adjustable camera will also serve you well as a photographic notebook, to catalogue things, for snapshots of people you meet, to have a record when you try to recollect their faces and so on.

Once your ambitions grow to sports and action photography, and more versatile poor-light performance, the advanced adjustable camera is the right tool for you. For lens interchangeability and close-up photography − large pictures of flowers and insects and the like − choose a reflex camera with its convenient screen viewing and focusing.

Beyond this you pay mainly for convenience and precision to get the best possible high-quality camera or one with automation features. That is up to you.

For the greatest reserve of quality in big enlargements professionals often choose an advanced roll film rather than a 35 mm reflex.

TWO SPECIAL CAMERA TYPES

Two kinds of camera fall a little outside the scheme of things we have discussed so far.

The instant-picture camera is one of them. This produces a finished print − black-and-white or colour − within a few minutes or less of taking the picture. It uses a very complicated arrangement of sensitised emulsions and chemicals, all built into the film. Seeing the picture almost as soon as you have taken it means that you can take it again if it did not come out right. On the other hand you are usually limited to prints roughly 8 x 10 cm (3¼ x 4 inches) large, and you get just one print of each picture. If you want duplicates you have to have this print re-photographed. The pictures are comparatively more expensive that those taken with conventional cameras − you pay for the convenience of having the result more or less immediately. Instant picture cameras themselves exist in various kinds corresponding to inexpensive simple, simple automatic, advanced adjustable etc. specifications.

The technical or view camera is the second type. It takes rather bigger single sheets of film (up to 20 x 25 cm or 8 x 10 inches) in light-tight holders. It is the modern version of what

used to be the studio photographer's big camera on a stand and now has numerous additional adjustments for special applications. It is somewhat slower to operate, but is used by the professional photographer who has to tackle any job, however unusual, and is expected to produce superb results as a matter of routine.

HINTS AND TIPS

TAKING CARE OF YOUR CAMERA

If you value your camera, do not drag it about unprotected in city streets or dusty country roads, or in woods and fields. Even an inexpensive camera is a piece of delicate mechanism and must be protected against dust.

Nor are prolonged sunbaths and heat beneficial to its health – or to the film. The plastic components contained in most cameras do not like excessive heat. And even the lens can suffer from very long exposure to the sun. Above all do not leave your camera in the glove box or rear shelf of a car standing in sunshine. (Cameras left in plain view in cars can also tempt thieves.)

Although the main selling point of pocket cameras and small 35 mm models is their pocketability, just any pocket is not the best place to carry an unprotected camera. Most coat and trouser pockets accumulate fluff, dust and grit that can also interfere with the mechanism. If you must carry the camera in your pocket, at least clean that out thoroughly first. There are also handy holders that clip on a belt to keep small or pocket cameras immediately accessible.

Get a protective case for your camera – if one is not already supplied with it. Keep the camera in the case when you are not planning to take pictures or picture sequences.

Fine sand is particularly dangerous, as it gets through the smallest chinks of the camera and upsets the mechanism. If this happens, the camera must be cleaned by an expert. Water is equally dangerous, so protect the camera against rain and spray, especially at the seaside or aboard boats.

Like the human eye, the cell of an exposure meter cannot bear direct sunlight for too long – another reason why the camera should not be left lying in the sun.

WHAT YOUR CAMERA WILL DO

Camera	Applications	Advantages	Drawbacks
Pocket camera	All-round snap-shots, portraits, preferably nearer to medium-distance subjects; photo-graphic notebook	Small, very pocket-able, easy loading	Very small nega-tive means limitation in big enlargement size
Compact 35 mm	All-round camera for all general photography	Medium priced, reasonably versa-tile, larger and hence more en-largeable picture size than pocket	Not quite as pocketable as No. 110 pocket camera
Single-lens minia-ture reflex	Universal precision camera for every kind of photo-graphy including specialised scientific, indust-rial, etc.	Direct-view screen image for picture and sharpness check, very versa-tile with numerous specialised accessories	Can become very high priced, also bulkier than compact minia-ture
Roll film reflex	Universal camera for every kind of photography inclu-ding professional and specialised fields	As 35 mm reflex, plus larger picture size for greater image quality reserve on enlarging	Gets very bulky, tends to be high priced
Instant print camera	General snapshot photography, special fields where immediate access to picture is important	Finished print available within less than a minute (black-and-white) or 5 to 10 minutes (colour)	Single print only, needs re-copying for duplicates; high material cost; cameras bulky

Film and picture format	Lens and shutter	More advanced features and notes
No. 110 cartridge film for 12 or 20 exposures 13 x 17 mm; a few similar cameras taking special cartridges for 8 x 11 mm or 10 x 14 mm exposures still exist	From simple *f*11 and single-speed shutter to *f*2.8 or *f*2 and multi-speed electronic shutter	Sometimes exposure automation, built in flash, lens-switch for tele shots
35 mm film for 12 to 36 exposures 24 x 36 mm (very occasionally 18 x 24 mm); some simple models for No. 126 cartridge film with 12 or 20 exposures 26 x 26 mm	Typically, good *f*2.8 lens, multi-speed shutter up to for instance 1/500 second (may be simpler)	Sometimes rangefinder, electronic shutter and exposure automation, built-in electronic flash; precision 35 mm may even use interchangeable lenses for extended versatility
35 mm film for 12 to 36 exposures 24 x 36 mm	High-performance inter-changeable lenses of various focal lengths and speeds; shutter range up to 1/1000 second or faster	Usually with through-the-lens exposure metering, may have exposure automation, remote control facilities etc.
No. 120 roll film for 12 exposures 6 x 6 cm or 16 exposures 4.5 x 6 cm	Interchangeable lenses of various focal lengths and speeds; shutter range usually up to 1/1000 second or faster	Often interchangeable film magazines and finder systems, some with built-in exposure metering. Now rare twin-lens reflex has two separate lenses for screen viewing and taking, generally bulkier and less versatile
Special film packs; print size, depending on model, between approx. 80 x 85 and 85 x 110 mm (3.1 x 3.3 to 3.3 x 4.2 inches)	Usually slow (*f*8 to *f*11) lens; generally electronic shutter controlled by photocell	Some models have re-flex viewing system, electric motor to eject exposed print, range-finder etc. Nearly all include exposure auto-mation

31

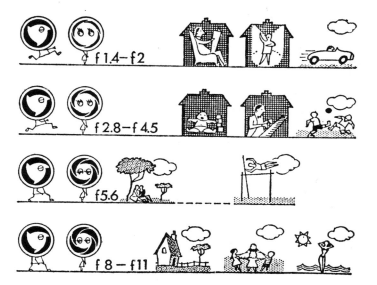

One factor controlling camera versatility is lens speed. The bigger the lens aperture (i.e. the faster the lens), the greater the scope of the camera. With a fast lens you can take photographs in poor light conditions and of fast-moving objects. A small-aperture (i.e. a slow) lens limits the use of the camera to good light conditions and slow subjects. The columns, read horizontally, tell what can be expected from a lens. For example, with an *f*2 lens you can shoot indoors with most light conditions, take stage photographs, or fast-moving cars. With an *f*5.6 lens, you can cover people out of doors under trees and not too fast sports. A slow lens of *f*8 to *f*11 is fine for brilliant outdoor scenes — such as holiday subjects — but only in good light. On the other hand you can take pictures indoors with flash with almost any camera (see page 138).

TAKING THE PICTURE

Basic rules and individual examples of successful technique

For Beginners Only

THIS IS ALL

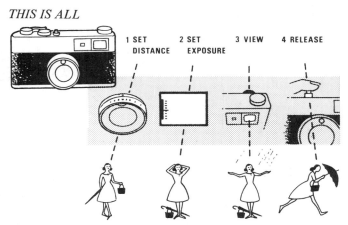

1 SET DISTANCE 2 SET EXPOSURE 3 VIEW 4 RELEASE

1. On the distance scale set the distance from the camera to your subject. You can guess this distance, pace it out (a normal step is about 0.7 to 0.9 metre or 2 to 3 feet long) or measure it with a rangefinder if your camera has one. To get both near and distant objects sharp together, use the zone focusing method explained on pages 40-41.

2. Set the exposure — by weather symbols — or if the camera measures it, check that the indicating needle is clear of all red warning signals. If you can select a shutter speed, set this to 60 or 125 (1/60 or 1/125 second) on the camera. If your camera has a range of exposure settings, select 1/125 second as the shutter speed and an aperture f 8 (or "bright weather" setting on camera) for bright outdoor subjects. For other cases see pages 36-37.

3. Look through the finder to check that your view includes what you want in the picture, for instance within a brilliant frame.

4. Hold the camera really steady while you press the release button to take the picture. Then wind on the film to the next exposure.

This is a general guide: consult your camera's instruction book.

EXPOSURE AUTOMATICALLY

On quite a few modern cameras a built-in light measuring system automatically selects the exposure. That leaves you with just one main worry: Is the available light within the range that the camera's electric-eye meter system can handle?

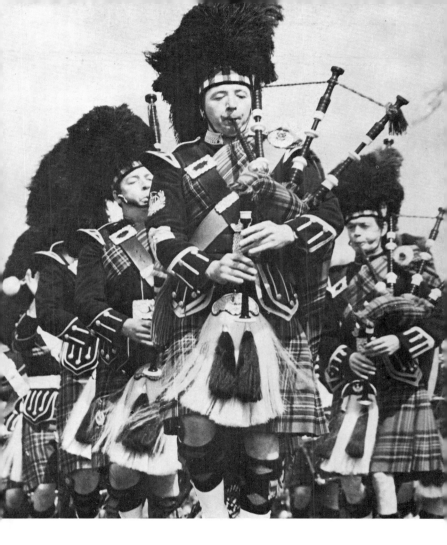

CAMERA AND LENS If you cannot get close enough to the subject you have to reach for it with a long focus lens. For this you need a camera on which the lenses can be changed for others that give different sized images for the same shooting distance. Photograph by *John Rocha, Britain.*

Very likely it is, for most outdoor daylight situations. Usually a red light or other warning signal in the camera viewfinder tells you if the light is not good enough. Usually that is also a signal that you should use flash, at any rate if you have a near enough subject. More about that on page 138.

With some cameras you may have a needle or a set of LEDs (light-emitting diodes) against a scale of apertures or shutter speeds telling you the exposure that the automatic system is selecting. If it indicates shutter speeds, that also tells you whether the exposure gets too long for a sharp hand-held shot. If the exposure time is longer than 1/60 second (e.g. 1/30 second or more) you usually need additional support for the camera or a specially steady hold.

On automatic cameras with a shutter speed scale, you can also select a faster speed, for instance 1/125 second, to be sure of sharp pictures. The camera then automatically selects the right aperture to shoot. Sometimes you may have a special warning light, e.g. yellow, to tell you that the exposure will be too long.

A second point to note is that for automatic exposures you must first set the camera to the speed of the film you have loaded in it. That you do best when you load the film (page 105). On cartridge-loading cameras (No. 110 and No. 126 sizes) the camera looks after that automatically, too.

... OR BY RULE OF THUMB

If your camera has a semi-automatic exposure meter, it is up to you to select either the diaphragm (aperture) *or* the shutter setting. Your best way then is to set the shutter to 1/125 second and adjust the diaphragm control until the meter needle on your camera (or in the finder) lines up with an index mark or pointer. This lining up operation then also sets the diaphragm to the right value for a correctly exposed picture. It is almost as easy as with a fully automatic camera ...

You can do it the other way round, too. Set the diaphragm

first and adjust the shutter to line up your needle. But usually you want to be sure of sharp pictures when you hold the camera in the hand, and 1/125 second is the best insurance there. So it makes more sense to set the shutter first.

If your camera has no meter, you may still have separate adjustments of aperture and shutter. For shots on a sunny day with a medium-speed film in the camera set the diaphragm to aperture $f8$ and the shutter to 1/125 second. With that you can take home very nice pictures of usual subjects — colour shots of Tom and Mary in their hiking outfit, baby's first steps, Miss so-and-so on the diving board — and they come out right even without an exposure meter.

So with a colour print film of 80 to 100 ASA, stop 8 and shutter at 1/125 second, photography is simplicity itself. If you have a black-and-white film of 125 ASA, use stop 11 instead of 8. You will find dozens of such subjects illustrated in photographic magazines, calendars and similar publications, all taken under these conditions. Sometimes you may read that a photographer used a 160 or 200 ASA film, or an exposure of 1/250 instead of 1/125 second. Don't worry about these variations. The result is usually the same, because the photographer allowed for the different film sensitivity with a different aperture.

Moreover, modern films have a certain amount of what is called latitude. That is, they can cope with a little more than the correct exposure without making a great deal of difference to the picture. Unless you happen to make colour slides, it doesn't matter that much if on many occasions you give 1/60 where an exposure of 1/125 second would have done.

With sunshine, a medium-speed film and a medium stop and medium shutter speed you are fairly safe in dealing with the usual run of subjects. Automatic cameras provide these settings on their own. But it is no accident that the simplest snapshot cameras with neither adjustable diaphragm nor variable shutter speed produce excellent results even in the hands of the beginner. Such simple cameras usually have an aperture of $f11$ and a shutter working at about 1/30 or 1/60 second.

One thing you must have in this case is good weather or a highly sensitive film. These are the necessary conditions for well-exposed films of the usual subjects without having to rack your brains with complicated calculations.

AN EASY WAY OF FOCUSING

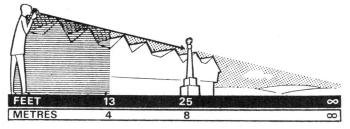

| FEET | 13 | 25 | ∞ |
| METRES | 4 | 8 | ∞ |

Of course we want our pictures to be sharp.

Here is a very handy method which enables you to take in objects which are quite near as well as things in the distance. To get all these items sharp on your film you must have a medium-size aperture, say $f8$, which is quite useful in any case with sunshine and a medium exposure. If you then set the camera to 8 metres, or just over 25 feet, you get a zone of sharp definition that actually begins about 4 metres or 13 feet in front of the lens. Beyond the subject the zone reaches as far as the horizon — to *infinity* as photographers and opticians call it.

So provided that an object is not less than about 4 metres or 12 to 13 feet from the camera, it will be sharp: the picturesque market cross, the ivy-covered church tower or the mountain with its pine forests and snow-capped peaks. So this near-to-infinity focusing gives you a picture containing objects in the foreground and objects in the far distance, all of them with almost the same sharpness or definition.

DEPTH OF FIELD

We get this unexpected bonus largely because we don't see as sharply as a camera lens. Strictly speaking a lens forms a sharpest image on the film of an object that is at the distance to which the lens was set. Objects nearer to the camera, or further away, form slightly less sharp images. Yet if we look at the picture, even enlarged, these nearer or further objects will still appear sharp because we cannot distinguish between absolutely sharp and slightly less sharp — at least not until the 'slightly less' becomes 'rather less'.

38

DEPTH OF FIELD You cannot always get near and far subjects equally sharp in the same picture. Decide which is the most important and focus on that. A small aperture will make the background sufficiently sharp to be recognisable; even if your main subject is very close. Photograph by *Pentti Paschinsky, Finland.*

For any focusing distance there is thus a zone of distances — beyond and nearer — within which objects come out sharp in the picture — or as near sharp as we can notice. This so-called *depth of field* zone is an immense help in photography, for it provides latitude in focusing. It is the reason why you can get away with a single distance setting for objects at such greatly different distances.

'Slightly less' and 'rather less' are obviously not very exact terms. You might see sharper than I or I might be prepared to accept slightly more (here we go again) unsharpness in a picture than you. Actually photographers and camera makers are in general fairly agreed on standards of sharpness to apply to this focusing latitude. It is on these standards that the above sharpness zones are based. If you think a picture need not be quite as sharp, you could allow objects to be as near as 3 metres or 10 feet from the camera; if you are much stricter, you would keep everything not nearer than 5 metres or some 16 feet.

Actually the picture is equally sharp in both cases. It is your own standard of sharpness that has changed, not the image definition.

Depth of field is still useful with cameras that allow you to focus accurately on a screen, for instance a single lens reflex, or that even focus automatically for you. For with these medium-distance subjects you are often concerned with having as much as possible sharp in the picture. But the near-to-infinity setting is obviously most useful with the simpler camera that has neither a focusing screen nor a scale.

The actual near-to-infinity setting depends also on the camera type. Here are typical figures, all for stop $f8$:

With a pocket camera with 25 mm lens focused on 4 metres or 13 feet, everything will be sharp from 2 metres or 6½ feet away.

With 35 mm miniature cameras having a standard 35 to 50 mm lens — and also with 6 x 6 cm roll film cameras and 75 or 80 mm lens — set the distance to about 8 metres or 25 feet. Everything will then be sharp from about 4 metres or 13 feet.

ANOTHER SIMPLE FOCUSING METHOD

If you look on the focusing scale of your camera you will notice, in addition to numbers of metres and/or feet, the 'infinity' sign ∞. If you set your camera to this point, distant objects will be sharp and near ones unsharp. This differs from the near-to-infinity focus just mentioned, which gives sharp definition to distant and to quite a few near objects. If you set your camera to infinity, you always get distant objects sharp even with a large

lens aperture. For near-to-infinity focusing on the other hand, you need a medium or small aperture.

So set your camera to ∞ when there is nothing close to the lens. Landscapes without any foreground, aircraft flying against the clouds and all such distant subjects are best captured by infinity focusing. This is also useful for pictures taken from a hillside, looking down into the valley, or from the top of a tower, provided that the nearest objects, tree tops, roofs etc. are far enough from the lens.

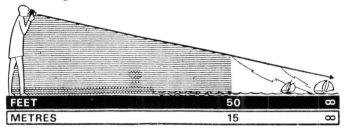

| FEET | 50 | ∞ |
| METRES | 15 | ∞ |

Just how far is infinity? Not of course literally infinitely far away. But you are safe in assuming that the lens cannot really tell the difference in distance between objects that are more than about 1000 times as far away as its focal length. With the standard 50 mm lens of a 35 mm camera anything more than 50 metres or roughly 150 feet away counts as infinity. Depending on both the focal length (usually engraved on the lens) and the size of the aperture, quite a lot of things rather nearer will be sharp. The table below gives approximate figures:

NEAR-TO-INFINITY SETTINGS

| Camera Size | Focal Length (mm) | Infinity begins for | | |
		Stop 2.8	Stop 4	Stop 5.6
No. 110 Pocket	25	12 m (40 ft)	8 m (26 ft)	6 m (20 ft)
35 mm	45-50	24 m (80 ft)	16 m (50 ft)	12 m (40 ft)
6 x 6 m (2¼ x 2¼ in)	75-80	24 m (80 ft)	16 m (50 ft)	12 m (40 ft)

So, even with infinity focusing, the zone of sharpness starts reasonably near to the camera — nearer, perhaps, than you would expect. And it starts nearest of all with a pocket camera with a small lens aperture. That is why, quite often, such cameras have

41

no focusing adjustment at all — you hardly need it if everything more than about 2 metres away will be sharp.

Nor do all cameras have a focusing scale with distances. You might just have symbols: for instance a 'landscape' symbol for distant subjects at or near infinity, a 'group' symbol for things about 3 to 4 metres or 10 to 13 feet away and a 'portrait' symbol for pictures of people at some 1.5 metres or 5 feet. The principle remains the same.

IT WORKS BEST WITH SUNSHINE

With a camera that has no built in meter but adjustable aperture and shutter settings, the formula: Sun + 80 ASA colour film + stop 8 + 1/125 second (or the same with stop 11 for 125 ASA black and white film) coupled with focusing at about 8 metres or 25 feet (near-to-infinity) is a magnificent golden rule for nearly everything outdoors. It produces hundreds of excellent pictures without tears. It ensures sharper definition for everything further away from the camera than 4 metres or 13 feet and gives sufficient illumination. The 1/125 second exposure is rapid enough for not-too-fast moving objects outside the minimum distance. And if such movement is far enough from the camera, it can be even faster — such as children at play, animals, cars travelling at a moderate speed — and still come out quite sharp on the film. It is also a way of quick shooting — bring the camera to your eye when you see your subject — without worrying or fumbling.

With this amount of information the veriest beginner with a camera will bring back good pictures provided he realises — or at least observes — the limitations of the method.

Remember — the zone of sharpness only starts 4 metres or 13 feet from the camera and you need sunshine. If the sky clouds over you need a longer exposure of 1/60 second. But then make doubly sure that you have no fast moving objects in the picture, or they would not be sharp. And you must take special care to hold the camera still (page 52).

Simplest cameras with few or no adjustable settings are subject to the same limitations: outdoor sunshine and subjects no nearer than about a dozen feet. You can go down to half this distance with pocket cameras because these have more depth of field. Within this limitation all cameras will produce good snapshots of whatever you point them at.

METERS TAKE CARE OF OTHER LIGHT CONDITIONS

If your camera has a built in automatic exposure meter, it will — as mentioned before — cope with other light conditions, too. The

SUNSHINE This is the ideal for black-and-white photography with sharpest definition and everything brilliantly lit as in this picture of Benjamin Disraeli's childhood home, Bradenham Manor, Bucks. Photograph by *Raymond Lea, Britain.*

meter then adjusts either the shutter speed or the lens stop (sometimes both) to allow for the sun going behind a cloud, a scene in the shade under trees or sometimes even when you go indoors. How little available light you can take pictures by depends on the camera's versatility, and that is in part what you pay for when you buy a more expensive camera.

Remember to watch for warning signals if you reach the camera's light measuring limit, or when you have a signal that tells you that exposure times are getting long and you need a firm support for the camera to avoid blurring the picture while you take it.

With less light, the larger lens aperture set by the camera reduces the overall zone of sharpness when you use infinity-to-near focusing. As a rule of thumb, reckon that on halving the stop number you have to double the distance setting and also the near sharp limit. Thus, with a 35 mm camera and stop 4 you get everything sharp from 7.5-8 metres (25 feet) to infinity if you focus on 15 metres or 50 feet. For anything nearer you must estimate or measure the exact distance and adjust the lens accordingly.

That is particularly easy with a reflex camera: you see how any object changes from unsharp to sharp as you adjust the lens and merely have to set the lens until the subject appears sharp in the finder.

SEPARATE METERS OR TABLES

Most of the more versatile cameras — i.e. with adjustable aperture and shutter settings — also have built-in automatic or semi-automatic exposure meters. There are however still cameras without a meter but with aperture and shutter adjustments — and often they are cheaper than cameras with meters. They offer versatility at a bargain price, though at the cost of convenience. Such cameras take just as good pictures as their more expensive fellows — just as a motor car with manual gearbox gets you to your destination just as quickly and as safely as an automatic car, but makes your work a little harder.

With a non-metering adjustable camera and outdoor sunshine subjects, use the rule-of-thumb exposure settings given on page 36. Or, get a separate exposure meter and measure the light level before the shot. Such a meter is worthwhile, and soon pays for itself because it saves you wasting film (especially with expensive colour film) — not to mention the unrepeatable pictures of a holiday abroad that you would lose with wrong exposures.

You point such a meter at the subject to take in the view you

AVERAGE LIGHT You have less depth of field and must take greater care with focusing, but all average subjects can be covered provided your background is unimportant and does not need to be sharp. Photograph by *Ed Buziak, Britain.*

DAYLIGHT EXPOSURE FINDER

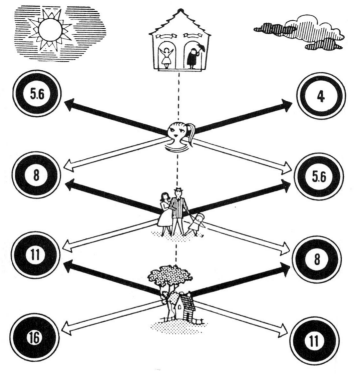

This daylight exposure guide for cameras without meter is valid for a medium-speed film of 64 to 125 ASA and a shutter speed of 1/125 second. This film speed range covers the majority of colour print films, medium-speed colour slide films and medium-speed black-and-white. To use it, look up the subject type in the centre column — landscape scenes, groups of people or portraits — and decide whether the subject tone is dark or light. According to the tone follow a black or a white arrow to the weather: sunshine at the left and overcast at the right. That arrow leads you to the aperture setting you need.

Example: you are photographing someone in light clothes in sunny weather at medium distance. So follow the centre subject group to the left by the white arrow: you need stop 11. If on the other hand your subject is wearing dark clothes, is near the camera and the weather is overcast, the black arrow of the top subject guides you to stop 4.

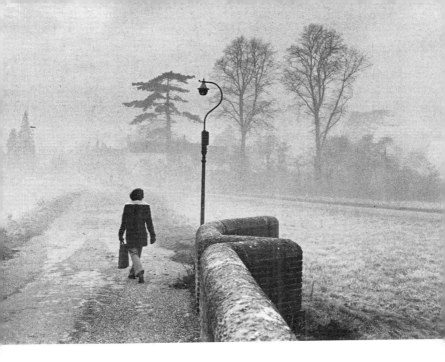

POOR LIGHT Depth of field is at a minimum and you need a meter or a self-metering camera to tell you what exposure to give or if you can shoot at all. Only the more versatile and more expensive camera can cope with such extremes. Photograph by *Raymond Lea, Britain.*

want to photograph and read off the position of a needle on a scale. A ready-reckoning calculator on the meter — set to the correct film speed — then shows which shutter speed you need for any aperture (or aperture for any shutter speed). So if the meter indicates 1/30 second for stop ƒ8, the scale may tell you that with stop ƒ4 you must give 1/125 second or that with ƒ16 you need an exposure of 1/8 second. Your choice depends on whether the subject requires a small aperture and a longer exposure (great near-to-far sharpness) or a shorter exposure (to cope with movement) with correspondingly larger aperture.

On some meters, you line up a second pointer with the indicating needle. That then directly sets the built-in ready reckoner. Alternatively you may have to adjust the meter needle to a fixed point, or the meter may have light signals to indicate the right setting: but the principle is the same in all cases.

Non-automatic built-in exposure meters work in the same way except that the ready reckoner part is mechanically coupled already with the aperture or shutter speed setting on the camera. That saves you the extra step of reading figures off the meter and setting them on the lens and shutter.

If you are really caught without any kind of meter, look at the instruction leaflet packed with the film. Usually that gives exposure settings for a range of outdoor conditions in various weathers — and they are surprisingly reliable. Page 46 shows an exposure guide based on very similar principles. Just don't try to use it indoors or for poorly lit subjects. There an exposure meter — in the camera or separate — is the only reliable way.

HINTS AND TIPS

EXPOSURE METER USE

It is important to know what an exposure meter can and cannot do. The meter — whether part of an automatic camera or a separate instrument — measures nothing more and nothing less than average lighting levels. It takes in the light reflected from the subject within the meter's angle of view. The engineers who design and calibrate exposure meters assume that the subject has a fairly uniform distribution of light, medium and dark tones. So an exposure based on the average light intensity reflected from the subject gives a correct picture.

In fact this is true for about 90 per cent of all outdoor subjects. Here are a number of hints for dealing with most of the remaining 10 per cent where a meter gives misleading exposure indications:

First, if the view includes a lot of sky, point the meter slightly

down to exclude most of the sky area. You can even do this with most cameras that have automatic meters: press the release button to its first pressure point to lock the automatic meter system and you can then repoint the camera even to take in more sky while the exposure will be that for little or no sky.

Second, with subjects against a very bright or a very dark background, go close to the subject itself for the reading. That excludes the background which could falsify the result. Again lock the reading where feasible by half depressing the release.

Third, where such a metering lock is inconvenient, you may be able to correct the reading with an override. For dark backgrounds set the camera for +1 stop (sometimes marked as 'back light') correction; for very bright backgrounds set to −1 stop.

Through-the-lens meters in reflex cameras operate in the same way as any other meter. But you can aim them more accurately as you see in the camera's finder just what the meter takes in.

For more advanced metering corrections see pages 110-111.

The Problem of Movement

TWO KINDS OF MOVEMENT

During the exposure — the instant while the camera's shutter is open — the lens projects an image on the film. To form a sharp picture, that image must be absolutely steady while the shutter is open. Any movement makes that image blurred, however carefully you had set the lens to the right distance.

Two main factors can make the image unsteady: movement of the camera and movement of the subject. The first makes pictures unsharp all over and comes from the lack of a steady camera hold. The second makes only the moving subject appear unsharp among sharp items in the rest of the scene. There are a few tricks for dealing with that, too.

INSTANTANEOUS SNAPS

The simplest cameras have a single shutter speed giving an exposure somewhere between 1/40 and 1/100 second, This is only just short enough to neutralise the effect of the average person's slight unsteadiness in holding the camera in the hands, and so to eliminate unsharpness due to camera movement. Where cameras have a range of shutter speed settings, all exposure times shorter than around 1/60 second are reckoned as 'instantaneous' and those longer than about 1/30 seconds as 'slow' or — if longer than about a second — as time exposures.

In fact, some people can hold a camera steady enough for 1/30 or sometimes even 1/15 second to obtain sharp pictures. Other more excitable people are unable to hold the camera steady even for 1/60 second without shaking. Their pictures are blurred all over and no use to anyone.

The longer the exposure time you can give with a camera (provided it has a range of different times) the greater the versatility with subjects in less than brilliant light.

It is worth using short exposure times whenever you can to achieve maximum steadiness. It is a fact that more pictures are ruined by blurring through camera shake than from any other handling error. On the other hand it is also worth cultivating ways of holding the camera as steady as possible under all conditions.

STEADY CAMERA The commonest reason for unsharp pictures is camera shake. If you want to get the best from your camera lens you must hold the camera steady and squeeze the shutter release smoothly but firmly. Photograph by *Horace Ward, Britain.*

HOLDING IT STEADY

The first contribution to camera steadiness is a relaxed hold. You should be able to support the camera so firmly that you can press the release button without jarring the instrument at the same time.

Part of that is correct releasing technique. Much depends also on the shape and size of the camera relative to your hands. People with big hands may find it more difficult to hold a tiny camera steady for the exposure. Sometimes that is even a factor in choosing what camera to buy.

But generally a steady camera hold is learned with practice. Start with the holding positions indicated in the camera instruction book. Try possible alternatives until you hit on one that is comfortable. Generally you should grip a camera with both hands and distribute the setting functions you need during picture taking (focusing, aperture or shutter adjustment to line up exposure meter needles etc.) according to which hand can reach the appropriate controls more easily.

If you use the camera at eye level — which is nowadays the case with most models — support the camera body as much as possible against your face. Use the camera's neck strap or wrist strap to tension it further against your hand or neck for a steady hold. Never hold the camera free in the air if you can help it — it is much less steady that way. And if you have to hold the camera in one hand, your chances of steadiness are worse still — you need a faster shutter speed to allow for that.

When you stand in the open, plant your feet slightly apart and tuck your arms and elbows into your body; that also makes for better steadiness.

LOOK FOR SUPPORTS

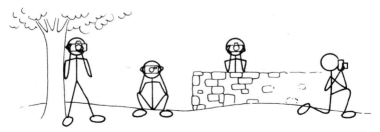

You can greatly improve your chances of avoiding camera shake if you look for additional supports to steady yourself. The ideal

way is to plant the camera on something solid: a chair back, a table top, a wall etc.

Next best is a support for your arms holding the camera. Look for railings, again chair backs or table tops, a fence or whatever else is handy. You can do worse than lean your elbows on the shoulders of a friend – or sit on the ground (if a low viewpoint is suitable) and lean your elbows on your knees. Of course in an armchair you have the arms of the chair to support yours that hold the camera.

There are innumerable other objects you can lean against out of doors: tree trunks, walls, fences, lamp posts, the roof or bonnet of your car, and so on. Indoors there are even more: walls, door frames, window sills and various items of furniture.

Use all the support you can get hold of. It could often make the difference between a slightly fuzzy and an absolutely sharp picture – and often also between being able to capture a subject that needs a slightly longer exposure and missing it.

RELEASE SMOOTHLY

But the steadiest camera hold is not good enough if you jerk or jar it while you press the button.

Cameras naturally vary in the ease with which they permit smooth releasing. Practically all modern ones have a button either on top of or in front of the body. Taking the picture involves pressing the button smoothly. Ideal is a camera where the release has a short travel and needs little pressure. The best releases are indirect: pressing the button or sometimes a disc releases a sensitive mechanism which in turn sets off the shutter. Equally smooth are electromagnetic releases built into some cameras.

Even if the release button has a longer or heavier movement, part of this movement only brings you up to a so-called triggering point at which the exposure is actually made. (Moving to the triggering point may release other camera functions, for instance automatic metering or aperture stop-down with reflex cameras.) Find this triggering point on your camera. When you want to take a picture press the release to that point, ready for the final push to shoot.

One secret of smooth releasing is having something steady to push against. Try to support the camera at the point opposite its release button. If the latter is on top, have a substantial part of your palm underneath the camera base, directly underneath the point where you press on the top. If the button is on the front, press against the rear of the camera at the corresponding point with part of your hand or face.

Practise releasing smoothly. One good way is to stand in front of the mirror and look at yourself through the viewfinder. That sensitively shows up even the slightest movement during releasing.

Remember also that due to its lower inertia a lightweight camera is easier to shake than a heavy model. The effect of camera shake is more serious when you use tele lenses on an interchangeable-lens camera (page 170).

AIDS TO SLOW EXPOSURES

Professional photographers, especially in the studio, mount their cameras on a tripod or stand for perfect steadiness. It certainly does keep the camera firm (provided the tripod is not flimsy) and is necessary if you take pictures needing long exposure times, for instance inside a dark church.

Tripods are a little cumbersome to carry around all the time. Fortunately there are a few useful alternatives.

One is a table top or bench top on which you stand the camera. More versatile is a table tripod. This small folding and pocketable stand holds the camera on a table, but also supports it steadily if you press the table tripod against a wall, column, door etc. You can easily make exposures lasting a few seconds that way — and you will rarely need anything longer.

Another aid is a monopod — like a tripod, but with only a single leg. It does not support the camera on its own, but steadies it against the floor while you hold it. It is much less cumbersome to take with you than a tripod.

You will need the special aids only in very poor light, for with most outdoor subjects you should get by with an instantaneous exposure of 1/60 second or shorter. Certainly such instantaneous snapshots will be considerably more numerous than long exposures.

MOVING OBJECTS DEMAND SHORT EXPOSURES

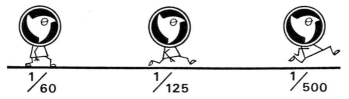

The second kind of movement that can produce unsharp pictures is that of people or things in motion in front of the camera. For if such people or objects move, so will the image that the lens

FROZEN ACTION For the fastest action, as in most sports, you need the highest shutter speed to 'freeze' movement in the subject and get a sharp picture. Photograph by *Peeter Tooming, USSR.*

throws on the film. And if the image shifts while it is on the film, it gets 'smeared' to a blur. The obvious remedy is not to leave the image on the film long enough to be smeared: use a short exposure time.

If the movement is not too fast, an exposure of 1/30 second will probably prevent obvious blurring, though 1/60 second makes that more certain. You can even take fast-moving vehicles at this speed, provided they are at some distance from the camera.

The swifter the movement and the nearer the moving object is to the camera, the shorter must be the exposure. Shots of sports events often need a shutter speed of 1/500 or 1/1000 second. But if the object, runner, car, etc. is moving away from or towards the camera, the exposure can be somewhat longer than if it moves straight across your field of view. For example a car disappearing into the distance straight in front of you will yield a sharp picture with a much slower shutter speed than one that is passing right across your field of view. The table on page 61 gives a guide to longest usable exposure times for various moving subjects.

Movement blur — either through camera shake or through moving objects — becomes particularly apparent in big enlargements. What might pass for sharp in a pocket-sized enprint for your wallet or album could well look disturbingly unsharp when enlarged sufficiently to hang on a wall.

During a very short exposure time the lens diaphragm must be open wider to allow more light to come in. That means also less depth of field and you have to focus more carefully. Using a fast shutter speed to get movement sharp does not gain you anything if the image is going to be unsharp through faulty focusing.

SNAPSHOTS MUST BE SNAPPY

A lot of people use their cameras for the 'we were there' type of record: father and the children in front of the hotel, mother and Jane on top of Mt. Snowdon and so on. Fine, if that is the kind of record you want. But the camera can do more than that: it can capture instants of real life that do not have to be planned or posed, but that are all the more interesting, amusing or telling for being caught spontaneously. That is the genuine snapshot, candid shot — call it what you will, it is an instantaneous glimpse of life.

Most of the time such snapshots involve people. After all, you can take your time over most static scenes, landscapes of views. You can learn snapshot techniques up to a point, for the rest it is a question of luck and a good eye for likely subjects that may crop up. The genuine snapshot just happens, today, next week, here, there, around the next corner.

SNAPSHOTS You have to be quick to capture a fleeting expression or a comical situation. To be properly prepared choose a fast film, set a small stop and fairly high shutter speed, pre-focusing the camera for a zone of sharpness to cover medium distances. Photograph by *Jiri Horak, Czechoslovakia.*

This is the kind of shot you have to be quick to capture. It is now or never. A moment later you will have missed it. Press photographers with all their wits about them have shown what can be done in the way of unpremeditated snapshots. But there is no need for the amateur to wait for a plane crash or a street accident. Good snapshots can be quite harmless and pleasant.

When Blackie, the cat, thinking he is alone, stands on his hind legs and delicately dips a paw into the bowl of goldfish, or when the girl at the bus stop opens her handbag and begins to renew her warpaint — here is you chance for a snapshot. So get your camera out and shoot. The picture must be safely on the film before Blackie realises that he has an audience and makes himself scarce — and before the lady sees her bus coming and pops the mirror and lipstick back into her handbag.

There are also some technical ways of being prepared. Good lighting is, of course, ideal. A medium speed film is fine, but a high-speed one is better — either black-and-white or colour. With a 400 ASA film you can for many outdoor snapshot occasions use stop 11 and set the shutter for 1/250 second even if the light is not brilliant. There remains the question of focusing. Near-to-infinity is not good enough here, as that does not get you things sharp at much nearer than 4 metres or 13 feet. It is no consolation to know that your sharp zone extends to the houses right over on the other side of the street. You need a near zone or snapshot setting. So focus at 3 or 4 metres (10 to 13 feet, depending on the camera) for sharp zones given in the table below.

You can use this snapshot setting for other subjects, too — in fact whenever near objects have to be taken quickly, though not necessarily with such extreme speed. This zone setting is still useful with more accurate focusing means such as the screen of a reflex camera or a rangefinder. For such focusing still takes more time than you can afford in capturing instant snapshots.

SNAPSHOT FOCUSING ZONES

Camera	Focal Length (mm)	Focus	Sharp zone with stop			
			f 4		f 5.6	
			from	to	from	to
No. 110 Pocket	25	3 m (10 ft)	2.0 m (6½ ft)	6.0 m (20 ft)	1.8 m (6 ft)	8.2 m (27 ft)
35 mm	45-50	4 m (13 ft)	3.2 m (10½ ft)	5.2 m (17¼ ft)	2.9 m (9½ ft)	5.6 m (18½ ft)
6 x 6 cm (2¼ x 2¼ in)	75-80	4 m (13 ft)	3.2 m (10½ ft)	5.2 m (17¼ ft)	2.9 m (9½ ft)	5.6 m (18½ ft)

ANIMALS The cat will not hold his pose for very long and at close range your zone of sharpness is so small that you cannot take a chance on the picture being sharp with a pre-set focus position. There is no choice but to focus quickly before he disappears. Photograph by *Raymond Lea, Britain.*

TRICKS FOR FAST MOVEMENT

If you want to take fast-moving objects or people and your camera has no fast shutter speed, don't give up. We mentioned two obvious ways of reducing movement effects: go farther away from the subject and take the movement coming towards you (or going away) at a fairly sharp angle. Here are two others:

Firstly, by swinging the camera you can follow subjects such as vehicles moving bodily across your field of view. This is one of the few occasions where you do not hold the camera rock steady. Instead, line up the subject in the viewfinder and smoothly swing the camera round so as to keep the subject centered in the finder. During this swing you gently press the shutter release to take the picture.

As the camera follows the subject movement, the image stays in one spot on the film, and hence sharp, even during this swing. And it will do so with a much slower shutter speed, for instance 1/60 second, than if you kept the camera completely stationary.

What gets blurred is the background – as it does whenever you move the camera. But now that doesn't matter – in fact it adds to the impression of fast motion, for instance of a runner, rider or racing car.

Secondly, many movements change direction at some stage and when they do, they have a so-called dead point. A high jumper leaps up to a highest point, but then has to come down again. So does a child on a garden swing. If you time your picture so that you release the shutter exactly when the subject is at this dead point, you can again capture the movement with a much slower shutter speed.

Such accurate timing needs a little practice. If you decide to press the button when the jumper is at the top of his jump, you will in fact catch him half-way down. Your hand takes a fraction of a second to react to your brain's decision. So get to know your reaction time and decide to release just that fraction of a second before – when the jumper has not yet quite reached the top. This anticipation is useful in other action situations, too.

PICTURES FROM MOVING VEHICLES

Don't take pictures from moving trains, cars or piston-engined aircraft unless your camera has a fast shutter speed of at least 1/500 second. You need this fast speed to overcome the vibration of the vehicle – not so much its relative movement to the surroundings. The problem is one of camera shake, but it becomes

almost impossible to hold a camera steady if what you are standing or sitting on is shaking.

If you absolutely must have a picture out of a train window, in this case don't lean your elbows on the window ledge or any part of the carriage. Instead stand with your knees slightly bent to dampen the vehicle vibration. That is a good idea also on board ship, though there engine vibration is much less.

When shooting out of any window: do it only if the window is reasonably clean.

EXPOSURE TIMES FOR MOVING SUBJECTS

Subject	Subject distance	Shutter speed for movement direction		
		Towards or away from camera	Oblique	Across field of view
People, slow animals	7-8 m (25 ft)	1/60	1/125	1/250
Cyclists, slow town traffic	7-8 m (25 ft)	1/125	1/250	1/500
Car, galloping horse, normal town traffic	7-8 m (25 ft)	1/250	1/500	1/1000
Slow train, normal car	15 m (50 ft)	1/125	1/250	1/500
Fast train, fast car (60 mph, 100 km/h)	15 m (50 ft)	1/250	1/500	1/1000
Aircraft landing, small	30 m (100 ft)	1/250	1/500	1/1000
Airliner landing	60 m (200 ft)	1/250	1/500	1/1000

SNAPSHOTS OF PEOPLE

For a snapshot of a child at play or a character in a market begin by turning your back on the quarry. Adjust your shutter and aperture at your leisure and set the camera to a suitable distance.

For some cameras, especially reflexes, you can get a right-angle finder attachment. This fits over the finder eyepiece and allows you to face one way, while the camera points in another direc-

tion and you still observe what goes on there, through the camera viewfinder. That way your victim is less likely to be aware of being observed by you. For people tend to feel that they are within a photographer's view only if the camera owner (rather than the camera) is facing them.

If you are just walking around the streets or the beach taking pictures of people, it is a good idea not to bother with focusing and exposure adjustments every time. They slow you down. Set a fairly small stop, say f8 or even f 5.6, and you can get every thing sharp over quite a range of distances (see page 38). Set your distance scale to about 4 metres or 12 to 13 feet. Then you can walk up to your subject until you are anywhere within about 3 and 5.5 m (or 10 and 18 feet) before bringing the camera quickly up to your eye and shooting. Quite often your subjects will not even know they have been photographed.

Set the shutter speed to match this lens stop for correct exposure. An automatic camera will take care of that on its own.

For action shots of a fast-moving subject from a fixed point, say a runner on the cinder track, your camera should be focused beforehand at some point that the subject must pass. Mark this spot by some detail – a tuft of grass or even a scrap of paper put there for the purpose – and shoot just as the moving subject reaches that spot.

The Problem of Distance

NEAR VIEWS REQUIRE CAREFUL FOCUSING

NEAR VIEWS REQUIRE CAREFUL FOCUSING

While it is an easy matter to get distant views sharply in focus by the simplest focusing method (page 38), near objects surprisingly enough, demand much greater care. The nearer they are the more care they require. A tree 100 yards away and the castle on the hill behind it, half a mile away, will both come out sharp in the picture with the same lens setting. But the child playing 4 or 5 yards away must have a different focus setting from the one you need when the child comes to within a couple of yards from the camera.

Simplest cameras with a small-aperture lens can opt out of this whole problem by covering a fixed range of distances – near enough for the family group on the lawn, though not for a close portrait. More versatile cameras with larger lens openings need a focusing adjustment for the lens even at medium distances. And you must know exactly to what distance to set the lens.

ESTIMATING DISTANCE

It's not difficult to estimate the distances you have to deal with in photography – it just needs practice. Mostly you have to estimate distances nearer than about 15 metres, or 50 feet. Beyond that everything is nearly always sharp with an infinity setting (page 40).

One simple estimating aid is to imagine how many 6 foot tall men could lie down on the ground head-to-foot between you and the subject. If you reckon that the group is 4 'person-lengths' away, you have a little over 7 metres or about 24 feet.

If you have the time, pace out the distance. Measure the length of your average pace (from the tip of one foot to the tip of the other) and cultivate a measuring walk of even paces. Then, if the subject is 6 paces of 0.6 m (2 feet) length away, you know the distance is 3.6 m or 12 feet.

Another way is to use your camera viewfinder to compare the finder height with the height of people in the scene. For instance a full-length figure may just fill the height of the viewfinder frame when he or she is about 3-4 metres or 11 feet away. Then, if the

person comes near enough to fill the finder from the top of the head to just below the waist, you have half a person-length and half the distance. If the finder field covers a close-up from the top of the head to the middle of the chest, the distance is likely to be about 1 metre, or 3¼ feet. A few cameras have special markings in the viewfinder for just this purpose.

But try this out on your own camera and viewfinder, and memorise a few simple reference points for quick distance estimating.

Whichever way you use, practise your estimating whenever you have the leisure for it. Try to guess the distance of items around you when you are out or a walk, in a waiting room, standing in a station waiting for a train and so on. Check each time by pacing or measuring how far you are right.

MEASURING IS BETTER STILL

Unless you are very good at it, estimating distances is subject to error. You can get away with it if the subject is not too near and the lens aperture not too large. The really safe way is to measure the exact distance of the subject.

One of the more popular camera types, the single-lens reflex, has a built-in focusing screen and other aids that show you whether the camera is correctly focused for a sharp picture. This is a great help, because with it you not only measure the distance but also set the lens correctly. You do not even need to look at the distance scale! The coupled rangefinder of certain other cameras does much the same thing, though it works in a different way.

These aids are intended chiefly for close-up views. For distant objects you can still easily get along without them. If your camera has a focusing lens but no such focusing aid, you can buy a separate rangefinder to take the guesswork out of estimating distances. It works just as well, but is a little slower — you have to

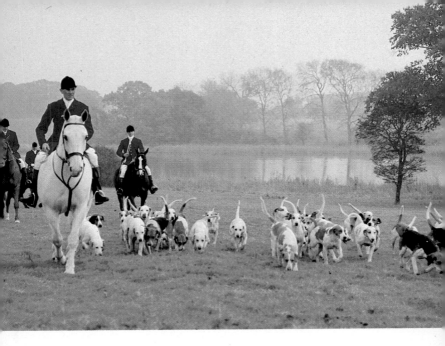

SHARPNESS (*page 67*) The best safeguard for sharpness is a steady camera. Use a well-balanced standing position, a firm grip and a high shutter speed. Photograph by *John Rocha, Britain.*

HUNTING PINK (*above*) A dash of colour among the quiet hues of a typical rural scene. If you want to emphasize the main subject in this way take care to avoid competing colours. Photograph by *Peter Stiles, Britain.*

ACTION (*page 66*) With repeated actions you can pre-focus on a point and shoot when the subject reaches it. Photograph by *Don Morley, Britain.*

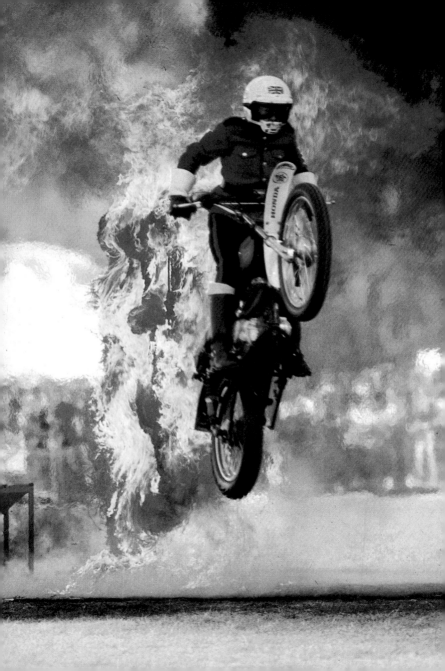

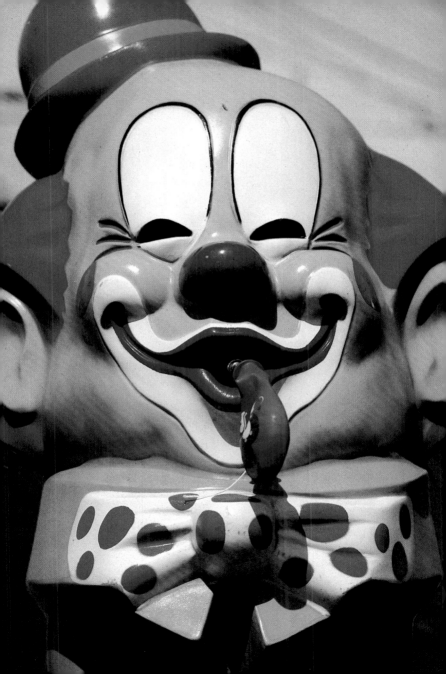

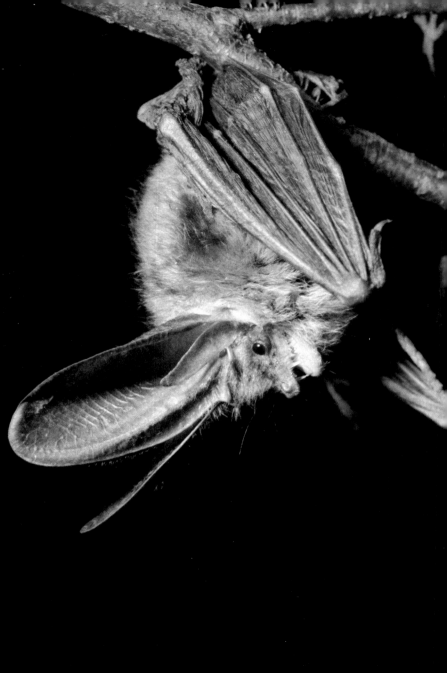

ONE COLOUR Monochromatic colour is very effective where the picture has a strong design form. You can find many regular patterns in nature if you look carefully enough. Photograph by *Herve Chaumerton, France.*

CLOSE UP (*page 69*) Natural colours magnified by using a 5 dioptre attachment lens on a standard 55mm camera lens. Photograph by *Raymond Lea, Britain.*

SUBJECT AND BACKGROUND (*above*) Ideally, all flower pictures should have a background free from distracting features and of a colour that goes well with the dominant colours of the bloom. You get results like this by careful selection of subject and camera angle. Photograph by *Jackie Tosh, Australia.*

FLASH (*page 68*) Certain subjects can hardly be photographed by any other means. Outdoors at night-time you have portable illumination wherever you want it and in large enough quantities to shoot with slow colour film for close ups. Photograph by *Peter Stiles, Britain.*

REFLECTIONS (*page 72*) Colours reflected in water are broken up by the surface ripples. You focus the camera not on the water surface but on the subject seen 'beyond' it. Photograph by *Horace Ward, Britain.*

measure the distance with the rangefinder and then set it on the camera's distance scale.

The cheapest kind of rangefinder is a metal tape measure that rolls up inside a little box you can carry in your pocket. But with some subjects using a tape measure is out of the question. The cat, for instance, nicely perched on the gate-post, would promptly disappear the moment you thrust a measuring tape under its nose. A proper rangefinder on the other hand is less obtrusive and quicker in action. Also it measures distances from about 0.6 to 30 metres or 2 to 100 feet − which is more than a pocket tape measure can do.

A SMALL STOP GIVES DEPTH OF FIELD

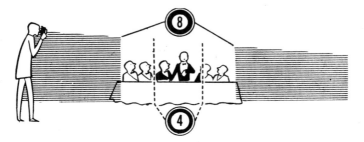

With near focusing, the focusing latitude becomes very small. The available zone of sharpness only covers subjects of comparatively little depth, possibly individual people. The problem becomes more difficult when everybody sitting at the table has to come into the picture. However carefully you focus, your zone of sharp definition is too narrow: either the people nearest the camera or those farthest away are out of focus − or sometimes neither is sharp. It's like trying to put a bus into your garage: it simply won't go in.

You can gain the necessary depth of field by stopping down, that is, by using a small lens aperture (high f-number). This brings every part of the subject within the zone of sharpness. For this purpose stop $f16$, which is not much used otherwise, is not too small. There may even be a case for a still smaller stop $f22$ − if available on your camera.

Another and less desirable result of these small apertures is that they let less light through the lens. That in turn yields a dimmer image on the film and you must compensate with a longer exposure. When that exposure time becomes too long for

SNAPSHOTS OF PEOPLE People, especially children, can be highly active.
Really spontaneous pictures may not allow you enough time to focus.
Select a fairly small stop and pre-focus the lens at medium close range. Then
just step up to your subject and shoot. Photograph by *Ed Buziak, Britain.*

SMALL STOP: GREAT DEPTH If you select a really small aperture you can get the picture sharp from the foreground all the way to the furthest distance. In bright sunlight onto a fast film you have no problems, but in dull weather you will need the camera rigidly supported because of the slow shutter speed you have to use. Photograph by *Raymond Lea, Britain.*

an instantaneous shot, you can no longer hold the camera in the hand and even slight movement in the subject results in a blurred image. All very awkward.

If the exposure meter – in the camera or a separate one – indicates 1/60 second for stop 8, you can set the camera to stop 16 but then get an exposure of 1/15 second. So, do not stop down the lens too far – only as much as needed for the required depth of field. The camera's depth of field indicator shows how much of the picture will be sharp at different distances and apertures.

When extensive depth of field is not a problem – i.e. when the subject itself does not extend much in depth, a wider aperture and correspondingly shorter exposure time (faster shutter speed) will do. But then you also have to focus accurately. For example at $f4$ and with the object at about 1 metre, or 3 feet, the depth of field amounts to no more than a few inches. Everything outside this small area is of course blurred in the picture.

A blurred background is not always a drawback, especially when near objects in front of it are in sharp focus. In such cases an unsharp background can be less distracting than a sharp one. When the unimportant bits of the picture are blurred, the eye picks out the really important items and ignores the rest. But preferably avoid blurred detail in the foreground, unless this is only meant to frame the view beyond. Normally, it is best to leave out anything unsharp between the camera and the main object.

SUPPLEMENTARY LENSES FOR FIXED-FOCUS CAMERAS

If your camera has no lens adjustment for focusing, there is one way of taking pictures of nearer things than the normal 3-4 metre or 10-13 foot limit of the camera. Simply place a supplementary lens over the camera lens. Such supplementary lenses are specially produced for many simple cameras. The marking on the lens

CLOSE-UP Painted Lady Butterfly. You can get as close to the subject as this by fitting a couple of supplementary lenses in front of the standard camera lens. At such short range you have to be extra careful with exposure; often with living subjects the best way to focus is to move the whole camera backward or forward. Photograph by *Peter Rowe, Britain.*

usually tells at what distance it renders things sharply. With the lens in position in front of the camera lens you just approach the subject to the right distance — 2 metres or 1 metre, as the case may be. (Measure that distance fairly accurately.)

If there is no special lens made for your camera you can often get one from a photo dealer by taking the camera to the shop with you. For most camera lenses have a screw thread on the inside of the front mount and many optical firms make supplementary close-up lenses to fit a variety of such screw thread sizes. Ask for a 1 diopter lens — that renders things sharply at a distance of 1 metre, or about 3¼ feet — or for a 0.5 diopter lens for sharpness at 2 metres or 6½ feet. There are also other supplementary lenses for still closer ranges — that is close-up photography proper (page 184).

HINTS AND TIPS

REFLEX CAMERA FOCUSING
The viewfinder of a single-lens reflex camera not only presents a large and bright image of the view taken in by the lens but also shows how sharp the picture will be when you take it. You can adjust the lens focus until the subject — John's handsome profile, the whiskers of the cat or whatever — appears sharpest in this viewfinder image.

Reflex cameras often have further focusing aids. The so-called microprism spot is a circle in the middle of the finder field where the image appears especially blurred if it is not quite sharp. Not only that, but picture details are broken up almost as if you were looking at things through a sheet of patterned texture (bathroom window) glass. A coarse pattern overlays everything. But the instant the lens is correctly focused, this pattern abruptly disappears and you see a beautifully sharp and clear picture.

When focusing with this system, you may have to turn the lens focusing ring to and from a little to make sure you get the sharpest point.

RANGEFINDER FOCUSING
In the other kind of focusing aid a small circle in the reflex screen centre appears, split in half horizontally or diagonally. The outlines of a sharply focussed object appear continuous across this circle. But as soon as anything is out of focus, subject outlines are split across the dividing line and displaced in the two halves of the circle. You then adjust the lens until the outline matches

DEPTH CONTROL For close to middle range subjects when the light does not allow a small stop you have to 'spread' the available depth of field across the features in the scene that you want sharp. On rangefinder cameras, work by the depth of field scale. On reflexes, check the image visually. Photograph by *Raymond Lea, Britain.*

up — for instance John's profile is continuous and not broken up as in a cracked mirror.

This type of split-image focusing works best with outlines more or less at right angles to the split. If your camera has a horizontal split and you focus on an upright door jamb, hold the camera horizontally — even if you want to take an upright picture afterwards.

Quite a few reflex cameras even offer both focusing aids: a split-image circle (or some variant of it) in the middle, surrounded by a microprism ring. This not only provides the best of both worlds, but is more versatile with different kinds of subjects. The broken-up pattern effect of the microprism area is particularly useful for subjects with a lot of fine detail texture — there the abrupt 'springing' into sharpness is particularly marked. Nor are you so dependent on subject outlines going in a particular direction. The split-image rangefinder system on the other hand may be a little quicker to use and is more distinct when the finder is quite dark in poor light.

RANGEFINDER CAMERAS

Some cameras have built-in rangefinders without a reflex screen. The finder picture is quite small but the image appears double in the middle. You focus this as with the split-image circle: adjust the lens until the double subject outlines fuse into one single outline. That at the same time sets the lens to the correct distance.

With very clever automatic cameras, complex photocell arrangements and electronic circuits built into such a rangefinder system check whether the image outlines are single (correctly focused) or double (out of focus). The electronic system then adjusts the lens until the focus is correct. All you have to do is point the camera so that an area in the centre of the finder covers the part of the subject you want sharp.

DEPTH OF FIELD AND INDICATORS

The sharp zone does not extend, as you might expect, equally in both directions of the focusing point. It is generally deeper behind the focused object than in front of it.

A striking example: With the camera focused at 8 metres and a suitably small stop (page 38), the zone of sharpness to the near side of the focusing point is only 4 metres deep, while behind it it stretches to infinity!

Most cameras have a depth of field indicator, and very useful it is. In a typical form it consists of several pairs of lines surrounding the focusing index — the mark against which you set the

lens's distance scale. Quite close to this index there might for instance be a pair of lines each marked with a '4'; further out might be a second pair of lines marked '8' and still further out another paid marked '16'. These numbers indicate f stops and the lines show the near and far limits of the depth of field.

Suppose you have focused the camera on 2 metres. On the distance scale one of the lines marked '8' may then be about halfway between the 1.5 and 2 metre marks, and the other '8' halfway between 2 and 3 metres. That means that at stop f8 the zone of sharpness extends roughly from 1.7 to 2.5 metres. Or, if the lens is set to infinity, the near limit of the depth indicator also shows the beginning of the zone for distant focusing. And if you set the infinity mark of the distance scale to any one of the aperture lines – for instance f8 – you can read off the nearest sharp limit opposite the other f8 line.

Last, but not least, this indicator also tells you the largest aperture you can use to cover sharply an object of known depth. It is always best to use as large an aperture as is consistent with subject conditions – to permit shorter exposure times of greater movement-stopping power.

GREATER DISTANCE FOR GREATER DEPTH

The zone of sharpness deepens, the further the subject is from the camera. It does so quite dramatically, as you can check on the depth of field indicator: At 4 metres you might have a zone from 3 to about 7 metres – overall 4 times as deep as the 1.7 to 2.5 metre range you would get with the same camera focused on 2 metres.

If you are stuck with a depth of field problem at near range, it may thus pay to go further away when a larger stop (in poor light) covers for the same zone of sharpness – or cover a greater depth of field with the same stop. If you are using negative film you simply enlarge the print more. True, for bigger enlargements you need a stricter sharpness in the negative. But this way still leads to an overall gain in sharpness.

Managing the Picture Space

VIEWING THROUGH THE FINDER

Most current cameras have eye-level viewfinders: you hold the camera up to the eye to aim it. To see as nearly the same view as the lens takes in, hold the viewfinder eyepiece really close to your eye and look into the eyepiece centre — don't squint into it at an angle. If you see the view inside a bright-line frame, the latter outlines the correct view even if the eye is not exactly centred behind the eyepiece. With such bright-line finders, hold the camera without obscuring the second matted finder window on the front, through which the bright-line frame gets illuminated.

With near views, especially of people, leave a little space above the head to avoid cutting off the top of the head in the picture. Viewfinders (other than in single-lens reflex cameras), are not quite accurate at close range.

You need to keep your eye to the eyepiece of a single-lens reflex, too. Here the picture on the finder screen is particularly large — things often appear as you would see them with the unaided eye. Yet if you don't look straight through the eyepiece centre you might miss part of the view, or of the various finder indications — aperture, shutter speed and/or the exposure meter needle.

UPRIGHT OR HORIZONTAL?

Most pictures we see are oblong. So is the format of most cameras. But when should we hold the camera upright and when horizontally?

A quick answer is to recommend a camera taking square pictures — such as the No. 126 cartridge format or a 6 x 6 cm (2¼ x 2¼ inch) roll film reflex. There you no longer have to decide whether to hold the camera upright or on its side, as both are the same. And if you do not want to keep the original square shape, you can crop the square to either a horizontal or an upright rectangle when you enlarge the negative. But that is awkward with a colour slide film, for there you have to mask down the transparencies — which in turn means a smaller projected image.

With a rectangular format examine your subject carefully

PICTURE SPACE: RECTANGLES A carefully framed subject benefits from fitting closely to the picture margins. Rectangular-format cameras lend themselves to very strong compositions. Photograph by *Ed Buziak, Britain.*

before deciding whether it fits better upright or horizontally. This is especially true for instant picture cameras where you have to take the print as it comes out of the camera. Reducing such prints by cutting out a section of a required shape might leave you with something too much like a postage stamp. That also holds for colour slide film in normal cameras where you largely project the image exactly as you took it with the camera.

Some subjects immediately suggest the shape of the picture: an upright format obviously suits a standing figure, tower or tall structure. A group of people or a landscape suggests a horizontal shape.

For the view itself there is sometimes little to choose between the two shapes. Consider, then, what aspect of the scene you want to emphasise. In, say, a picture of a lake, do you want to convey the expanse of water, with its sailing boats and the long line of hills on the opposite bank, or are you chiefly interested in the sky and its masses of cloud towering above the shimmering water? In the first case hold the camera horizontally; in the second, an upright shot gives the desired effect. The same applies to many other subjects. It is less a question of mere reproduction, but it is a matter of interpretation too.

GET IN CLOSE

Every photograph you take should record your impression of a particular scene at a particular time. Today it may be the face of a friend, another day a child at play or a country scene you saw on holiday. When you pick up the picture days or weeks, or even months, later and look at it, it should immediately − if only temporarily − take in the whole of your imagination, dismiss all thoughts of daily worries and recreate the reality of yesterday. More than this, your photos should be able to convey even to a stranger something of what you have felt and experienced.

But for this kind of impact the picture must clearly show the object − person or place − that you got excited about at the time. And by 'clearly' we mean that the main subject should be as large as possible, filling the picture and with all useless frills and distracting detail left out.

The right approach is a matter of emphasis. The easiest way of emphasising the importance of something is to go close to it. The closer you go to an object, the bigger it appears in the picture and the better use you make of the available picture space.

If you make your own prints by enlarging your negatives − in colour or black-and-white − you can also concentrate the subject

PICTURE SPACE: SQUARE The square-format camera suggests a different type of composition such as this, though many people select rectangular pictures from the basic square shape. Photograph by *Jiri Horak, Czechoslovakia.*

matter in the picture by leaving out anything distracting at the top, bottom or sides. Such cropping of the image is less easy if you have sent your film to a photofinishing laboratory that only enlarges the full negative area. And it is, again, difficult with colour slide film that produces transparencies for projection. Even with negative or print film you are best off if you leave out as much unnecessary matter as possible before you take the picture, rather than after.

On some pocket cameras switchable lenses give you either a normal view or a tele view. The latter is an enlarged section of about the central 40 per cent of the picture area — useful if, for instance, you cannot get quite as close to the subject as you would like to. There may be a fence in the way, or people are apt to get self-conscious if you approach them too closely with the camera. And if you are stalking animals, they are easily frightened.

Advanced cameras can do rather more of this by completely changing the lens for a different one (page 170).

TILTING THE CAMERA

Tilting the camera is not the same thing as holding it at a slant. Usually the top and bottom edges of the picture (and of the finder view) should be horizontal. Otherwise the horizon appears to slant, water flows uphill or towers lean to one side, even if they are in London or New York and not in Pisa. If you are going to make enlargements, you can again partly remedy this by cropping the print at an angle until the towers are upright once more. It is more serious with instant-picture cameras and with colour slide film where cropping makes the actual picture you get smaller, and you cannot compensate by enlarging it further.

By tilting the camera we mean pointing the lens up towards the sky or down to the ground — deliberately, not by accident. It's an odd fact: when you take pictures that include buildings and you point the camera up just a little to take in the top of a small structure, the result looks like an accidental tilt. The building appears to lean backwards, largely because the vertical sides are no longer parallel but seem to converge towards the top. And this slight convergence makes people think, 'Aha, somebody couldn't quite get the view into his picture.'

If you propose to tilt the camera, tilt it thoroughly rather than just a little. Then people know that that is how you meant it to be. That, incidentally, applies just as much when looking up at buildings as when looking down.

However, if you want buildings to look straight, hold the camera level and go back far enough to take in the whole of the

GET IN CLOSE You do not get good pictures of people standing by shyly at a distance and getting a tiny image on the film. Move in close and get a real feeling of contact with the person you are shooting. Photograph by *Ed Buziak, Britain.*

structure without tilting. If your camera can use interchangeable lenses (page 172) a wide-angle lens takes in even big buildings from nearer by. Yet, if you have to tilt the camera up just a little to avoid cutting off the top of an Italian campanile, not all is lost; to some extent you can still correct converging verticals during enlarging (page 246).

LOOKING UP

Pointing the camera up from a low viewpoint greatly helps in isolating subjects. If you get down on your knees so that your model stands well above the lens, the background with all its disturbing and distracting detail sinks out of sight. The principal subject of the picture remains in undisputed possession of the field of view. The market cross or equestrian statue, the rather ordinary group of tourists, a gymnast doing a handstand on parallel bars − all of them gain impact when they stand out against the sky. Attractive clouds there may make a welcome addition to the picture. But a cloudless (brilliant blue or uniformly grey) sky is also effective as a background. In the latter case it may not even be obvious that it is the sky when you see the picture.

Black-and-white shots may need a yellow filter to give such sky backgrounds sufficient tone (page 128). With exposure meter readings be careful not to measure the bright light coming from the sky, which would give underexposed shots, but the light reflected from the main subject or darker foreground.

THE BIRD'S EYE VIEW

Extensive subjects containing a mass of detail − a beach with its crowd of holiday makers, a city square with its traffic, a flock of grazing sheep − are best taken from above. People and things which, seen from the same level, present the appearance of a confused mass, now sort themselves out into small individual groups that are much more easily recognised. The observer's eye wanders pleasantly from item to item, covering the whole ground progressively.

Shots from above are thus the exact opposite of shots from below, not only in method but in the results obtained. Whereas with the upward tilt you can deliberately isolate figures or objects by taking them out of their surroundings, the bird's eye view from above swamps them with endless detail.

For a picture of the crowded street scene, a viewpoint from the top of a building − or even from a window or balcony − is the best. The village with its few score houses clustering around

LOOKING UP A subject containing many complicated features is best photographed against a plain background. With an upward view, buildings are seen against the sky and this removes awkward obstructions. Photograph by *Horace Ward, Britain.*

the church can best be taken from a neighbouring hill top. For other objects a doorstep, a park seat, a wall or a table often gives a better view with a higher viewpoint.

Bird's eye views pose fewer exposure correction problems as pointing the camera downwards automatically cuts out an excessively bright sky or distant view. Also, depth of field required is far less than in pictures where you want both near-by objects and a distant background sharp.

Here, as in other things, do not exaggerate. True, people and vehicles taken from above sometimes look quite amusing with the foreshortening produced by the extreme angle. And if long shadows are present, as in the early morning or late evening, the results can be most effective and possibly even grotesque. But an endless parade of pictures with violently tilted camera angles — up or down — becomes a bore. After all, we don't spend that much of our time craning our necks upwards at things or leaning over the edges of parapets.

CIRCLING AROUND

One noticeable difference between many a beginner and the more experienced photographer is the way in which they approach a subject. The temptation, the moment you see an attractive view, is to get the camera up to your eye and shoot.

That is fine with snapshots and unexpected small happenings and expressions. There you have to shoot fast or you lose the picture. Shooting first and thinking afterwards is still acceptable if you are unlikely to have much chance to take pictures later — for instance if you are with a coach party that has stopped for a few minutes to admire a picturesque panorama.

But whenever time allows, the experienced photographer takes his time. The first impression is not necessarily the best. An Italian Renaissance church is not improved by a modern lamp post intruding into the foreground, especially if you can give that lamp post a miss by moving a few steps to the left or right. The view of a village in the valley probably looks much the same from 20 yards further down the road — but may by then be attractively framed by a few foreground trees.

Where the subject is not likely to run away, exploring it from different directions and angles is nearly always well worthwhile. It not only presents alternative outlines, different relations between foreground and background, but often also different lighting effects and shadows.

That, incidentally, is true of people, too. If the friends you are photographing on a picnic screw up their eyes, it's nearly always

EXPLORE THE SUBJECT Subjects that do not move and allow you time to consider a different approach should be looked at from all angles. Perhaps you may find an unusual picture like this stern view of the Cutty Sark. Photograph by *John Rocha, Britain*.

the sun that bothers them, not the camera. Go round to one side or the other: if they turn with you, faces will relax when they no longer have to face the glare. Equally, a step to the left or right will shift a tree that appears to be growing out of someone's head, to a less ludicrous and inconspicuous position. There is no end to the possibilities.

BREAKING THE RULES

Photography should be a way of life, of collecting visual memories, small slices of life, records of views and events that impressed or excited us.

Once upon a time photographers — like painters — built up pictures in much the same way as buildings: elements were arranged to balance each other, to suggest static or dynamic directions and so on. All this was codified in so-called rules of composition.

That certainly is a way of producing pictorial images. You can fill the picture space with patterns and masses of light and shade, if you feel that this yields more impact or whatever. But you don't have to. The purpose of such arrangement is to concentrate attention on the subject of your picture. But in art, more than anywhere else, rules exist to be broken. If you like a picture, take it — whatever the rules say.

The various suggestions of going close to a subject, trying different viewpoints and angles only aim to give you the opportunity of seeing possibly an aspect of an approach that particularly attracts you or that you failed to notice before. That is what picture taking is about.

HINTS AND TIPS

FINDER PARALLAX

On many cameras the viewfinder is located a little above and/or to one side of the lens axis. As a result the finder takes in a slightly different view from the camera lens — much as our left eye doesn't see absolutely from exactly the same viewpoint as the right.

You can forget about this so-called parallex error with subjects placed more than 6 feet away. But if you go nearer, then with a viewfinder located above *the lens it takes in a little more above the subject than the lens brings on the film. Likewise, it takes in less below the subject than the lens. With near shots you should allow for that by leaving more space above the subject in the finder than you expect to get on the film.*

If the finder is displaced to one side *of the lens as well, allow a*

little extra space in the picture towards that side, too.

Brilliant-frame or bright-light finders often have a couple of little marks in the frame, or perhaps a dotted line across it, to show the more restricted limit of the view at close range. With such parallax marks simply make sure that the subject is well within the boundaries formed by these marks.

With single-lens reflex cameras you can forget about parallax: as you see the picture formed by the lens, you naturally see the same view as the lens.

VIEWFINDERS AND SPECTACLES

To see properly through a viewfinder you should have your eye as close as possible behind the finder eyepiece. (That applies equally to single-lens reflex camera finders.) This can become a little difficult when wearing spectacles. For some cameras you can get eyepiece correction lenses. These match your spectacle prescription and screw into or clip onto the viewfinder eyepiece. You can then look through the finder with this lens in position and without your spectacles, and still see the image clearly. The only drawback is that you must take off your glasses whenever you look through the camera finder and put them on again to see normally.

Eyepiece correction lenses are specially useful with single-lens reflex cameras because with these you often have to take in figures or signals around the finder field – meter needle, aperture and/or shutter speed information and so on.

Sometimes such eyepiece lenses fit on the eyepiece together with a rubber eyecup. This keeps out stray light and so allows you to see better through the finder. It also prevents such light from affecting through-the-lens exposure meter readings. For such meters often read the brightness of the finder screen image, and to do that properly they want to see only the light coming through the lens, not stray light edging in through the eyepiece at the back.

Which Kind of Film?

In most cameras you can use three main kinds of film: colour print, colour slide and black-and-white.

Colour print film — as the name implies — eventually yields colour prints. Sometimes it is called colour negative film, because the image formed on the film itself is a negative — a small picture with the tones and colours all topsy-turvey. From those pictures the photofinisher who develops the film makes colour prints of convenient size to carry in your wallet or stick in an album. You can have much bigger prints made, too, to hang on your wall, for instance. With an enlarger and a few accessories you can also make the enlargements yourself. Even a small camera can, in this way, produce quite big pictures.

Colour slide film yields smaller pictures on pieces of transparent film. They are as big as the film you put in the camera — in fact, they are on that very same film. Colour slide film is also known as colour transparency film or reversal colour film, because it does not use a separate negative.

Projected colour slides can look much more colourful, brilliant and impressive than colour prints. However, you need to set up a projector or viewer every time you want to look at the pictures. You can also get colour prints made from slides, though prints made from pictures taken on colour print film often tend to show better colours.

Finally, *black-and-white film* is like colour print film but its negatives can produce only black-and-white prints. For a long time that was the only kind of photography in use.

COLOUR PRINT OR COLOUR SLIDE?

More people use colour print film than either colour slide or black-and-white. It is many ways the most convenient, both in use and for looking at the results. You look at colour prints directly as you hold them. You can carry them with you. You can have any number of prints made from the same negative or — subject to quality limitations — enlarge them to big pictures. Colour print quality on the other hand is not always the very best. That is partly because a print can rarely be as brilliant as the original scene

or subject: the colour image on paper simply cannot reproduce brilliant sun-kissed geraniums in your window box together with deep luminous shadows in the doorway. You will just have to live with that fact and make the best of it. It is also partly because the way the colours turn out largely depends on how expertly the negatives are printed. If you do that yourself, it depends on you; if a photofinishing laboratory does it, it depends to some extent on whether an operator keeps pressing the right button on an automatic machine.

With colour slides, processing is much less likely to ruin a well-exposed picture. The colours are much more brilliant when projected on a screen. But a projector (or special viewer) is something extra you need in order to look at slides. Often you have to black out the room as well. It's a little like the difference between a simple cassette or record player and a full hi-fi system: both can play back pleasant music but to benefit fully from the superior hi-fi quality, you must take much more trouble.

The colour slide actually exposed in the camera is usually the best of its kind. Duplicates — and even prints — can be made, but they are never quite as good as the original.

Instant-picture colour materials for the amateur, however, only yield colour prints.

BLACK-AND-WHITE OR COLOUR?

Most of the time our world looks colourful — whether with bright flowers, exotic costumes, the trappings of a carnival, tropical scenery and birds abroad or just delicate pastel shades of a quiet

spring day. So the obvious way of recording all these impressions, memories and experiences is on colour film.

But during the years of being largely restricted to black-and-white film, many photographers learnt to see how a picture just made up of different tones of grey from white to black can create a specially dramatic impact. Black-and-white images are much more of an abstraction and possibly lend themselves to more — and easier — experimental treatment.

Practical points count too: black-and-white is less expensive than colour, easier to handle and much simpler for making your own prints. It is kinder to mistakes in exposure. Normally black-and-white films are print films: they yield a negative from which you can make (or have made) small or large prints.

You can also have black-and-white prints made from colour negatives. If done properly, they look quite good — possibly a shade less sharp than prints from black-and-white film. But that's like buying a motorboat and then rowing it. In fact each type of film — colour print, colour slide and black-and-white — performs best in its own field. Yet they can switch roles once in a while if necessary.

THE TOPSY-TURVY WORLD OF THE NEGATIVE

We've mentioned the negative: it is the key to most photographic processes. When light reaches the sensitive layer of the film, it eventually (after development) makes the film go black. The more light reaches the film surface, the denser the blackness; the less light, the paler the film remains. So when the camera lens projects an image of the scene in front of it onto the film in the camera, it is the bright sky portion of the image than turns blackest. A dark doorway in the image on the other hand remains almost clear. This image in reverse tones we call the negative; it shows all the brightness values of the subject, but topsy-turvy.

That is true only if the right average amount of light reached the film. If you had too much light — too much exposure — even the

dark doorway becomes quite dense on the film and anything lighter in the subject gets impenetrably black: the film is over-exposed. If you allow too little exposure, even the brightest sky can produce little more than a faint greyness on the film. Anything less bright fails to make any impression at all − the picture is underexposed. That's why you must have the right amount of light for a correct exposure.

A colour negative does something similar to the colours too: the bright blue sky of the view becomes not only dark but also yellow. A dark red dress is not only light in the negative but gets a bluish-green tint. A green lawn becomes pink. All other colours are changed round too. It's not quite so obvious when you look at the negative, because an orange tint covers it all − but the colours are all there underneath − topsy-turvy.

When you make a print from the negative, you run through the whole process again so that everything comes right once more: what was a dark sky area in the negative is again a bright sky in the print while the faint patches representing shadows on the negative become properly solid again on the print. The colours, equally, are switched back: the sky to blue, the lawn to green and the dress to the red it was originally.

It is this two-stage process that makes photography so versatile. It allows you to make big or small prints, as many as you like, and you can play about with the colours.

What of the colour slide that seems to do it all without a negative? Actually it still goes through a negative stage, but that all takes place during processing in the same film. It's all over by the time you get the colour slide back from the processing laboratory or photo dealer.

HOW SENSITIVE IS THE FILM?

Some films are so sensitive that they need very little light exposure to produce a given darkening of the sensitive layer, other less sensitive ones need rather more.

As correct exposures can be quite critical, we must know fairly precisely how sensitive a film is. Fortunately scientists in film makers' laboratories have worked out standard ways of measuring and designating film sensitivity − or film speed, as it is called. The most usual way is with the ASA speed index. This is quite straightforward: a film of 250 ASA speed is twice as sensitive as one of 125 ASA. Films used in general photography may range in speed from about 25 ASA to over 3000 ASA − and that's quite a range!

Virtually every film you buy today has an ASA rating marked

somewhere on the packet. Sometimes it may have other system ratings, too, for instance DIN or GOST. The latter is a Russian system very similar to ASA (the numbers are slightly shifted) while DIN runs in single-number steps. The table on page 107 compares these film speed ratings. But usually you can forget about anything other than ASA.

The ASA speed is something you must set on an appropriate control on your camera's exposure meter. After all, it must measure the right exposure for the speed of the film you have loaded in the camera. With some cameras – the types taking No. 110 or 126 quick-loading cartridges – a notch on the cartridge engages a kind of 'feeler' inside the camera to set the ASA speed automatically. Such cameras give the right exposure on their own with any film you care to load.

HOW SENSITIVE SHOULD IT BE?

At first sight you might think that the more sensitive or faster a film, the better. Certainly, with a fast film you can take pictures in much weaker light than with a slow film. Or you can use a very short exposure time (fast shutter speed) for rapidly moving subjects even when the light is not good. Just think of photographing a football match on a grey winter afternoon. A fast film also gets you pictures by street lighting at night – and you can still hold the camera in the hand without risking camera shake.

At second sight there are a few snags. Fast film is fine for fast movement or in poor light. It may be too much of a good thing on a brilliant sunny day. For with too fast a film you overexpose the picture even at the smallest lens aperture and with the fastest shutter speed on your camera. (That is most likely with simple cameras.)

The other snag is that the quality of the film's image is generally better with films that are not so fast: it is more brilliant, even sharper, more detailed for enlarging and colours, in colour materials, tend to be better, too.

So there is no one 'best' film – ideal for any and every kind of picture. The fastest film is not best, any more than a racing car is the most suitable vehicle for taking out the family.

Fortunately the average medium-speed film you can buy in almost any photo shop is a good compromise. It is fast enough for taking pictures in less than brilliant sunlight – especially if you can adjust the shutter speed and aperture on your camera – nor too fast to risk overexposure the moment the sun comes out. And it is more than acceptably good for sharpness, brilliance and colour.

That's just as well, for it would be most awkward if you had to

change the film every time you want to take a different kind of picture — out of doors, indoors and so on. (Switching films is easier on some very expensive cameras — but it's still a nuisance.)

All-round colour films have speeds of 64 to 100 ASA; black-and-white ones a little higher — about 100 to 200 ASA. With such a film you are well set for most occasions.

DIFFERENT KINDS OF FILM

With some cameras you don't have much choice between slow and fast films. Thus, all No. 126 cartridge camera films are of the all-round medium-speed kind. With other cameras, for instance 35 mm, you have a wider choice:

High-speed films of 250 to 400 ASA exist in colour print film and black-and-white versions for greater versatility in poor light conditions. If your camera has fast shutter speeds (up to at least 1/500 second) and you can set small lens stops, you can still use this film type for most daylight subjects. You sacrifice a little quality, though. There are similar colour slide films, too.

Extreme-speed films beyond 400 ASA exist only in black-and-white. They are rather specialised and used by people for whom getting a picture in tricky light conditions is so important that they are prepared to put up with some quality drawbacks.

Slow films of around 25 to 50 ASA exist as colour slide and as black-and-white film. You need good light for reasonable exposures but these films yield extra sharpness and detail resolution. There even big black-and-white enlargements still look sharp and clear. The same holds for colour slides in this film group when you project them on a screen.

DAYLIGHT AND ARTIFICIAL LIGHT FILM

Usually the colour slide film you buy is a so-called daylight film. It is ideal for all outdoor photography, pictures taken with flash and even indoor shots by daylight. With most people that covers well over 90% of picture taking.

For some cameras (mainly 35 mm and roll film) and with some film brands you can also buy artificial light type colour slide film. It may have various labels, such as 'Type A', 'Type K', 'tungsten' etc. This is the better film to use for indoor shooting by lamplight (not flash), or for outdoor pictures at night, by street lighting. Professional photographers also use it in their studios when working with tungsten lighting.

Why the difference? Colour slide film faithfully records the colours of things as it sees them. Colours depend a lot on the kind of lighting by which you look at them. Most of the time we look at things by what we think is white light. However, not all white lighting is equally white. If you switch on your table lamp in the daytime, its light looks distinctly orange compared with the daylight coming in through the window.

The fact is, white light is a mixture of light of all colours – violet, blue, green, yellow, orange, red. Only the mixture is not always the same: the 'white' lamplight contains a little more red and orange – and a little less violet and blue – than the 'white' daylight.

Scientists have tried to measure this whiteness of different kinds of light. They express this on a so-called colour temperature Kelvin = K scale. The whiter (or more bluish-white) the lighting, the higher the colour temperature; the more reddish the light balance, the lower the colour temperature. Thus daylight is reckoned to have a colour temperature of around 5000-6000 K (absolute temperature scale); studio tungsten lighting is 3200-3400 K and normal household incandescent lighting very roughly 2800 K.

Colour temperatures are a very rough and ready way of specifying 'whiteness' of lighting and they cannot be used with all light sources, either – not for instance with the yellow sodium street lighting which is not a mixture of *all* colours.

Colour temperatures are, however, useful for generally specifying kinds of lighting and the film balance with colour slide films.

This difference between daylight and lamplight is usually noticeable only when seen side by side. In the evening, when only the lamp lights up things, we quickly get used to regarding that light as much as white as we did the daylight a few hours earlier. Our eyes are easily deceived (not only by colour).

The colour slide film is not. It faithfully notes the hues and tones of things in daylight and just as faithfully records the rather more reddish look things take on by lamplight. Hence, slides taken by artificial light appear all orangey, quite unlike the way we remember the scene.

Special artificial light type slide films cope with this by being

more sensitive to the sparser blue content of tungsten lighting, and less sensitive to the greater red share. That way, slides taken by tungsten light look more like pictures by daylight − or how we think they ought to look.

Of course, if you use artificial light colour slide film in daylight, the pictures look wrong again: this time all too blue. As it is inconvenient to switch from daylight to artificial light type film in the camera, you can sometimes adapt the film's colour response by special filters, more about that on page 123.

DAYLIGHT TYPE ONLY WITH PRINT FILM

All this is a problem peculiar to colour slide film − not to colour print film. For once the slide film has recorded a picture, it has remembered it with all the colour hues, right or wrong. There is nothing you can do to change it any more. You must select beforehand how slide film is to record a scene − if necessary by selecting the type of film.

With colour print film the colour rendering can still be controlled to some extent when you make a print from the negative. So a daylight type colour print film usually does for other kinds of lighting, too. Anyway, normally it is the only kind of colour print film you can buy.

Nor does the kind of lighting greatly influence black-and-white pictures. Modern black-and-white films are sensitive to light of all colours but they record these colours only as brightnesses − lighter or darker grey − and not in hue. True, red objects may appear lighter in a picture taken by lamplight than by daylight, and blue items slightly darker. But these differences are so slight that you would rarely notice them.

OTHER QUALITY POINTS

You may come across a few other terms in descriptions of film characteristics. Usually they are related to the choice between all-round, low-speed or high-speed films. For the record, here they are:

Graininess has to do with the fine structure of the image. Seeing people from a distance, a crowd of people looks a human mass so compact that there seems no room even for a child to slip through. When you go close up, the crowd is not nearly as dense as you thought. The image in the film is a little similar: to the naked eye the different tones look uniform, but under a magnifying glass or microscope they are seen to be made up of individual dark specks of various sizes.

These dark specks become recognisable when you look closely

at a big enlargement made from a small negative — or when you project a slide on a big screen. The smooth tones become a grainy pattern. The bigger you enlarge the picture — depending also on the film used — the more noticeable this graininess becomes. Generally high-speed films have coarser grain and slow films finer grain. So you can enlarge negatives made on a slow film to bigger print sizes before the grain becomes too disturbing.

The grain structure in colour pictures is often coarser than in black-and-white, but less distinct because it is formed by blurred blobs of different colours, superimposed in various ways. Black-and-white films have finer but sharper grains made up of tiny silver particles.

In practice the grain of all-round films is fine enough not to show up even in medium-sized enlargements — up to say 20 x 25 cm or 8 x 10 inches. With slow, so-called extra-fine grain films the negatives can be enlarged much bigger still without appearing noticeably grainy. And with high-speed films you have to put up with some grain for the sake of capturing pictures that you couldn't photograph on a slower film.

Detail resolution is also tied up with fast and slow films. Coarse grain tends to hide fine detail. So the finer the grain to start with, the finer the detail the film can resolve. But the image on the developed film is always less sharp than the image projected by the lens, for this image spreads a little within the thickness of the sensitive layer. This spreading is less with thin-layer slower films; on thicker high-speed films the final picture may be a shade less distinct. Colour films have multiple layers to record the different colours; there you lose still more definition.

So for utmost image sharpness use a slower film when conditions allow, and use black-and-white rather than colour if a colour image is less important than a sharp one. One exception is the slowest kind of colour slide film. This yields very much sharper pictures than colour print films or medium-speed slide films.

With negative films — black-and-white even more than colour — the degree of exposure can also affect sharpness. Black-and-white films have quite a lot of exposure latitude: you can overexpose and still get an acceptable print. But the overexposed picture is very slightly less sharp — noticeable again only in big enlargements.

INSTANT-PICTURE FILM

Instant-picture cameras take two rather different kinds of material: single-sheet and peel-apart.

Single-sheet material yields colour prints which, after exposure, emerge from the camera as a single blank card. The colour begins

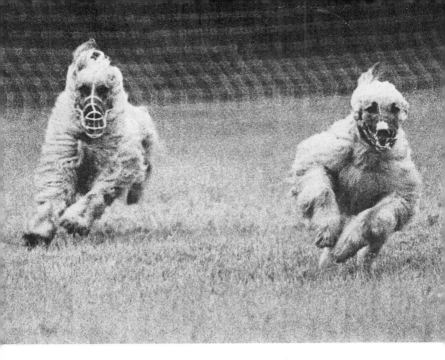

GRAIN Very fast films essential for the short exposures used in action
photography have much coarser grain structure than normal films. Selecting
a part of the negative for enlargement inevitably increases the effect of
this grain. Photograph by *L.B. Feresovi, Czechoslovakia.*

to appear on that within a few seconds and is fully finished in about 5 to 10 minutes. Behind this almost magically simple happening is a complex series of processes that all take place in ordered succession within that thin card which is the picture. You have in fact a kind of microscopic chemical factory working full out, all automatically, while the picture appears.

In *peel-apart* instant-picture systems you pull the picture out of the camera by a tab after every exposure. The picture is a sandwich of a negative and a positive sheet. The pulling-out process starts the chemical developing reactions between them. After a couple of minutes or so you peel the sandwich apart (hence the name) into the finished print and the negative. The latter is thrown away. With some peel-apart materials you can however recover the negative by a special washing process and then use it like an ordinary black-and-white film negative.

Peel-apart instant picture materials may yield colour prints — a slow to medium-speed material — or black-and-white prints. Usually the black-and-white material is very sensitive; you can take pictures with it in quite weak indoor light.

HINTS AND TIPS

THE RIGHT FILM PACKAGE

For most amateur cameras, films come in rolls or cartridges. Once the film is put in the camera, you can almost forget about it for anything from a dozen to three dozen shots. Having these convenient 'ammunition packs' means that you can get on with carefree picture taking.

But be sure you know the right film package for your camera. It's easy with cartridge cameras: they take either the small No. 110 (pocket format) or the larger No. 126 cartridges. Cameras taking standard 35 mm film are fairly straightforward, too: at the most you have to decide on the film length you want — 36 or 24 (or sometimes still fewer) exposures.

It gets trickier with roll film and other formats. Most current roll film reflex cameras take No. 120 film. But at various times camera makers produced numerous odd formats for different film packings — and film makers faithfully produced films in those packs. In many cases you can still buy them today, even where cameras have been obsolete for up to nearly 50 years!

So if your camera takes an unusual film size — anything other than No. 110, 126, 35 mm or 120 roll film — make a special note of it and be sure to ask for the right film when you buy it in a photo shop. With some of these special sizes you may have to

look quite hard, for only a few of the larger shops may stock them.

Note also the make and kind of camera for instant-picture materials. Here different makes are even less compatible: a camera for single-sheet instant-picture films won't take the peel-apart type, nor vice-versa. And one make of instant-picture film will not necessarily fit another make of camera.

LOAD WITH CARE

The exact manipulations for putting a film in the camera vary a little from model to model – so read the camera instruction book carefully.

Cartridge cameras are easy to load: you open the back, drop in the cartridge and close the back. Then you only have to operate the film transport knob or lever until it locks – and you are ready to shoot.

With other cameras, loading may need just a little practice. Here is a hint: get a film (the cheapest black-and-white) expressly for wasting it, to practise loading and unloading. Do it carefully step by step with the instruction book, then wind the film all up in its cartridge or spool again and try once more – until you can do it easily, smoothly and almost instinctively.

Don't rue the cost of such a practice film: you won't be anxious over what you do with it. Yet it may well save you ruined films later on – possibly with good pictures on them – or missed subjects while you were fiddling with the film.

Even when you've really got the hang of loading, don't throw away the practice film: it will come in useful in learning how to load a film tank, too (page 260).

LOAD IN THE SHADE

Film packings – cartridges, rolls, etc. – are very largely light-tight. Although the film comes out of the cartridge through a slot, any light has to go into the slot past the film and then round a very crooked path before it can do any harm. By that time such leaked light has become very weak indeed. But if you leave a cartridge lying for a long time in the sun, even that weakest light may eventually ruin the film.

So you can safely load and unload cameras in daylight. It's safer not to do it in brilliant sunshine – better find a shady spot or at least turn your back on the sun and load or unload the camera in your own shadow.

When you load a film in a camera with built-in meter, remember also to set the film speed. Only instant cartridge

models don't need that – the cartridge automatically sets the speed.

THE FILM ADVANCE

With a film load of anything from 8 to 36 (or even more) exposures you must advance the film in the camera after every shot. That winds the exposed piece of film out of the camera's film window to bring a fresh section into position. Follow the camera's instruction book in turning the knob or lever that controls the film transport.

Some people wind on the film after every shot, others like to wind just before taking a picture. People who do the latter argue that the film lies flatter if it has just been advanced (no film is ever absolutely flat) but you have to remember really to wind the film before you shoot. Otherwise you find yourself pressing the button and the release is blocked – and while you quickly wind the film, you have lost the subject. Sometimes you may also decide not to take a picture, after you have wound the film.

If you wind after an exposure you always know exactly where you stand. So that is easier and more habit-forming. For the mechanics of camera operation should be a habit; it's the picture you should concentrate on, not the knobs and levers.

The problem is solved with motor-driven cameras. Such drives or winders advance the film after every shot, whether you like it or not.

Nor do you have any choice with instant picture material: after an exposure the finished picture has to come out of the camera before you can take the next one.

At the end of a 35 mm film the whole film needs rewinding into its light-tight container before you can unload the camera. (If you open the camera before rewinding, you spoil most of the film.) Instant cartridge cameras are again simple: you open the back, tip out the cartridge and close the camera again.

FILM SPEEDS COMPARED

Nearly all film you buy carry an ASA speed figure, as mentioned earlier. Occasionally a film may also show film speed in DIN or even in the Russian GOST system. Also you may have bought or borrowed a camera whose exposure meter setting is not calibrated in ASA. The table on page 107 then tells you how the speed ratings compare.

FILM SPEED SYSTEMS

ASA	DIN	GOST*	ASA	DIN	GOST*
25	15	22	200	24	180
32	16	32	250	25	250
40	17	32	320	26	250
50	18	45	400	27	350
64	19	65	500	28	500
80	20	65	650	29	500
100	21	90	800	30	700
125	22	130	1000	31	1000
160	23	130	1250	32	1000

* Approximate

Some Technical Refinements

EXPOSURE LATITUDE

We have seen that the film needs a correct exposure to record properly the light and dark tones — and brilliant or soft colours — of the subject. Fortunately there is some leeway in what constitutes a correct exposure. Under some conditions the film may put up with quite considerable exposure errors and still produce acceptable pictures. That is just as well, for otherwise you would have to spend more time on elaborate exposure measurement than on taking pictures.

The degree of exposure latitude depends on both the subject and the film. The latitiude is more restricted with colour slide film. For there only the camera exposure determines how the finished slide will look. When you project the slide you want to see detail and colour in deep shadows. Yet you don't want to lose delicate detail in the bright parts. In an overexposed slide that light detail disappears. An underexposed one is darker all over, but you might get away with it if your projector is sufficiently powerful. In practice a colour slide film that has double the correct exposure is already too pale: the latitude towards overexposure is about 50 per cent or half a lens stop interval. A slide underexposed by 1 to 1½ stops may still be acceptable — that is the underexposure latitude.

Exposure latitude is greatest with black-and-white film but this, also, is partly dependent on the kind of subject. If a scene has only a few tones of different brightness, the film can accommodate them quite easily, even with widely varying exposures. So with low-contrast subjects you have more exposure latitude on a negative film. With contrasty views — bright snow scenes and dark figures against them — exposures must be more accurate to render both right.

On average, you can expect an exposure latitude from −½ to −1 stop to +3 or +4 stops — in other words you can often get away with up to ten times overexposure. Unlike colour slide film, a negative film bears overexposure better than underexposure.

With colour print film the situation is similar to black-and-white, though the latitude is rather less, for wrong exposure

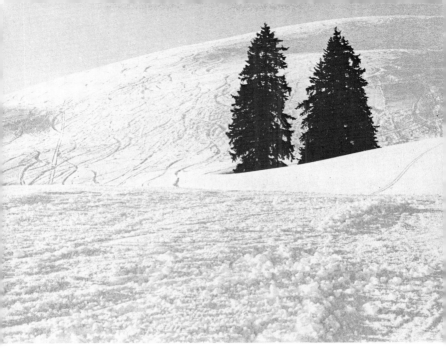

EXPOSURE LATITUDE: CONTRASTY SUBJECT Snowscenes are very difficult to get exposed correctly because the tonal range is too great to accommodate on the negative. Exposure must be very accurate if the photograph is to render all tones as they appear. Photograph by *Jan Ake Rundqvist, Sweden.*

affects the colours, too. Exposures should not be more than 2 stops over.

All this is, of course, a safety margin. For the pictures are best − sharpest and most faithful in colour − if the exposure is right. That is why most present-day cameras others than the very cheapest ones have some form of built-in exposure meter.

HOW ACCURATE ARE EXPOSURE METERS?

Exposure meters indicate or − in automatic cameras − set the right exposure in about nine cases out of ten. Those are the subjects where you have an even mixture of light and dark tones − a few black shadows, not too big, a few bright highlights, possibly a little (not too much) sky and a lot of medium tone values. There nothing can go wrong. What the meter sees is also what controls whether you get the right exposure. If the sun comes out to flood the scene with light, the meter takes note and sets, or indicates, less exposure. Or, if the sun hides behind clouds, the meter cell again notices the drop in brightness and quickly gets the shutter and diaphragm to let through more light to compensate.

But some subjects do fool the meter. They are not views that are just dark or just light: the meter can cope with that as easily as it can with changes of weather. But it can get upset if a scene includes large areas that are very bright and small ones that are very dark, or vice versa. An outdoor view with a bright sky is one example, and easy enough to cope with. Others are great expanses of snow or sand with just tiny figures, views with large shadows and small bright spots − for instance when the sun comes from the side or behind the subject − or people or things against a strongly contrasting background.

CONCENTRATING ON THE SUBJECT

The last kind is easiest to deal with. Where the camera's meter tells you the settings but doesn't actually set them, you can let the meter have its own look at the view beforehand. If you think Jean in her new dress would show up particularly well in the sunshine in front of a dark doorway, that big area of black will give the meter cell quite the wrong impression. So go right up to Jean till the meter's view takes in only her and no doorway. Now you can note the right exposure, set it and go back to where you want to take the picture from. With your help the meter has outwitted the subject.

You can be equally cunning if Fred in his dark suit stands in front of a whitewashed wall: again go close enough till the meter no longer sees any wall.

110

There are a few other dodges to the same effect. If you cannot get close enough to the subject with the camera, try finding some medium-toned object nearby — a stretch of lawn, roadway, another companion — and check what exposure the meter tells you there. If they are both sitting in the same sunshine (or other light) you need the same exposure for Jean 25 yards away as for Tommy standing next to you.

RULES OF THUMB FOR METER CORRECTIONS

Failing near exposure readings on a subject — hardly convenient for quick snapshots — you can allow for unusual conditions by giving more or less exposure than the meter indicates. The exposure meter is a faithful adviser, but it's incapable of judging when it's being fooled. You have to decide that, according to the subject type.

A common kind of non-standard subject is one with over-average dark areas: deep shadows with just a little highlight, bright views through dark doorways or your friends against a dark or heavy background. The meter tends to read somewhere in between — too much exposure for the bright view because it's unduly influenced by the doorway; too little exposure for the dark shadows, because it is affected by the brightest rays of light, too.

So you now have to make up its, and your, mind: if the bright view matters but the doorway doesn't, give less exposure than the meter indicates. If you want detail in the dark shadows despite the small bright areas, increase the exposure.

Work in terms of one exposure step at a time: one lens stop larger for more exposure or smaller (higher f number) for less exposure. Alternatively switch to the next higher shutter speed for less exposure and lower speed for more. A one-step correction is usually right when you become strongly aware that the subject hasn't got evenly matched bright and dark tones.

The situation is reversed with views of large bright and small dark areas — people in the snow, on the white sand at the seaside and so on. (Don't confuse this with bright lighting, such as brilliant sunshine, for the meter takes care of that.) Here the meter can't quite believe that all that snow is really white and so tries to expose as if it were grey rock. To get a white snow effect, you must increase the exposure by about one stop. Yes, *increase*, not decrease because the meter cell is mislead. The same applies if you want a portrait shot of someone against the snow: the latter makes the meter read too little exposure for the face. The situation is similar to when you had too much sky in the picture.

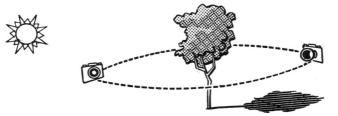

Now that you know a little more about less common exposure situations, you can also tackle more ambitious light conditions.

When the sun is shining, many photographers are tempted to shoot with the sun behind their back.

With landscapes and views in town you generally have little choice: you have to take the light from wherever it comes. But this kind of direct lighting yields flat, shadowless pictures that are rarely pleasing. And people invariably screw up their eyes against the glare of the sun.

Side lighting gives better results, for you see shadows cast by it giving things depth and body. Foreground and background which with back lighting seemed to lie on top of each other, are now clearly separated.

With black-and-white film you can go even further: though you lose colour, you gain dramatic impact by more pronounced interplay of light and shade. One of the more telling ways of doing that is by taking pictures against the sun – with the sun in front or to one side, or even right in front of the camera. Only avoid the sun shining directly into the lens. That would produce all sorts of bright spots and circles overlaying the image.

Against-the-light photography is exciting. Long shadows lie alongside patches of brilliant sunshine. Bright rims pick up outlines. Sometimes the light between the near foreground and the distance, with its millions of light-reflecting dust particles, seem so solid that you could grasp it. It is remarkable how the most unpromising subjects – depressing suburban streets for example – can be transformed and beautified by shooting into the sun. There are other subjects, too, such as the maze of tree trunks and masses of foliage in a forest, which are simply unthinkable as photographs with any other than against-the-light illumination.

Equally dramatic are against-the-light shots over water, with scintillating reflections from the water surface.

Since the light comes at such an acute angle from in front of the camera, you must use a lens hood or sun shade. This fits over the front of the lens and protects it against the glare of the sun, just as we protect our eyes by shading them with one hand. The lens hood also shields off bright glare from things in the foreground. If there is a shady spot handy, such as a doorway or arch under which you can stand while you take the picture, you can dispense with the lens hood. Often even a shadow cast on the camera lens by a branch of a tree, a lamp post or the hat of a companion does the job.

The lens hood cannot of course give any protection for the rare shots where the sun or intense reflections are actually in the picture.

AGAINST-THE-LIGHT EXPOSURE

As against-the-light pictures show things largely from their shady side, you need enough exposure to show some detail in the shadows. With the exposure meter measure either from near-by to read primarily the shadows, or if the meter can only take in the whole view, give one step extra exposure. For against-the-light shots in outdoor summer sunshine count on an exposure of around 1/125 second with stop 5.6 for 100 ASA film.

It's a different matter if no detail at all is required in the foreground shadows. In that case measure the exposure from the brightly lit background — usually 1/125 or 1/250 second with stop 8. In the final picture that gives you a dark and detailess foreground, and behind it the landscape or cloudy sky brightly lit and rich in detail. An inn sign seen from the street below, a monument standing in a sunny street, or a cross such as one sometimes sees in the fields in France, outlined against the line of blue hills — these and similar subjects are ideal for against-the-sun silhouettes.

The small aperture with a focus setting of 7.5 metres or 25

feet gives you a near-to-infinity zone (see page 38). That way you have sharp definition from the fairly near dark foreground right up to the bright distance if needed. And if the foreground is a nearly detailless silhouette, a slight loss in sharpness there won't be that noticeable.

AGAINST-THE-LIGHT COLOUR

The dramatic effect of against-the-light shooting is ideal for black-and-white photography. Such subjects can also look good on colour slide film, for the projected transparency can render the immense brightness range from the dark silhouette — possibly even with some detail — to the brightest sunlit spot. It is important however, to get the correct exposure, and this is particularly difficult here even with an automatic camera. For what the meter indicates or sets depends entirely on how large the shadow portion is, not how bright the light.

Professional photographers faced with tricky exposure conditions usually make several exposures at different levels. For instance if they think that a sailing boat against the sun on the lake should have 1/125 second at $f5.6$, they take three shots at $f4$, $f5.6$ and $f8$. They may even make additional exposures halfway between $f4$ and $f5.6$, and again between $f5.6$ and $f8$, if the subject is important enough. It costs a little more in film but is a worthwhile insurance for a good picture.

High-contrast subject like this are, however, likely to be disappointing on colour *print* films. For the colour print can rarely cover the brightness range of the original scene. And when you go for silhouette-like rendering, a lot of the colour is lost.

WHICH APERTURE AND SPEED?

With both the shutter and the aperture controlling the light, there are many occasions where you can use several alternative combinations for the same effective exposure. Thus 1/125 second at $f5.6$ is the same, in effect, as 1/60 second at $f8$ or 1/30 at $f11$. So which is best?

Well, all of course are usable. But one difference among many between the novice and the expert is the way in which they choose their exposure combination. Beginners tend to stop down as far as they can even if there is nothing to be gained from great depth of field. In part that's a fear of a blurred image, in part also limited confidence in being able to focus properly.

The expert on the other hand tends to go for large apertures and high shutter speeds if he doesn't absolutely need greater depth of field. That is a better insurance against unsharpness

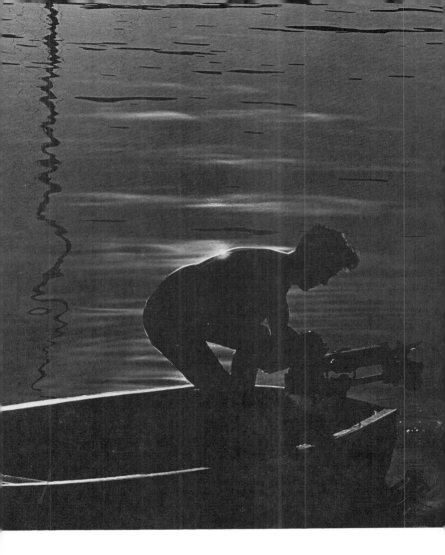

AGAINST THE LIGHT If exposure is based on the highlight area then the mid tones are rendered in silhouette. The effect is unreal, but dramatic. Photograph by *Neville Newman, Britain*.

through camera shake, though you have to focus more accurately and ensure that the smaller depth of field includes everything you want to get sharp in the picture. Incidentally, modern lenses yield better sharpness at a large to medium aperture that at their smallest stop.

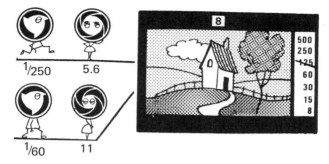

Owing to the various degrees of sharpness in the image, more limited depth of field often makes pictures more interesting. The essential item, be it man or beast or inanimate object, is clear and sharp while the mere incidentals and tedious background detail are suitable subdued. You can choose just what you want and leave out the rest, unlike in the shot taken with a small aperture where everything is evenly sharp.

So it is often better to use a large aperture with a faster shutter speed, and focus that much more precisely. With a reflex or rangefinder camera that is no extra trouble, anyway.

PICTURE SERIES

You may often be tempted to take a series or sequence of photos — especially if you use a miniature camera and have 20 or more exposures on one roll of film. There you can afford to use up several shots on the same subject.

It is sometimes difficult to get people, children and even animals relaxed for informal pictures. They take a while to forget that the camera is there and to stop putting on a sheepish I-am-having-my-picture-taken expressions. If the camera keeps clicking away as you talk to them, it will capture more and more relaxed characteristic expressions. Professional photojournalists often use this technique for telling pictures of people they interview.

If the worst comes to the worst you can choose the best or a few best shots and throw the others away. But it is often worth-

116

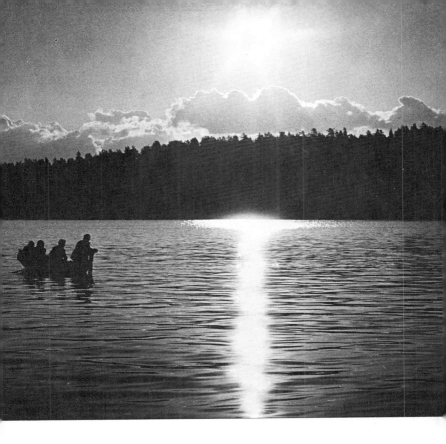

SUN IN THE PICTURE Midnight sun. The extremely short exposure and smallest stop with fast film kept the sun from blinding the film with light. The sky and its reflection on the water become mid tones and all mid tones are total shadow. Halation in the sun and on the water spreads into these areas. Photograph by *Pentti Paschinsky, Finland.*

while to keep several snapshots of a series. The changes in expression or attitude during such a shooting session give you a picture sequence almost like a movie show, though perhaps not so dramatically alive as a film.

Motorised winders, available for many single-lens reflex cameras, make such sequence shooting easier still. The winder attaches to the camera and couples with the film transport mechanism. You then only press a button to take a picture and automatically advance the film for the next shot. That way it is easy to take up to two pictures per second. With more advanced motor drives even up to five pictures per second are possible — that becomes virtually a movie film sequence.

Winders or drives are particularly handy for sports and action photography. If you want to catch a tennis star as his racket hits the ball, catching the right moment is very difficult. With a motorised sequence that you start running a second or so before, you have a much better chance.

COLOUR, LIGHT AND HARMONY

Choice of viewpoint and of light direction are two ways in which you can control the effect of your photographs. Colour is a third.

Obviously for most of your photos you have to take the colours of the subject as you find them. Often you also have to take the lighting as you find it. However, colour pictures of people look best in soft rather than harsh lighting — with slightly veiled or hazy sunlight rather than in the brilliant glaring sun. On the other hand, colours do look more lively by any sort of sunlight than they do on a dull day. (But the coolness of dull-weather colours can deliberately accentuate the mood of such a day.)

Beginners in photography often tend to include too much in a picture: John and the Colosseum or Betty and the flower beds — when you could get much more interesting pictures by concentrating on John, the Colosseum, Betty and the flowers all separately.

Betty and the flowers is also likely to be a riot of colour — which can be too much of a good thing. Just as in the best photographs one main subject dominates the picture, so harmonious colour effects depend on not having too many competing brilliant hues. The flower bed complete with its red, yellow, blue, orange etc. flowers and green foliage is fine for a gardening catalogue. Your photos however look better if you concentrate on just a handful of flowers and one or two main colours at a time. The many different ways in which the sun strikes the individual

flower petals and is reflected from them and from the greenery provides a myriad of subtle pastel shades. And it is these, with just one or two brilliant hues that give the picture richness without screaming at you.

When you take pictures of people, you won't normally have much to say in how they are dressed. But you can at least select a background which harmonises with the colour of the clothing. Anything will go with a pale blue sky and, in fact, with most subdued background tones — buff or grey stonework etc. Avoid brilliantly coloured backgrounds if you can: a green lawn competes quite viciously with a mauve dress.

BEWARE OF REFLECTED COLOUR

In fact, green lawns raise another problem in pictures of people: the grass reflects a greenish tinge into the flesh tones of the face, making it look almost sickly. For the same reason avoid taking colour portraits near strongly coloured walls, especially of so-called cold colours — violet, blue or green and intermediate tones. Strongly red-reflecting surfaces (e.g. a brick wall) similarly produce reddish tinges. These may be quite wrong, too but at least look healthier in a face.

Colour also creates various psychological effects related to subconscious seeing habits. One is that so-called warm colours (red, orange, yellow) often give the impression of being nearer and cold colours (green and especially blue to violet) of being further away. Hence a scene with reddish to orange-brown tones in the foreground and bluish to violet in the distance gains apparent depth.

Secondly, people are apt to notice many more colours in a picture than they do when looking at their surroundings. In everyday life we mostly content ourselves with a superficial perception of local colours. When we look at a colour picture we notice for the first time secondary shades, colour reflections,

119

coloured shadows and so on. So even a picture that faithfully reproduces natural colours often appears too colourful.

The colour film's tendency — especially with slide film — to respond significantly to slight colour hue changes is the reason why you need differently balanced films in daylight and in artificial light (page 99). Equally, the film picks up the blue snow shadows (yes, they really are blue when lit by light from the sky) and various hues of light reflected from coloured surfaces.

HINTS AND TIPS

THROUGH-THE-LENS LIGHT METERING

Many 35 mm single-lens reflex cameras with a built-in exposure meter measure the brightness of the finder sceen image formed by the lens. Such through-the-lens (TTL) metering automatically allows for many exposure variables due to the camera: angles of view of different interchangeable lenses (page 171), close-up exposure factors etc. As you see what you are measuring, you can aim the camera accurately for near readings.

As a further refinement, the meter cells often measure more of the light around the centre of the image. By this so-called centre-weighting, the meter cleverly ignores large sky areas, strongly contrasting backgrounds etc. outside the middle portion of the picture. So exposures are right more often even with less usual subjects. You only have to check that the part of the view that matters for exposure purposes occupies roughly the centre region of the finder image. That's useful also with automatic cameras.

DODGES WITH AUTOMATIC CAMERAS

Automatic cameras measure and set the exposure a fraction of a second before taking the picture — while you are still pressing the button — or even during the exposure itself. So making close up and other similar special readings is more difficult.

Some cameras simplify this with a meter lock: you take a near reading, engage the lock, go back to where you want to shoot from and take the picture.

The alternative, with many automatic cameras, is to apply an exposure correction. This is the same as the correction for special subjects — up to one or two steps over or under — but selected directly by a control on the camera. It may be a button or lever, labelled something like 'backlight control' to give you one step more exposure. Or you may have a knob and scale calibrated in half or even one-third steps from say −2 to +2. That covers everything from two stops (4x) underexposure to two stops over.

120

If your automatic camera has no such override, you may achieve the same effect by a higher or lower film speed setting. Double the ASA rating set for a −1 step underexposure, halve the ASA selected for +1 step overexposure. After such a correction be sure to return the camera setting − the exposure override or ASA adjustment − to its normal position. Otherwise all following shots will be under- or overexposed to the same extent.

SEPARATE EXPOSURE METERS

There are still cameras with a full range of lens diaphragm and shutter speed adjustments but no meter. And there are still separate 'manual' exposure meters. Their main drawback is that you must transfer the settings read off the meter to the camera itself. Yet hand-held meters are less cumbersome for near and other special readings − you only have to manipulate the meter and not the whole camera. Modern meters of this kind are often highly sensitive even down to candle light, have a narrow angle of view and often even a viewfinder to help in accurate aiming. And the most sophisticated ones show shutter speeds and/or apertures as a digital readout, just like a pocket calculator.

With all exposure metering remember to set the meter to the correct speed of the film in your camera. Only cartridge cameras (No. 110,126) do this automatically for their built-in meter.

THE LENS HOOD

Most lens hoods are rigid metal tubes or cones or collapsible rubber types that fold flat for easy transport and storage − you many even be able to keep them on the camera in its case. There are also rectangular or square hoods supplied for specific lenses.

If you have forgotten the lens hood, you can make one from a piece of card shaped into a tube and stuck down the side. But you must calculate the length carefully or the tube could cut off part of the view.

FILL-IN LIGHT

With side-lit and back-lit subjects it is more difficult to get a correct exposure for both the dark shadow parts and the bright sunlit portions. You can make matter easier with bright reflecting surfaces near the subject to throw some light into the subject. Professional sometimes carry big sheets of white or silvered plastic or card for the purpose.

You can also arrange the subject near suitably reflecting objects. If you must take your holiday trip companions in front of Cologne (or Milan or Chartres) cathedral, at least ask them to

pose so that you yourself have a neighbouring sunlit wall behind you for more luminous shadow lighting.

The most convenient fill-in light is flash (see page 148).

Filters and Other Lens Attachments

LIGHT, COLOUR AND COLOUR FILM

Colour slide film, as we have noted on page 100, quite faithfully reproduces variations in the prevailing light colour and the way in which objects look different by 'white' daylight and slightly more yellowish tungsten lamplight. That's why you need different kinds of colour slide film for these light sources.

Daylight, too, varies quite a lot. We associate its characteristic colour usually with sunlight in the middle of the day, in a sky with at least some white clouds. If there are no clouds, the lighting gets bluer. In the mountains, the light is richer in ultra-violet rays. You can't see them but the film can: it reacts as if it saw more blue and yields transparencies with a bluish tint or cast. In the shade under a blue sky, the lighting is also distinctly blue: your warmly suntanned face loses its ruddy glow.

At the other end of the scale, the light as the sun rises — and even more as it sets — is quite reddish. And the colour film again takes notice.

You may like your sunsets to look orangey-red — but perhaps not quite as red as the film makes it seem. It's not the film's fault — your eyes have simply got used to it. But you notice it all the more when you look at the colour slide.

COLOUR CORRECTION FILTERS

If you want a late afternoon shot to look as natural in colour as a midday one or if you don't care for the cold bluish rendering of subjects under a blue sky, you can easily modify the light colour. If you were to look at a sunset through a pale blue glass, it would look like a midday scene, not sunsetty at all. You can similarly 'warm up' the colour character of blue skylighting by looking through a pale yellow or orange glass.

You can buy such tinted spectacles for your camera. They are called filters and come as round coloured discs in a mount that screws into, or clips over, the front of the lens.

There is a little more to it, for these filters must be just the right depth of colour for their different correction functions. You need only a very pale amber filter to correct the blueness

of sky lighting. Such a filter is in fact called a skylight filter. If the filter you use to counteract the reddish evening sun is more than just very pale blue, it overdoes its job: the picture would then turn all bluish, which is worse than the reddish rendering.

Secondly, filters must be very precisely made in glass that has been carefully ground and polished absolutely flat. For otherwise it is not much use having a good lens: a badly made filter would turn the sharpest picture partly unsharp again. The table on page 129 tells you about the filters you might need.

Note that this is with colour slide film. Filters are rarely needed with colour print film where you can correct most colour rendering errors, including those of the light, when the print is made. About the only filter you should still use even with colour print film is the ultraviolet for alpine photography. For UV rays in high mountains may distort the colour response of the film to an extent that makes efficient correction difficult even during printing.

ARTIFICIAL LIGHT TO DAYLIGHT

If a pale blue or pale orange filter can compensate for reddish evening sun or too blue skylight, similar filters can modify the colour quality of lamplight — the incandescent type — to allow photography on daylight type colour slide film. As the lamplighting is too reddish, you need a bluish filter. Similarly, a pale

orange filter turns daylight more reddish to match the colour balance of artificial light type colour slide film.

These colour conversion filters are handy if you have a daylight type colour slide film in the camera and you want to take a few shots by tungsten lamplight. Alternatively, you could unload the partly used daylight film (at any rate with a 35 mm camera), load the artificial light type film, then reverse the procedure and reload the partly used daylight film. But that's very cumbersome to say the least — putting a colour filter in front of the lens is much more convenient. The only drawback of a filter is that it reduces the effective film speed; you need a little more exposure than you would need with the right type of film.

With colour print film again you need no filter with any daylight conditions (except an UV filter in high mountains) and, strictly speaking, you can even get away without it in artificial light. There is, however, a case for carrying out part of the colour correction as you take the picture rather than when you enlarge it: if you take your film to a photo dealer to let a photofinishing laboratory make the prints, the finisher generally relies on very automated printing machinery. And sometimes these automatic printers treat every film as if it were exposed by daylight and fail to allow sufficiently for the artificial light character. (There is no artificial light type colour print film available for amateur photography.)

MAKING UP FOR LIGHT LOSS

Tungsten light is reddish because its white-light mix contains less blue than that of daylight. An artificial light type colour slide film compensates for this by being much more sensitive to the blue share of white light. If you use a daylight film for the purpose, you must reduce its red balance. That is what the bluish filter does. But the sum of less blue light and less red sensitivity adds up to less overall sensitivity: in effect you lose speed. You compensate that by increasing the exposure time or using a larger lens stop. The daylight film/tungsten light conversion filter in fact needs about two stops extra exposure — if you were using stop *f*5.6, you must open the lens up to *f*2.8. Alternatively you

125

can increase the exposure time fourfold — for instance from 1/125 to 1/30 second.

Such a filter is said to have an exposure factor of 4x (4 times the exposure). Sometimes it is marked with something like '−2 EV' which in this instance indicates the need for opening up the lens by two stops. The two corrections are interchangeable, or you can open the lens by one stop and use the next faster shutter speed (double the time). But don't open the lens by two stops and at the same time use two shutter speed stops slower!

The conversion filter for artificial light colour slide film in daylight only cuts back the film's excessive sensitivity to the blue end of the white-light mixture. The speed loss here is much less — less than one lens stop. So you might adjust the aperture from $f5.6$ to a point just short of $f4$.

The other filters used in colour photography — to compensate for bluish skylight or yellowish evening sun — are so pale (and so hold back very little light) that you can forget about exposure corrections.

FILTERS WITH BLACK-AND-WHITE FILM

Black-and-white film can reproduce colours of nature only in terms of brightness values. So in the final print Mary's pale pink dress will obviously appear a much lighter grey than the dark blue car she's standing next to. If, on the other hand, the car is a medium red and the dress a mid-green, you will hardly be able to tell the difference — both look grey, for the black-and-white film is colour blind.

One way of distinguishing between the two again is to arrange for the red car to record noticeably darker in the picture than the green dress, or vice versa. You can do that with a filter mounted in front of the lens. This needs much darker and much more deeply coloured filters than for adapting a colour slide film to different light conditions.

A red filter looks red because it transmits red light for preference

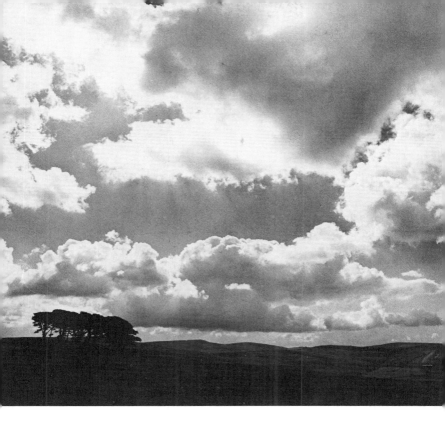

CONTROLLING THE SKY An orange filter fitted over the camera lens holds back the blue sky but transmits light from the white clouds, which look startlingly dramatic, especially when outlined by the sun. Mid blue sky appears mid grey; deep blue is rendered black. Photograph by *Ed Buziak, Britain.*

and holds back light of other colours, including green. If you look at the car and Mary's dress through the red filter, the car already appears much lighter — as it will do in the final picture. Conversely, with a green filter the dress would record lighter and the car darker. But the point is you could again tell the difference. So with strongly coloured filters you can modify the way in which black-and-white film records brightness values of coloured objects.

CONTROLLING SKY AND HAZE

The most frequent use of filters arises in landscape views where you have blue sky and white clouds. We see the clouds against the sky because we can tell the colours apart. For the film the sky is virtually as bright as the clouds so that the latter almost disappear. The remedy is a yellow filter which holds back blue light from the sky, so making the latter darker. The white clouds can now stand out again.

The yellow filter holds back only part of the blue light. An orange filter holds back rather more: the blue sky appears even darker. If you have plenty of clouds, the effect will look somewhat exaggerated, almost like an incipient thunderstorm. The result is darker still with a red filter.

The sky is blue only because the atmosphere preferentially scatters the blue part of the white sunlight. This scattering is quite noticeable even when you look at distant hills: they seem to disappear in a kind of bluish haze. On the film, ranges of hills farther and farther from the camera also become less and less distinct in the picture. The scattered blue literally overlays the view with a haze.

The blue-cutting action of the yellow filter suppresses this haze for a clearer distant view. With an orange and a red filter, haze cutting becomes more and more pronounced. In a picture taken with a red filter, distant landscape detail appears considerably clearer than you ever see it directly.

FILTERS FOR CONTRAST

With some subjects the main job of the filter is to separate in tone objects of different colour but similar brightness — like the red car and green dress. It works with other colours that differ sufficiently in hue, especially when they are saturated and brilliant. Purples and greens, red and blue, orange and greens — in all these combinations a filter of one or the other colour mentioned lightens the tone of the object of its own colour in the print.

FILTERS FOR COLOUR SLIDE FILM

| Filter colour | Lighting and effect | Exp. increase | | Typical desig-nations |
		Factor x	Stops larger	
Colourless* (UV)	Cuts out UV rays, prevents blue cast in mountain subjects**	1	—	UV
Colourless* (skylight)	As above, also yields warmer rendering on dull days and on sub-jects lit mainly by blue sky	1	—	Skylight, 1A, R1.5
Very pale amber	As above, rendering still warmer, for subjects in shade lit only by blue sky. Also reduces effect of distant haze.	1	—	81A, R2
Pale amber	Artificial light type film used in daylight	2	1	85, 85B R11
Very pale blue	Neutral rendering for scenes by late after-noon sun	1½	½	82A, B2
Pale blue	Corrects very reddish sunlight; also ordinary household tungsten lighting with artificial light type film	1½	½	82C, B4
Pale blue*	Adapts daylight type film to tungsten-halogen lamp light	4	2	80A, 80B B11

* Also recommended in these applications with colour print film.

** All amber filters are also UV absorbing, so no UV filter is needed in addition.

At the same time it darkens the tone of objects of the other colour.

A filter may also help in differentiating tone graduations of its own colour. Different shades of green in spring foliage appear lighter and more distinct against darker foliage if you photograph through a light green filter. The same filter makes people appear sun-tanned (it slightly darkens the value of the normally pinkish flesh colour of light-skinned people).

These more elaborate distinctions of colour contrast are fortunately not that frequent in photography. Otherwise you would have to carry a full selection of filters all the time. Contrast filtration is more common in scientific photography (e.g. microscope stains), copying and similar special fields. So with normal subjects a yellow filter, and possibly a light green and an orange one, cover all tone control situations you are likely to meet.

FILTERS FOR BLACK-AND-WHITE FILM

Filter colour	Effect and application	Exp. increase Factor x	Stops larger
Yellow (light) to medium	Darkens sky in landscapes emphasising clouds	1½—2	½—1
Deep yellow	As above, pronounced lightening of yellow, darker blues	2—3	1—1½
Light green	Darkens sky in landscapes emphasises clouds, makes skin tone look more sun-tanned, lightens green foliage	3—4	1½—2
Deep green	Darkens blue and red, lightens green; used to enhance red/green contrast	4	2
Orange	As deep yellow; also reduces haze in distant views	3—4	1½—2
Red	Renders sky almost black, eliminates most haze. Lightens red and orange, darkens green, blue, violet; used to enhance green/red contrast	4—8	2—3

FILTER FACTORS FOR BLACK-AND-WHITE

These strongly coloured filters hold back more light than the pale filters employed in colour photography. So these filters have higher filter factors, requiring greater exposure correction, too.

Again, compensate either by increasing the exposure time (slower shutter speed) or by opening the lens aperture. Use a large stop where you must have a short exposure time, for instance for action subjects. Alternatively, use a slower shutter speed where depth of field is important.

The table on page 130 sets out the filters for black-and-white photography together with their filter factors.

Generally yellow filters have an exposure factor of about 2x, orange filters 3—4x and red filters 4—9x.

The filter factor depends on the particular film used, on the actual filter — red filters of different makes may look alike, but might require noticeably different exposure factors — and even on the colour of the prevailing lighting. Thus red filters have lower factors by more reddish artificial light than by normal daylight. But the latitude of most modern films is quite sufficient to cope with most of these variations. For that reason ignore also excessive accuracy in filter factors quoted by manufacturers, for instance 1.3 or 1.7 times. Such figures are cumbersome to handle; you can quite cheerfully ignore the decimals and use the next whole number. For not only is it difficult to specify conditions under which a filter factor might say be 1.8 times instead of 1.6 times; on many cameras you cannot adjust the exposure time except in whole, double — or half — steps, anyway.

FILTERING REFLECTIONS

Maybe you have occasionally stood in front of a shop window and found it difficult to see — or to photograph — inside because of the detail of the street strongly reflected by the window glass. Or have you been troubled by excessive catchlights in pictures of glass or china objects?

A special filter that can deal with this kind of problem is the polarising filter or 'screen'. Light reflected from nearly all non-metallic shiny surfaces undergoes a physical change called polarisation. This is associated with the orientation of the light waves in a beam of light. Our eyes cannot tell the difference between unpolarised and polarised light, but the polarising filter can. If you look through the filter at such reflections and rotate the filter in front of your eye, you will find one position where these reflections are most subdued. If you then put the filter in front of the camera lens in that position (don't turn it either left or right),

the picture you take will show the reflections similarly subdued. But don't turn the camera from horizontal to upright (or vice versa) after mounting the filter — otherwise the reflections will be strongest instead of weakest!

With a single-lens reflex camera you can directly watch the effect of the polarising filter on the image you see on the finder screen. You can turn the polarising filter while it is already on the lens.

Reflections subdued in this way include those from shop windows, from spectacles, the sheen of numerous polished surfaces from shiny paper to varnishes, water and wet surfaces, paint and so on. You will rarely suppress reflections completely — that depends also on the direction of the light falling on the surface and of the camera pointing at it — but you can often get rid of the more disturbing glare.

The polarising filter does all this with either colour or black-and-white film. The filter itself though fairly dense is virtually colourless. With colour film it can also darken blue skies without changing the colours in the rest of the scene. This again depends on the direction in which you point the camera and the direction of the sun. The effect is most pronounced if the sun is at right angles to your camera direction — i.e. from the left or the right. It is least when the sun is directly behind you. This of course applies only to blue sky, not to a white cloudy one.

SOFTENING OUTLINES

Normally you want your pictures to be as sharp as possible, and lens makers go to a great amount of trouble to ensure sharp definition. Yet on occasion a picture with soft outlines more attractively renders atmosphere or mood than absolute pinsharpness.

Do not confuse 'soft' with 'unsharp'. If you do not focus the camera accurately or do not hold it steady, you get an outright blurred picture, not softened outlines. For the latter always have a sharp core image overlayed by a slightly blurred one that provided a luminous, almost dreamy, effect of soft focus.

The most convenient way of producing this with any camera is with a soft focus attachment mounted in front of the lens. This is a plane glass (or plastic) disc with a series of engraved concentric rings or embossed lenslets or 'humps'. These patterns divert and scatter some of the light from the subject before that reaches the lens. The result is a weak unsharp image. In the final positive picture edges of dark portions appear lit by neighbouring areas. The whole image is suffused with a soft radiance, transforming

quite ordinary objects. Sun-bathed landscapes taken against the light with the help of such an attachment give the pictures real beauty.

However, use soft focus sparingly and with discretion. It is not advisable with dull or low-contrast subjects, for it reduces image contrast. A dull view with soft focus looks even duller. You can, however, use the attachment equally with colour or with black-and-white film and it needs no exposure correction.

MULTI-IMAGE ATTACHMENTS

Another lens aid for usual effects is the multi-image or prismatic attachment. This is a plane glass disc with its front surface ground to a number of facets at different angles to each other. It may have anything from two to six such facets: the latter look a little like the enlarged face of a polished gem stone.

The attachment acts as a multiple prism. The facets split up the light rays and form two, three, or up to six separate images side by side, grouped in the pattern of the facets: don't expect the images all to be equally bright or equally sharp.

As the multi-image attachment splits up the light between part-ly overlapping images, they need more exposure. Increase the lens aperture by half a stop (for two or three images) to one and a half stops (six images).

This is of course really a trick-photography gimmick, but at-tractive on occasion, for instance with pictures of people. It works best with small bright subjects against a fairly large dark background, pictures of people, illuminated advertising signs at night etc. The multiple images do not show up well against light backgrounds.

HINTS AND TIPS

FILTER SELECTION
Manufacturers' catalogues tend to list dozens of different filters for every kind of occasion. In practice you will rarely need more

than two or three. In fact, use a filter only when you really need it. For lens makers compute their lenses to give the sharpest possible pictures with just the glasses in the lens. Adding more elements such as filters very slightly reduces lens definition – not to mention the additional risk of deterioration through fingerprints on the filter.

For colour print film the most you will ever need is a colourless ultra-violet-absorbing filter for photography in the mountains.

With colour slide film the most useful filter is a skylight filter to counteract the cold bluish rendering in dull weather or of subjects in the shade. This also cuts back excess ultraviolet in mountain views and haze in distant landscapes.

Other filters are far less important. Possibly you might use a pale blue to correct the redness of late afternoon sunshine, and/or a colour conversion filter if you are caught with a daylight-type film in tungsten lighting or vice versa.

With black-and-white film a yellow or yellow-green filter covers nearly all needs, especially for landscape shots with blue sky and clouds. Anything more than that from the table on page 130 is for special effects only.

SIMULATED NIGHT SHOTS

One such special effect with black-and-white film is a landscape that looks like a moonlight view but is taken in broad daylight. For this you place a red filter in front of the lens but increase the exposure only by about 2x (1 lens stop) instead of the 4x more normally required. That way you get an inky black sky, walls of a ghostly white, and heavy, detailless shadows. If you try these artificial light effects, see that the sky is cloudless and that usually welcome foreground figures, people, cars, dogs and so on, are absent. They would spoil the midnight atmosphere.

HEAVY FILTERS WITH COLOUR FILM

The heavy yellow, orange, red, green etc. filters listed for black-and-white film are normally useless with colour slide film; they would turn the colour transparency uniformly yellow, orange, red etc. But very occasionally this is a handy way when you do want a slide in a particular single colour. Try the filter with the same exposure factor as for black-and-white film, but make extra exposures with one lens stop larger and one lens stop smaller – to be on the safe side.

Don't use this method with colour print film. With that such special effects are far easier to do during printing.

134

SIMULATED NIGHT Taken in broad daylight through a red filter on medium speed black-and-white film but giving only partial compensation in exposure for the filter factor. Photograph by *Geri Della Rocca de Candal, Italy.*

FILTERS AND METER READINGS

As in most single-lens reflex cameras the exposure meter measures the light coming through the lens, it should also allow for the light held back by a filter placed over the lens. In numerous other cameras the meter cell in the lens rim is similarly covered by a filter mounted on the lens.

In fact, the meter cell is not sensitive to different colours in quite the same way as the film. So exposure corrections indicated by a meter measuring through a filter are not always reliable. They are fine with the very pale correction filters used with colour film and also with green filters employed with black-and-white. But the meter cell tends to ignore the action of yellow filters – the filter does not cut down the part of the light that the cell reacts to – so adjust the exposure by the filter factor even when the camera's built-in meter measures through the lens. With orange and red filters the effect on the meter cells is about half of what it is on the film, so correct by half the filter factor.

NO NEED to worry about dull weather if you have a flashgun. You carry your own sunshine with you, even in the rain. Photograph by *Ed Buziak, Britain.*

Your Own Light with Flash

The sun doesn't shine all the time and we often need other lighting when the prevailing light is not strong enough for correctly exposed snapshots. The most convenient way is with flash; you virtually carry pre-packaged sunshine around with you. The packages are very small because the light only lasts for a small fraction of a second. Flashlamps or units would have to be much bigger to keep it up for any length of time. As a snapshot exposure also lasts only a fraction of a second, the flash need be no longer. However, you must arrange for it to occur during the 1/60 second or so while the shutter is open for an exposure.

SIMPLE ELECTRONIC FLASHING

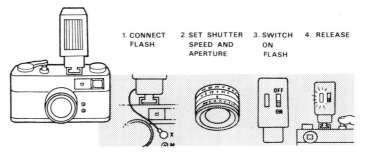

1. CONNECT FLASH 2. SET SHUTTER SPEED AND APERTURE 3. SWITCH ON FLASH 4. RELEASE

1. For simple flash shots mount the unit on the camera — usually in the accessory shoe — and check that the flash unit has made contact with the camera's circuit. If you have no hot shoe, plug in the flash lead.

2. Check that the camera shutter is at 1/60 second or the right speed recommended for electronic flash. Set the lens aperture according to the flash distance and guide number.

3. Switch on the flash unit and wait until the ready light comes on — a small light usually at the back of the unit that lights up 10 to 15 seconds after switching on.

4. The ready light shows that the flash is ready for operation. So press the camera release to shoot.

After the flash wind on the film and wait until the ready light comes on again, ready for the next exposure. Switch off the flash unit when you have finished taking pictures.

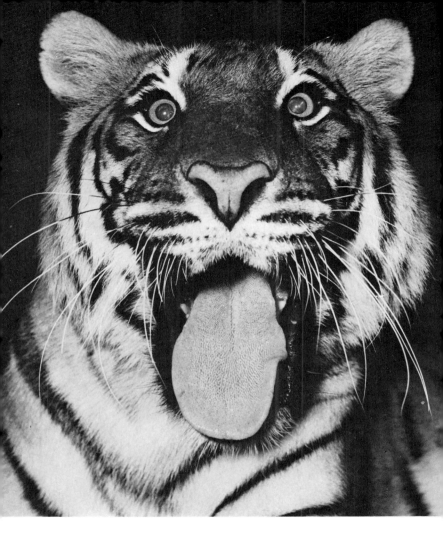

FLASH EXPOSURES only last for a tiny fraction of a second. You can capture momentary events and even if the subject is quite active he comes out sharp. Photograph by *Manfred Pabst, Germany.*

SYNCHRONISING IT

Virtually all modern cameras have a device that ensures that the flash lights up at exactly the right time when you need it during the exposure. Usually it is an electric switch that triggers the flash. The connection is made through the centre contact in the accessory shoe into which you fit the flash unit (hot shoe contact) or by a lead that plugs into a socket on the camera. Many cameras have both a 'hot' shoe and a flash socket.

This synchronisation does not always work at all shutter speeds: with most cameras you have to set 1/60 or 1/30 second to ensure that the flash gets its proper say in the picture during the exposure. The camera instructions usually tell you the fastest usable speeds for flash − it also depends on the kind of flash you use. Don't take pictures at a faster shutter speed (shorter exposure) or you may find part or all of the image missing.

ELECTRONIC OR BULBS?

There are two main kinds of flash: electronic units and flash bulbs. Electronic flash uses a small tube containing a special gas and discharges a high voltage spark through this gas. Except for the short flash duration − 1/1000 second or less − the principle is not unlike that of a fluorescent tube. In electronic flash units that you carry around with you, a small set of batteries produces the power and electronic circuitry converts it to a form suitable for discharging as a flash of light. The greater the light output, the bulkier the circuitry has to become and the bigger the flash unit. The smallest electronic flashes are no bigger than a packet of cigarettes but still yield enough light for correct exposures with fairly nearby subjects. Bigger − still portable − units can cover groups at moderate distances; really powerful units have largely replaced bigger tungsten lamp set-ups in many professional studios.

Flash bulbs work rather differently. A small quantity of combustible wire sealed in a glass envelope in an oxygen atmosphere is ignited and burns with an instant flash. Nowadays bulbs are usually grouped in fours in flash cubes or in eights or tens in Flipflash, Topflash and flash bar arrangements. Mostly these plug directly into the camera if the latter has an appropriate socket. There are also adaptors for fitting some of these different forms of flash to different cameras. With such multiple flash bulb set-ups you can shoot 4, 8 or 10 pictures in succession without having to change individual bulbs − each device more or less automatically triggers the individual bulbs one after the other for successive pictures.

The light of an electronic flash approximates in quality to day-light. Most flash bulbs have a bluish lacquer coating that modifies their light also to match daylight. So you can take your flash shots indoors or out, as with daylight, on daylight-type colour film.

GUIDE NUMBERS FOR RIGHT EXPOSURES

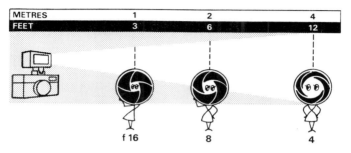

METRES	1	2	4
FEET	3	6	12

f 16 8 4

Correct flash exposure is, if anything, simpler than daylight exposure. Electronic flash is shorter than the exposure time, so shutter speed plays no part in exposure. What does play a part is the distance from the flash to the subject. The nearer the flash, the more intense its effect. As you go further away it rapidly drops — much faster than the increase in distance. At twice the distance you only have one-quarter the light intensity; at three times the distance only one-ninth. Physicists call this the inverse square law. What makes it interesting for us is that lens apertures follow a similar law. Stop $f8$ lets through not twice as much light as $f16$ but four times as much.

This adds up to a very simple way of figuring flash exposures, namely with so-called guide numbers. The guide number characterises the flash unit and the film speed. With a given film in the camera and a given electronic flash unit, this always remains the same. To get the right aperture you only have to do a quick bit of simple mental arithmetic: divide the distance into the guide number. The result is the f stop.

So if your flash has a guide number of 56 (with the film speed you are using) and your subject is 10 feet away, you need $56/10$ = 5.6 as the lens stop. If the subject is only 5 feet from the flash the stop becomes $56/5$ = approx. $f11$.

All you have to check is that you have the right guide number — usually in the instruction book with the flash — and that you know to which distance units it applies — metres or feet.

You can work it the other way too: if you set the aperture to $f5.6$, keep 10 feet from the subject and the exposure will be right (guide number $56/5.6 = 10$ feet).

With many electronic flash units all this figuring is done for you on a calculating dial that you set to the speed of the film. Then you can directly read off different lens apertures opposite a scale of distances. Set the camera lens to the aperture opposite the distance you are using – or select a distance opposite the lens aperture you have set. That is all there is to it.

The guide number also depends on where you take the flash picture. Indoors reflected light from the walls and ceiling does contribute a little to the exposure – less in big rooms with dark wall decoration, (e.g. oak panelling), more in small rooms with very light walls. Allow for this by assuming a guide number about 25 per cent lower in the first case and up to 40 per cent higher in the second case.

Outdoors at night the guide number drops even more, say, by about a third.

COMPUTER FLASH

Normally the exposure meter even on an automatic camera cannot adjust camera settings in time for the very fast flash. But some automatic flash units look after controlling the exposure on their own. These so-called computer flashes have a special photocell that 'sees' how much light of the flash the subject reflects back towards the camera. And when the cell has seen enough light, it simply switches off the flash.

All this goes incredibly quickly, for even a normal electronic flash is over in little more than $1/1000$ second. And with this automatic switching the flash can be as short as $1/20,000$ second or less.

The beauty of this system is that you can forget about exact distances. If you go nearer to the subject, the cell responds to more light and switches off the flash sooner. If you go farther away, the cell lets the flash go on for longer. It resembles the exposure automation in some cameras, except that the computer flash uses nothing but electronic circuits, with no levers, springs or other mechanics.

There are shortest and longest limits even to the computer flash duration. The subject must not be too near or too far. Provided that it is within the flash range limits marked on the unit – typically something like 0.5 and 5 metres or 20 inches to 16 feet – you only have to set the right aperture – and you can shoot. (The aperture depends on the film speed.)

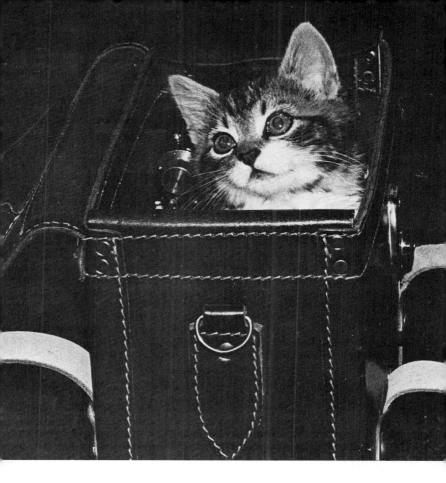

KITTEN IN CASE However dark the subject or surroundings, you can still get a well-exposed picture with a flash. A computer type unit takes care of the exposure automatically, making sure you have the right amount of light for the distance. Photograph by *Neville Newman, Britain.*

With many computer flash units you can switch the range to match the flash duration to two or three different apertures. That gives you more versatility in alternative lens stops for greater or less depth of field. The distance ranges for automatic operation vary as well; check these in the instruction book or on the calculator dial of the flash.

FLASH CUBES AND FLIPFLASH

If electronic flash units can be compact, flash cubes are downright tiny. Into less than a cubic inch they pack four minute flash bulbs, each in a small reflector. To use flash cubes you must have a camera with a flash cube socket or a suitable holder to fit into the camera's accessory shoe.

There are two kinds of flash cube: the electric type with eight small wires coming out of the rim of the flash cube fittings, and the non-electric Magicube or X-cube which has no wires. Each fits only cameras made to take it.

To shoot with flash cubes you plug the cube into the socket on the camera top so that one of the cube faces points towards the subject. Set a shutter speed of 1/30 or 1/60 second — on many simple cameras plugging in the flash cube automatically selects this speed. For a subject about 4 metres or 13 feet away set the aperture to $f5.6$ or $f8$ with medium speed colour film — or $f8$ to $f11$ with black-and-white.

Then shoot just as with the electronic flash, After the shot rotate the flash cube to bring a new unspent bulb to the front for the next shot. With quite a few cameras, advancing the film automatically rotates the flash cube as well. After four flashes take a new cube.

The Flipflash is a flat package about as big as two matchboxes end-to-end, with eight or ten miniature flash bulbs. Again this is usable only on cameras designed for it. Plug the Flipflash into the appropriate socket on the camera so that the bulbs face the subject. As you shoot picture after picture, the four or five bulbs in the upper half of the Flipflash fire in turn. Then turn the unit upside down and plug it in at the other end to fire the other flashes.

Flash cubes and Flipflash have a guide number — used as for electronic flash. With medium speed (80–100 ASA) colour print or colour slide film this is around 20–25 in metres. With high-speed (400 ASA) film you can count on a guide number of around 60. In feet the equivalents are about 66–76 and about 200 respectively.

There are other special multi-flash bulb packages, for instance

144

flash bars, that exclusively fit certain cameras. The plug-in fittings may be different, but the principle is the same.

ON AND OFF THE CAMERA

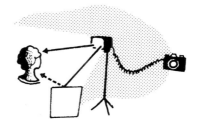

Fixing a flash — electronic, cube or Flipflash — to the camera top is certainly convenient. It floods the subject with light. If all you want is a record of what is in front of the camera, you cannot go wrong.

But — like the sunlight coming from directly behind you — a camera-mounted flash does not produce very interesting lighting. Being bathed in a frontal glare makes people and things look a little boring. True, people won't be screwing up their eyes. The flash captures them before they have time to do that. But the results hardly look natural; after all, people don't spend their time sitting in the glare of a floodlamp. At best the pictures look like those captured by a press photographer. News cameramen often have to use flash in this way, because they must bring back a picture — any picture.

If you are not tied to a flash that can only plug into the camera top, you can do better. With many electronic flashes it is not too difficult.

One way is to take the electronic flash out of the camera's accessory shoe, connect it to the camera with a synchronising cable or lead, and hold it about a foot or so above and to one side of the camera. Better still get someone else to hold it for you while you keep your grip on the camera. This lighting immediately gets more interesting. The picture begins to show shadows and, with the light no longer from dead front, faces gain roundness. Even a little separation from the camera helps.

With some flash units you can achieve that separation by attaching the flash with a camera bracket instead of in the accessory shoe. Such a bracket or rail screws to the camera base and holds the flash on a handgrip attached to this rail. Often that

145

gives you a better hold on the camera, too, as you can grip the camera body with one hand and the bracket with the other.

With a computer flash remember however to keep the photo cell pointed at the subject.

BOUNCING FROM THE CEILING

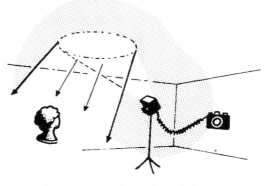

A flash off the camera gives more depth to the lighting but is still rather harsh. The shadows that now appear in the picture are quite black and stark, still far from how we are used to seeing people and things indoors or out.

You can convey this atmosphere of general diffused lighting by pointing the flash not at the subject but at the ceiling. Provided this is reasonably light and not too high, it now acts like a huge reflector and bathes the subject with soft uniform lighting from above.

This is useful for portraits indoors, children, parties and so on. One benefit also is that people at different distances from the camera receive much more nearly the same light than with a direct flash. So the scene is more evenly exposed, too. As the light largely comes from above it appears rather more natural. It need not necessarily be a ceiling however: you can direct the flash at a nearby wall.

For the correct lens aperture with bounce flash remember that the light has to travel up to the ceiling and back down again. This combined path is the effective flash/subject distance for guide number purposes. On top of that regard the guide number as reduced by about one-third to allow for light absorption and scatter by the ceiling.

For most efficient reflection, point the flash at a patch of ceiling halfway between you and the subject. With near items that indeed does mean pointing it almost vertically upwards. With groups a little further away, a 60° angle upwards is about right.

If you are using a computer flash for bounce flashing, the photo cell of the flash should receive the light coming from the subject towards the camera. On many current computer flashes you can swivel the reflector up while the photocell still points to the front. Or you may be able to mount a separate sensor photocell in the camera's accessory shoe and link it to the flash with a cable. If you can do none of these things, switch the unit to manual operation and work out the aperture from the guide number as described above.

MORE THAN ONE FLASH

You can produce more elaborate lighting effects with several flash units. For instance you could have one flash on the camera for general fill-in lighting from the front and a second flash coming from above and to one side to make the subject look rounded and create some modelling by shadows. You will have to fire these flashes all at the same time which involves long flash leads and multiple plugs. This works best with electronic flash units and there are outfits consisting of a main and one or more supplementary lamp units that you can link together by cables.

An even more elegant solution is a slave flash system. Here you have one flash fired from the camera in the usual way; the second flash is not connected by wires at all but is mounted on a small photocell unit. When the light from the camera flash hits the photocell, the latter fires the second or slave flash. All this happens so quickly that you can still use the same shutter speed to synchronise the flashes. Needless to say, one camera flash can at the same time trigger any number of slaves, though setting them all up can become a bother.

Slave triggering units are available mainly for electronic flashes. But there are special types also for flash units taking bulbs. Only here the firing takes longer and you must use an exposure time not shorter than about 1/15 second.

FLASH IN DAYLIGHT

Flash is a convenient substitute for sunshine when the latter is not available. But curiously, flash can also help to improve pictures together with sunshine. It can do so especially when the sun is glaringly intense.

Strong sun also casts strong shadows that look very dark in the

picture — so dark that the print just cannot reproduce such dark shadows correctly with the same exposure as the film would need for the brilliant sunlit parts. With black-and-white film you might get away with such dramatic contrasts; with colour print film the picture would be almost useless.

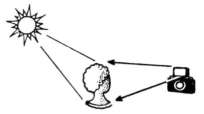

So use a flash to lighten those dark shadows for a more balanced effect. It is a handy way also when you take pictures of people in the sun outdoors and they cannot keep their eyes open because of the glare. Simply turn the set-up round and have the sun shining obliquely from behind Aunt Mary and young Johnny. That puts their faces in the shade and expressions can relax. A flash then lights up the faces to make them look natural.

As on these occasions you want to lighten shadows that directly face the camera, a camera-mounted flash — electronic or otherwise — is fine.

MATCHING THE DAYLIGHT EXPOSURE

One last problem is the exposure. The camera settings have to allow for the sunlit part of the view. You could then use the daylight exposure, making sure that the shutter speed is not too fast for the flash, and match the distance to the aperture.

For instance, if the normal daylight needs 1/125 second at $f8$, you would first switch to 1/60 second (to make sure of synchronising the flash) at $f11$. If your flash unit has a guide number of say 33 (metres), you would have to have the flash — and yourself with the camera — at $33/11 = 3$ metres from the subject.

The result will be well exposed but tend to look somewhat artificial — as if you had the sun coming over Mary's and young Johnny's left shoulders, and at the same time also coming from the front. For a more natural picture the front light from the flash should be distinctly weaker than the sun.

With colour shots the best way is to increase the flash/subject distance by one-half. Instead of 3 metres, keep the flash at 4.5 metres. That reduces the exposure on the flash-lit shadows just

enough to make them look still like shadows yet appear luminous in the picture.

In more general terms this is equivalent to treating the flash as if its guide number were half as high again for daylight fill-in purposes. With black-and-white film you might treat the flash as if the guide number were doubled, for in black-and-white shots the shadows can be a little darker.

With a computer flash set the camera lens to one stop smaller than the flash requires — and of course match the shutter speed for the correct daylight exposure. (Again be sure however that the shutter speed is right for the flash.)

Sometimes these calculations can yield flash/subject distances that are shorter or longer than you want. If the distance is too short, the flash is too weak for the effect you want. Remedy that by using a larger lens stop (and correspondingly adjusting the shutter speed as long as it stays within the usable range for the flash).

If the distance is too long, the flash is too strong for that particular fill-in location. That is liable to arise with large electronic flash units or fairly near portraits. To remedy that, tie one or more thicknesses of a fine pocket handkerchief or thin tissue paper over the front of the flash reflector. Count that for each handkerchief or tissue thickness you can reduce the flash/subject distance by 30 per cent. If you had to be 10 feet away with the bare flash, you can come down to 7 feet for the same effect with one handkerchief thickness over the reflector.

HINTS AND TIPS

WHICH TO CHOOSE

Electronic flash is the most economic way of taking flash pictures. The flash tube lasts virtually indefinitely and your only running expense is the batteries. On the other hand you pay rather more for the flash unit and it is heavier than flash cubes, bars etc.

With flash bulb systems you pay for the flash as you can use it at a rate comparable with the cost per shot of the film and printing. But you can stuff flash cubes and Flipflashes in your pocket as and when you need them.

The choice in part depends also on what your camera will take. Electronic flashes are usually easier to adapt to flash cube or Flipflash-using cameras with adaptors. The reverse is less often possible.

FLASH CAMERAS

Some cameras have a small electronic flash unit built in. This saves taking a separate flash unit with you and is handy for near pictures of people about 4–10 feet away. It is useful also for fill-in flash in daylight and the flash power is rarely too great for effective filling in.

Some cameras also have a semi-automatic flash coupling between the aperture and distance settings. Setting the lens to the guide number of the flash engages the coupling. As you then set the lens to a greater distance, the aperture opens up and vice versa.

WHICH BATTERIES?

Most small electronic flash units are powered by dry batteries, e.g. four size AA cells. Preferably buy so-called alkaline cells rather than standard dry batteries – they last much longer. Rechargeable nickel-cadmium batteries cost more but you can recharge them when they are exhausted. Electronic flash units may have such nickel-cadmium batteries permanently built in. The drawback there is that if you are caught picture taking while the battery runs out, your flash unit is out of action until you have recharged it. With dry batteries you simply put in a new set and carry on shooting.

Cameras that take electric flash cubes usually also take a battery to fire them. The type depends on the camera model. Magicubes (type X) on the other hand need no battery at all for they are fired mechanically. Flipflash units are fired electrically by a device in the camera that generates a brief high-voltage pulse without a battery.

SINGLE FLASH BULBS

Apart from flash cubes and Flipflash you can use single bulbs in varying sizes for more powerful flashes. These bulbs need a special flash holder with reflector and a battery to generate a firing current.

Flash cubes and Flipflash units have a built-in filter coating to match the flash lighting to daylight for photography on daylight type colour slide film or on colour print film. Larger bulbs may not have such a filter coating and are then suitable only for use on their own, without other kinds of lighting about (e.g. sunshine).

MORE ON SYNCHRONISATION

More advanced cameras may have adjustable flash synchronisa-

150

tion, controlled by a small lever or switch. This may have two positions marked 'X' and 'M' or 'FP'. The latter setting on cameras with focal plane shutter – usually single-lens reflexes – permits the use of special flash bulbs even at fast shutter speeds up to 1/1000 second for example. With normal flash bulbs and flash cubes however set the shutter speed at one step slower than the recommended electronic speed – usually that is 1/30 second.

On cameras with leaf or diaphragm shutters the X synchronising setting for electronic flash is usable with all shutter speeds. The M setting serves for flash bulbs – with larger bulbs at all shutter speeds. At the higher speeds however, the flash guide number becomes lower because the shortest exposures are shorter than the duration of an ordinary flash bulb.

Computer flash units yield specially short flashes at close range when the built-in cell stops the flash early on. Such exposure times – of the order of 1/10 000 or 1/20 000 second – are useful also for stopping action at close range. That way you get sharp pictures of small animals, even insects, but also reasonably near subjects such as children at play. To make the most of this short-exposure range, use the largest lens aperture adjustment of the flash unit. For instance if you have three aperture options of f4, f8 and f16, set the flash to f4 and the camera lens as well. Remember however, that this also gives you the least depth of field – which could be troublesome when shooting at very close range.

RED EYE

Colour shots of people taken with flash sometimes show their eyes with a red spot in the centre in place of the usual black pupil. It may happen when you have a flash mounted close to the camera lens axis, for instance in a pocket camera, and if the person photographed is looking straight into the camera lens. The flash then reflects from the red retina at the back of the eye and the lens takes in this reflection as a red spot.

The likelihood of 'red eye' is less if the flash is a little to one side or above the camera. A couple of inches separation greatly helps. For instance with flash cube camera mount the cube on a flash cube extender rather than plug it into the camera top. This is a stalk that still transmits the firing action from the camera to the cube. The Flipflash, thanks to the higher location of the bulbs above the camera, also reduces the risk of red eye.

Doing without Sunshine

WHEN THE SKY IS OVERCAST

Many amateurs, on principle, never use their cameras except in very bright weather or with flash. If they do not have a clear blue sky and lots of sunshine, they can only imagine subjects lit by flash. And, of course, they make the unfortunate subject, whether it is little Betty or old Uncle Charles, pose in full sunshine. Otherwise they would think they were wasting good daylight.

This is not for lack of enough light. Even if the sky is overcast, the light is still bright enough for exposures of 1/60 or even 1/125 second with an aperture of around f5.6. In some respects such pictures actually look better than shots taken in full sunlight. Moreover, exposure meter readings are more reliable when the sky is overcast than when you have brilliant sunshine and dark shadows. The bright areas tend to trick the meter into setting or indicating too short an exposure. Further, the emulsion is better able to cope with less violent contrasts of light and shade.

The problem of contrast applies especially to colour shots on colour print film. With a partially lit subject you just cannot get both the highlights and the shadows correctly exposed at the same time. And even if the colour negative does show the semblance of an image in both areas, colours are liable to be wrong. Moreover, they are wrong in one direction in the lighter parts and in another in the darkest areas — for instance overexposed highlights may turn reddish and underexposed shadows bluish. That kind of colour distortion you cannot correct in enlarging.

Overcast skies are associated with more than one kind of weather. At one end of the range you have scenes with just softly veiled sun. This is the ideal lighting for colour, for it still keeps the colours saturated and warm, while producing balanced tones and shadows. At the other end of the range thoroughly bad weather has attractions of its own. For instance rain or snow storms sometimes produce interesting pictures of objects which on a bright sunny day would not be worth taking. With a comparatively longer exposure, say 1/30 or even 1/50 second, falling snowflakes or rain drops appear in the picture as

continuous streaks or lines. That makes the photo all the more effective.

The comparatively less colourful scene in such weather might tempt you to photograph in black and white. That is certainly more dramatic, but colour exposures do not have to rely on cramming in all the colours of the rainbow. The subdued greys and browns on a rainy day are still colours, especially if they are offset by a bright patch of say, the red coat of a person walking in the street.

When photographing comparatively dull views, wintry scenes etc., on colour slide film you have rather more exposure latitude than with brilliant contrasty subjects. A normal exposure as measured by the meter in such cases tends to yield a heavy darkish result — fine if you want to enhance the deadly dull atmosphere of the day. But if you give double the exposure (or one lens stop larger) the resulting colour slide is often easier to project.

THE ADVANTAGES OF A MISTY DAY

In many respects mist produces ideal conditions for photography, It greatly subdues colours which, at first sight, seems to make it particularly suitable for black-and-white photography, Nature, shrouded in mist, is already reduced to the required 'study in black and white.' It shows a wide range of greys which can be faithfully captured without difficulty.

In colour however the very subtle shades of brown, green and yellow coming through the overall greyness gives such pictures enormous charm. The very absence of extended contrasts brings out the life and quality of the few hues. And the limited tone range means that you will have no problems with losing part of the effect in a print. Even colour print film has more exposure latitude than with many other subjects. On colour slide film, again, increase the exposure to about double of what the meter indicates, to make sure that the delicate light tones of mist remain light.

Even the constant conflict between foreground and background which in clear weather often spoils a good picture is quickly settled in misty weather. The middle distance and especially the far distance step back of their own accord, since the further things are away, the more densely they are shrouded in mist. So you focus on the object in the foreground and you can dispense with great depth. This means that you can use a large aperture. And if the distance is somewhat hazy, this will be attributed to the mist and not to focusing errors. However, have suitable objects such as trees, persons, vehicles etc. in the fore-

ground to emphasise the depth between the clear detail near the camera and the gradually receding distance.

Pictures of misty scenes in sunlight are especially effective if they are taken against the light. The resulting silhouette combined with the various tones of grey produces a unique sense of distance. The mist also subdues the harshness of heavy shadows against the light.

EXPOSURE FOR MISTY SCENES

The lack of contrast on a misty day also makes exposure metering easier. However, contrary to usual practice, reckon the exposure now not from the shadows — as in sunny weather — but from the lighter background. In a black-and-white shot this makes the nearest objects very dark, in fact underexposed, but this is how we see things. The light curtain of mist in the background makes things close by look almost black by comparison. Increasing the exposure for detail in the darker objects tends to destroy the mist effect by overexposure.

Things change somewhat when the mist comes dense enough to be almost a fog rather than a light veil. For now the scene is dominated by light to medium grey which must not become too dark. On colour slide film in particular this calls for some over-exposure — about twice what the exposure meter indicates — to preserve the airy delicate veiling.

Pictures taken in the mist at night are particularly beautiful. The atmosphere is luminous in the light from shop fronts or street lamps. People and things loom up black against the white wall of mist.

Where movement is involved, fast films and large-aperture lenses are necessary. Even then you may have to expose for up to half a second. With care, any blurring can be kept to no more than would seem natural in the misty conditions.

OUTDOOR NIGHT VIEWS

There are hundreds of opportunities for making this kind of picture. It may be the town, blazing with street lamps and electric signs, or a village, dimly lit by the feeble gleam of an old-fashioned gas lamp. Tomorrow, perhaps, or next week, some public building will be all lit up in honour of some civic celebration, or a famous monument will be floodlit. Subjects of this kind sometimes provide amazingly beautiful pictures. So it is well worthwhile taking out your camera sometimes even at night, for the technique is not that difficult.

If the subject of the picture is fairly extensive it is rarely

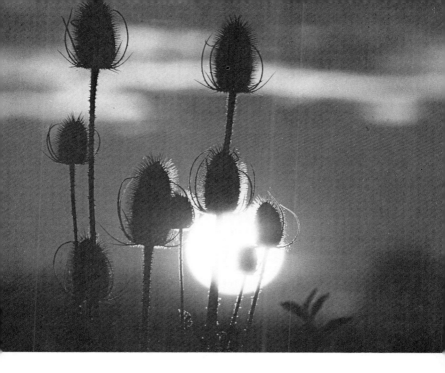

SUNSET Teasels can be seen against the setting sun on a winter night. This shot was taken with a telephoto lens and the small aperture set necessitated a long exposure with the camera on a tripod for absolute steadiness. Photograph by *D. Doble, Britain*.

illuminated brightly enough for an instantaneous exposure. The exposure time is liable to run into seconds or even minutes. You will therefore need some patience – and a firm support for the camera. That may be a tripod or a convenient wall, bench etc.

A large aperture is not important, as the exposure can be as long as required.

Provided the camera has a time exposure setting (usually marked B) that allows the shutter to be kept open, even the simplest model can produce night pictures of static subjects.

EXPOSURE LATITUDE AT NIGHT

The exposure itself can vary within wide limits. For with subjects of this kind there is always some underexposed night and some overexposed light – specifically, bright street lamps actually in the picture. In between are floodlit areas, pools of light under lamps etc. – all of which tend to spread out more the longer the exposure. So the less the exposure, the more night and less light you get; the longer the exposure the more light and less night. With too long an exposure the night effect is lost and the picture might as well have been taken in daylight.

Nor are exposure meter reading very reliable because night views rarely include a large representative area of mid-tone. The meter reading is thus affected by how much light and lamps there are in the picture rather than by how bright the illuminated areas are. The table of page 168 gives a good guide to the kind of exposure to aim at.

Use a lens hood if you have one. For a lens hood not only protects against the sun but is equally useful where other bright lights appear within the picture area or just outside it. People passing in front of the camera will do no harm if the exposure runs to more than 30 seconds, because in the short time they walk past their impression on the film is too weak to show up.

On the other hand beware of the lights of passing cars unless you want to make the disembodied white and red streaks across the picture part of the pictorial pattern. If you don't, then have a hat handy to hold over the lens whenever a vehicle appears in view, until it has passed. Be careful of course not to move the camera.

Flash can also help such night views. However you employ it not on the camera – where it would have no noticeable effect on a more extended scene – but on its own. For this you decide what areas of the foreground or middle distance need more light enhancement than they are getting from the prevailing illumination. Set up the camera on a stand or support for the time exposure,

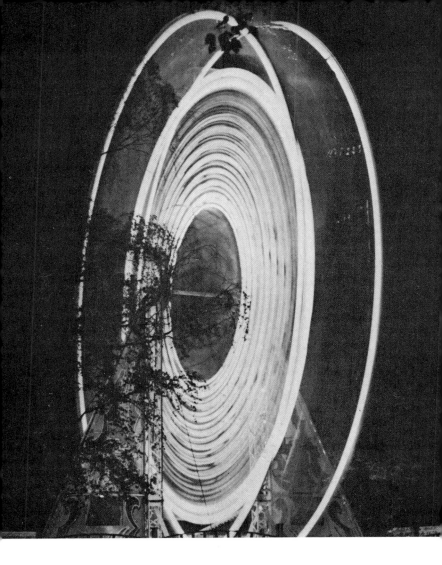

BIG WHEEL At night with a time exposure the lights on this ferris wheel make lengthy trails if the exposure is sufficiently long. A rigid support for the camera is essential. Photograph by *Peter Rowe, Britain.*

open the shutter and go with the flash unit near the first area that you want to light up. Point the flash unit at that spot and fire it with the manual firing switch (nearly every electronic flash has one). The flash must of course not point towards the camera; preferably arrange to fire the flash from a point hidden from the camera, e.g. behind a column, doorway etc. If the worst comes to the worst you can even hide the flash behind your own body which might then appear as a silhouette in the picture. Repeat this procedure — while the camera shutter is still open — at the other points to be lit up. Then close the shutter to terminate the exposure.

NIGHT LIFE

A lot of the night scene, especially in towns, is alive and bustling. There the leisurely methods for a romantic old corner are out of the question. To capture the life you need almost snapshot exposures — yet in light conditions far dimmer than daylight.

Well, it is not as difficult as it sounds. You do of course need a high speed film, of at least 400 ASA, and a large lens aperture — $f2.8$ or larger. Don't try to take this kind of subject with slower cameras — at least not unless you can use flash.

Your camera's exposure meter may or may not be a help — it depends on its sensitivity which may well fall short of reading street lighting at night.

However, even if the meter gives a reading, rely on it only if you measured through the lens (with a reflex camera) and you did not include significant dark areas. Otherwise, even with an automatic camera, it is safer to take a close-up reading as explained on page 111, on say the ground in a well-lit part of the street, and base exposures on that.

The largest lens aperture generally means that you have to focus accurately, for the depth of field becomes rather limited. Focus on objects nearest to the camera because they, at all costs, must be sharp. The fact that the background is then out of focus is less objectionable than in daylight pictures. It often adds valuable 'atmosphere'.

Even with the large aperture and high speed film, exposures may run anywhere between 1/60 and 1/4 second. The former is still fine for a hand-held shot, the latter definitely isn't. You therefore need a firm support for the camera. In a bustling city street at night a tripod is not very convenient. But you can often prop the elbows on some convenient railing or balustrade — quite an effective way of keeping the camera steady. Otherwise, you may stand up with your back to the wall (literally), quite stiff

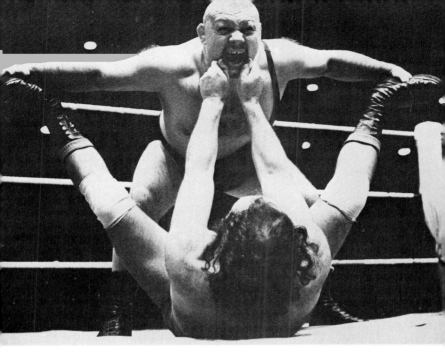

LOW LIGHT Shooting by available light may require you to work at full aperture so focusing must be very precise. This may be tricky with moving subjects but if the action is confined to a particular space you can set the focus to that zone and then just concentrate on events. Photograph by *Jan-Ake Rundqvist, Sweden.*

as if you were a human camera-stand, press your elbows and your camera close to your body and gently squeeze the release button while you hold your breath.

With these longer times you must wait until obvious moving items in the field of view are as still as possible. But this can still give you snapshots that faithfully capture the mood of the street by night, lit with the glare of street lamps, shop windows and advertising signs.

Both the street lamps and the advertising signs can produce unexpected results in colour pictures. In streets lit by mercury or sodium (yellow) discharge lamps you might as well forget about colour pictures, unless you particularly want to record the overall blueness or yellowness. Advertising signs often come out quite different on the film from how you remembered them. This is due to the rather special lighting balance of such discharge sources: the film may just see them in a way that radically differs from your eye. But it is still worth experimenting.

Colour slide film is not usually available in quite as high a speed as colour print or black-and-white material. So there you may have to rely rather more on longer exposure times with the camera held very steady. Use the artificial type slide film for street shots at night; on daylight film all the lighting (other than of mercury lamps) looks rather orangey-red.

Utilise also whatever additional contribution you can get from available light. Thus, brightly lit shop windows also throw a lot of light into the street − so do some cinema or theatre entrances and similar more or less public locations.

Remember to take your camera with you too in rainy weather. At night the glistening wet streets add enormously to the impact of the scene − and to the light in it.

NIGHT SPOTS AND ENTERTAINMENT

To make pictures in the theatre, music hall or circus you must observe the same rules as for night photography outside. To capture action you again need short exposures. The fastest possible film and a wide lens aperture are more essential than ever, because movement on stage, and especially in a circus ring, is apt to be pretty rapid. So any exposure longer than 1/60 or 1/125 second is out of the question.

While theatre stages and especially circus rings are well lit most of the time, other indoor night spots are not. However romantic a candle-lit restaurant, however psychedelic a disco, you are not normally likely to be able to record it with a camera. And don't try with flash either, for that destroys the atmosphere and may

160

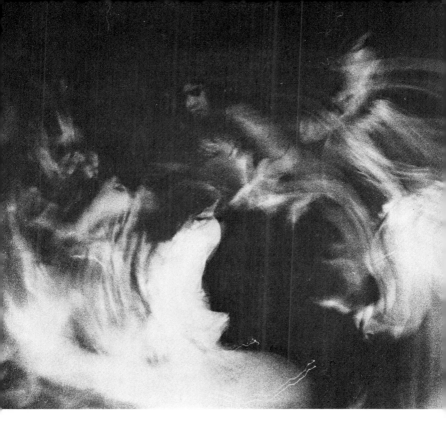

LOW LIGHT BLUR An unusual approach to low light shooting is to let the moving subjects blur as much as they like. The bright lights moving across the film makes wispy images full of mystery and movement. Photograph by *Peeter Tooming, USSR.*

make you unpopular. For that kind of subject you need ultra-fast film and ultra-fast lenses — the kind available only with a very sophisticated camera. To avoid disappointment it is as well to know the limitations of your equipment.

In all places of public entertainment you must either obtain special permission to take photographs or ensure beforehand that photography is allowed. Even where permission is granted, be careful not to disturb the audience.

INDOORS BY DAYLIGHT

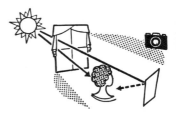

Even the brightest room is considerably darker than you would at first imagine. When you come in from outside, your eyes — though dazzled by the sunshine — adjust themselves to the inner gloom, so you see things much brighter than they really are. But in fact if you measure it with an exposure meter, you would find that the brightest level in the middle of an average living room is less than one-hundredth of that in the street or on the lawn outside.

If you want to photograph the room itself or motionless objects in it, this meagre illumination is quite sufficient. You can stop down the lens as much as you like for the required depth of field, for if the camera is supported on a tripod or a table you only have to leave the shutter open long enough to allow the weak light to act on the film. Your camera's exposure meter will tell you for how long — or even control the exposure automatically.

Near the window the light is much more intense, some eight to ten times as strong as in the middle of the room. So make portraits with the model near the window. With a large lens aperture that may allow exposures somewhere between 1/30 and 1/2 second — and you don't need much depth of field.

One problem with portraits taken near the window is that the part of the face away from the window is in dark shadow. If you can place your model in a bay window, the shadows are

considerably lighter as light streams in from three sides. Or, if possible, arrange for light from a second window or from a white wall to relieve the shadows.

Since hard lighting is particularly unsuitable for faces, try to arrange things so that a white tablecloth or similar surface acts as a reflector to help illuminate the dark side of the sitter's features. Or place a screen at some distance from the model — for example a large white cloth — to provide the desirable lighting for the shadow side.

The other way is to use a fill-in flash as described on page 148. Exposures are in this case calculated as for flash filling in the shadows in daylight. And as indoors you are more likely to be able to stand the camera on a table or other support you can also solve the problem of too strong a flash: simply use a smaller lens aperture with a slower shutter speed and prevail on the model to keep still.

USING LAMPS

The obvious indoor lighting is electric lamplight. Ordinary room lamps are, however, rather weak and need a correspondingly long exposure. If you replace the ordinary 60 watt bulb in a table lamp by a 100 watt or stronger one, the exposure may become short enough for snapshots with a high speed film and a large-aperture lens. You gain even more light by replacing the bulb by a 250 watt photoflood bulb. This is an overrun lamp. It operates at a much higher temperature than usual, and so yields a lot of light for comparatively little current. You pay for it at the other end — such lamps only have a burning life of about a couple of hours. Take care not to use photoflood lamps in too small table lamp reflectors, or the heat may damage the latter. But people taken by the light of a usual reading lamp often feel more at home.

You can also turn your lounge into a regular photo studio with special home photo lighting units. Usually these consist of a small high intensity lamp of the so-called tungsten-halogen kind in a reflector and a fitting that you can mount on a stand, fix to a chair back etc. The light of these lamps — typically 600 or more watts — is adequate for snapshot exposures at reasonably close range. For with lamp lighting it is the distance between the lamp and the subject which counts, not the distance between the subject and the camera.

Such tungsten-halogen lamps, and photofloods, have the advantage of yielding a whiter light than ordinary household bulbs. This makes them more suitable for colour photography

163

on colour slide film. The type A artificial light slide film is specially balanced for correct colour rendering with this type of lighting. With household lamps on the other hand, even artificial type colour slide film still yields rather reddish colours. Matters are less critical with colour print film, but even there the nearer the lighting quality approaches daylight (e.g. electronic flash or flash cubes) the better — see page 141.

SETTING UP LAMPS

A lamp, even in a reflector, is a much smaller light source than the bright sky outside. The light thus does not reach everywhere and leaves a lot of dark shadows which makes the lighting rather contrasty. This is not very favourable for colour photography and also makes exposure measurement difficult.

So when taking pictures of people by lamplight aim to even out the lighting as much as you can. Don't worry overmuch if the effect begins to look a little flat; in the picture it always appears harsher and more contrasty.

In the first place don't bring lamps too near to people's faces. Keep them at least 1.5 metres (or 5 feet) away, placed not too much to the side of the camera, otherwise you again get hard shadows in the picture. You can balance the effect better also with a screen placed on the darker side of the subject to reflect light into the shadows — as with daylight setups indoors (page 163).

Do not however use flash for fill-in lighting with tungsten lamps if you shoot on colour film. For electronic flash and flash cubes match daylight, not lamplight. A mixture of these two kinds of lighting would yield reddish illumination on part of the subject and more bluish on the rest — you can correct either with filters, but never both at the same time. Even colour print film cannot yield correct print tones if the subject was exposed by such mixed lighting. Don't try it unless you deliberately want that effect.

TWO LAMPS ARE BETTER THAN ONE

Indoor portraits with the light of one lamp are really only half a job. One side of the person's face is usually too strongly lit while the other half is too dark. Even the white screen is only a partial improvement.

A better way is to replace the screen by a second lamp. Place this further away from the model than the first lamp, for its purpose is merely to put light in to unwanted shadows – just like a fill-in flash. The other lamp provides the main lighting.

The relative positions of the two lamps can be changed at will: you can place one lower than the other, set the two lights at any acute angle to each other and so on. The lighting effect is different with every new arrangement, and you can experiment if you are so inclined almost like a studio photographer.

Nor are you limited to formal set-ups. Cunningly placed photo lamps can simulate all kinds of natural lighting effects. For instance, a lamp can light a scene as if you had the sun streaming in from the window. Hidden out of sight in a fireplace it can create a firelight illumination (here you may deliberately want a reddish colour character, so shoot on daylight type film if you are using colour slide material) and so on.

HINTS AND TIPS

THE LONG-EXPOSURE PROBLEM

We saw earlier how the shutter and diaphragm work together in controlling the exposure. Normally this is a very equal partnership: if the shutter halves the time during which it is open and the diaphragm doubles the light intensity it lets through, the correct exposure remains the same.

This works fine in daylight and other bright light situations – in fact wherever the exposure time is shorter than about half a second. But the partnership becomes a little lopsided if the light gets weak enough to need much longer exposures. What happens

*then is that the shutter not only has to stay open longer to com-
pensate for the reduced light but on top of that you pay a penalty
and have to keep the shutter open longer still. For instance, you
might find subject conditions that need 1 second at aperture f4.
If you stop down to f8 for more depth of field, you should need
4 seconds exposure. But you there run into the long-time penalty
– photographic scientists call this reciprocity (law) failure – and
in fact you might need twice as much again, or some 8 seconds.
This penalty may increase even more sharply at longer times, over
10 seconds or so.*

*The trouble is that it is not very predictable and varies for dif-
ferent films. Generally, colour films – colour slide as well as
colour print – suffer more from reciprocity failure than black-
and-white ones. Some film manufacturers publish reciprocity
failure data to tell you how much extra exposure increase you
need with longer times. As a rough rule allow 50 per cent more
between 1 and 4 seconds, 100 per cent between 4 and 10 seconds
and say 200 per cent more up to 20 seconds.*

ELECTRICAL LAMP SAFETY

*Electrical equipment, especially when fed from the household
or other mains supply, can involve risks. They are the same as
with other electrical equipment but there may be more of a
hazard through unfamiliarity in handling photo lamps. Note
especially three points:*

*1. Make sure that the lamp or other equipment is of the right
voltage for your district. Running 110 volt lamps on a 240 volt
circuit very rapidly burns out the lamp. A 240 volt bulb on a 110
volt circuit on the other hand gives very dim light indeed. Even
small voltage differences – 220 instead of 240 volts – affect the
intensity and especially the colour quality of the light.*

*2. Powerful lamps get very hot. So keep them away from fabrics,
especially flimsy curtain material, and be careful when picking up
lamp holders – they also can be hot. As constant heat can in time
affect wiring insulation, photo lamp systems should really be
earthed and run off a power supply socket rather than a normal
lighting circuit.*

*3. Don't overload your lighting circuit. Two 800 watt tungsten-
halogen photo lamps will blow 5 amp fuses on a 240 volt cir-
cuit. (On a 110 volt circuit even a single 800 watt lamp is too
much.) That is another reason for running photo lamps off power
circuits that can carry greater loads.*

*Extend the burning time of short-lived overrun photo lamps by
switching them to full power only when you are actually ready*

to take the picture. Many such lamp units have half-power switching for setting up and all the preparations. It is the full-intensity burning time that is numbered; with careful management you need not have the lamps on at full power for more than 5 to 10 seconds per shot.

EXPOSURE METERING WITH LAMPS

Unless the lighting is very even, the deep shadows (for example in the background) of a lamp-lit setup can mislead the exposure meter. A useful trick, much used by professional photographers, is to place a large grey card in the centre of the subject field, facing the camera viewpoint, and then go close up with the camera and/or exposure meter to measure just the brightness of this card as lit by the lamps you are using. Base the exposure on this reading.

You can also use a white card, but in that case quadruple the exposure obtained (four times the exposure time, or open the lens aperture by two stops). The white card has one advantage over the grey one: it extends the measuring range of the meter cell to lower exposure levels.

AN AID TO FOCUSING

Accurate focusing is often difficult in poor light – either bad weather or in a dim room – especially on the screen of a reflex camera. A leaf from a tear-off calendar with large figures, held or stuck up at the correct distance, will help you to focus exactly.

A USE FOR YOUR UMBRELLA

You may not like carrying an umbrella about with you, but it is very useful for snapshots in the rain. Not so much because it keeps you dry, but because it protects the lens in the absence of a lens hood.

If you have a companion with you who is kind enough to hold the umbrella, leaving both your hands free to hold the camera, by all means accept the offer of help.

NIGHT

You need not necessarily wait until it is pitch dark. Dusk is a more comfortable time of the day and will give you night effects without too long exposures. Often the residual glow in the sky adds considerable interest to the picture as it shows up a silhouette of the skyline that tends to disappear altogether when the sky goes fully black.

The ideal moment for such dusk shots is when the street and

other lighting have already come on but there is still a significant amount of skylight. Generally this condition of ideal balance lasts only about ten minutes or so, so you have to be ready for it.

You can make effective studies of picturesque corners and narrow streets by lighting them up with the headlamps of your car. If you are not sure of the state of your battery, keep the engine running at a fast idling speed – or you may be stuck there for the rest of the night!

The exposure depends on the power of your headlamps but may typically be around 30 seconds with a medium stop and fast film. The camera must of course be on a tripod or other firm support. But do not rest it on the bonnet of the car while the engine is running – keep it away from any vibration.

EXPOSURE GUIDE FOR OUTDOOR NIGHT PHOTOGRAPHY

Subject	Film Speed		Aperture				
	400 ASA	f1.4	f2	f2.8	f4	f5.6	f8
	200 ASA	—	f1.4	f2	f2.8	f4	f5.6
Moderate lighting: Provincial town, quiet residential streets with street lighting		½ sec	1 sec	3 sec	8 sec	20 sec	1 min
Better lighting: Station, well-lit factory, bright hotel lobbies		¼ sec	½ sec	1 sec	3 sec	8 sec	20 sec
Bright lighting: Well-lit city streets advertising signs		⅛ sec	¼ sec	½ sec	1 sec	3 sec	8 sec
Brilliant lighting: Floodlit buildings, well-lit shop windows, etc.		1/60 sec	1/30 sec	1/15 sec	⅛ sec	¼ sec	½ sec

Exposures are very approximate. For instance half the times are often sufficient if the ground is wet or snow covered. The longer times allow for reciprocity failure. As exposures are more critical with colour film, it may be useful to take several shots at different exposures. For colour slides use artificial light type slide film (200 ASA); with black-and-white stick to 400 ASA.

More Than One Lens

By going nearer to the subject or further away you can control how much of the view the camera takes in. When Fred is sitting on a park bench, it is entirely up to you whether you move in close for a head-and-shoulders view or back away to take in the bench and the Magnolia tree behind it. How big Fred is going to appear in the picture from any given viewpoint — for instance another park bench across the path — depends however, on the camera lens. More specifically, it depends on the focal length of the lens, a quantity that is related to how far behind the lens you have to have the film. A lens of short focal length can bundle Fred and his bench into a small piece of film quite close behind the lens. That is why small-format cameras use short focus lenses. A lens of longer focal length would be used in a larger camera where Fred and his bench would fill a larger picture.

If you used the same longer-focus lens with a smaller camera, the picture would just cover as much of Fred as would go into the smaller film format — perhaps just his head and shoulders. Using a lens of longer focal length is thus a handy way of getting a bigger picture of Fred without going closer. It is handier still if you are photographing subjects where it is not convenient to go closer: the goalkeeper on the football pitch when you can get no nearer than the upper terrace, or a mountain at the other side of the valley that would take you several hours to cross.

THE DUAL-LENS CAMERA

Most simple, and quite a few not so simple cameras have just one lens permanently built in. You have to make do with that. On many cameras however, the lens is removable and you can change it against one of longer or shorter focal length.

The simplest way of providing alternative lens scope is in the tele-pocket camera. This two-lens camera covers either normal views or, on moving a lever, changes its lens for larger views. At this so called tele position the camera behaves as if it were viewing the scene through opera glasses: the detail is magnified but the coverage reduced. That's logical, for if you photograph a

head and shoulders larger in the same picture area, you have less space for surrounding detail.

Use the normal lens setting therefore for general scenes: landscapes, the crowds on the beach, the group in the garden. Switch to the tele setting for shots where you might wish you had opera glasses with you: larger detail of the coat of arms above the church door, the head-and-shoulders portrait of Uncle Fred, or his grandson feeding the pigeons on the path. That way you can keep further away and not disturb them.

MORE SCOPE WITH MORE LENSES

Most current single-lens reflex cameras from almost the cheapest upwards take fully interchangeable lenses. As they usually have a focal plane shutter just in front of the film, lens changing is easy without disturbing the film or risking light falling on it. That means that you can use an immense lens range. With 35 mm reflex cameras that can cover focal lengths from 15 to 20 mm at one end to 1000 mm or more at the other. The finder screen of the reflex camera at the same time shows the correct view with any lens, from the immense field of the wide-angle to the highly magnified tele view. That is what makes the reflex camera particularly versatile with different lenses.

Similar considerations apply to the larger roll film reflex. Here, however, everything is scaled up: focal lengths are longer and lenses get bulkier. The longest lenses are very bulky indeed.

Rangefinder cameras may also take interchangeable lenses with the same ease, but subject to practical problems. The first is that the camera's own viewfinder only covers the normal or standard lens. Additional frames inside this finder may show the view for one or two further focal lengths. To use the others, you need supplementary viewfinders that clip into the camera's accessory shoe. And with certain lenses you need a reflex housing that effectively turns the rangefinder camera into a reflex.

The second problem is that the rangefinder becomes less

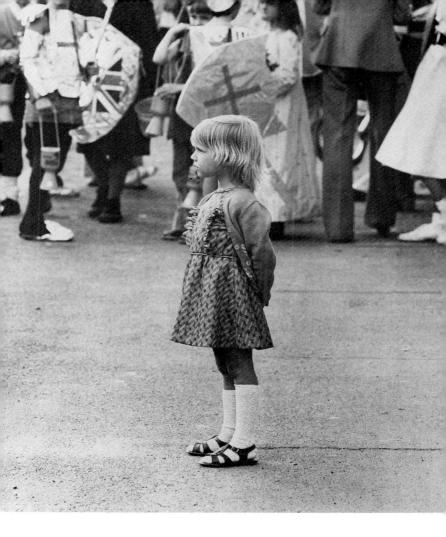

MEDIUM LONG FOCUS Long focus lenses, in this case a 250 mm on 6 x 6 cm format, bring distant subjects closer but it is more difficult to hold such lenses steady enough to get a sharp picture. You need a faster shutter speed than normal and, to allow that, probably a fast film too. Photograph by *Horace Ward, Britain.*

accurate with longer focal lengths. For the latter need precise focusing at greater distances — which the rangefinder is no longer capable of.

WIDE-ANGLE TO TELE

With such a lens range one or two focal lengths count as 'standard' or 'normal'. By convention, this standard focal length is roughly the dimension of the picture format diagonal, or a little over or under. With a 24 x 36 mm miniature camera the standard focal length is thus about 45 to 55 mm, with a 6 x 6 cm roll film camera around 75 to 80 mm. In each case lenses with shorter focal lengths than the standard count as wide-angle lenses, and those with longer focal lengths as long focus or tele lenses. There are further subdivisions: medium wide-angle, wide-angle and ultra wide-angle on the one hand, and medium, long and extreme tele on the other.

Progressive superlatives apart, a wide-angle lens thus simply takes in more of the view — Fred *and* the Magnolia tree — from a given viewpoint. The wider the angle of view, the shorter the focal length. With an ultra wide-angle lens you might include not only the Magnolia tree but also a lot of lawn on either side and the path in the foreground. That is handy when you cannot go back far enough from a wide subject, for instance buildings on the other side of the street. Indoors it is particularly difficult to take in more than a fraction of the room with the normal camera lens. We are used to turning our head this way and that to look round but the camera has to take it in all in one glance. It can do that with a suitable wide-angle lens. That, incidentally, makes the room look much more spacious in the picture than it really is. Wide-angle photographs of the interiors of caravans or boats are a favourite way in advertising literature of disguising how really cramped the accommodation is.

In landscapes a wide-angle lens also helps to convey the breadth of a view, say down the valley from a hilltop. In fact on this scale of nature you cannot change how much you get into the picture without long and arduous walking; with interchangeable lenses you can do it painlessly from one spot.

Tele lenses progressively fetch things nearer like opera glasses or — with the longer focal lengths — like binoculars or powerful telescopes. A tele lens is handy for unobserved snapshots of people, as you can choose a viewpoint further away instead of sticking the camera right under their nose. In sports photography the tele lens brings you a close view of the action you cannot get near to. In landscapes and architecture you get more detailed

WIDE ANGLE A wide-angle lens deepens the perspective, so distances are exaggerated and nearby subjects appear overlarge if you do not step back from them. Photograph by *Ed Buziak, Britain.*

shots of a picturesque church half-way up a hillside or — if you do get nearer to it — the fine detail of its decoration.

WIDE-ANGLE AND TELE PERSPECTIVE

As long as the viewpoint is the same, the picture you get with a longer-focus lens is identical with an enlarged section from the middle of a shot with a short-focus lens. So you could in principle get a tele picture by enlarging a small centre section of a wide angle one. You would have to put up with the coarser grain and slight definition loss involved in huge enlargements. The image arrangement or perspective — the size relationship between nearer and more distant objects — is, however, unchanged.

Yet there us a subtle way in which wide-angle and tele pictures look slightly odd. Wide-angle shots appear curiously cramped. This is partly because they take in more subject matter than we are used to seeing in a normal print or slide. Partly, also, proportions appear exaggerated with violently converging lines and foreground objects dramatically dwarfing those further away.

Photographers often talk of perspective distortion, though distortion is not really the primary factor. What makes normal prints of pictures taken with wide-angle lenses look strange is the fact that our angle of view as we look at the print is narrower than the angle the camera took in with the wide-angle lens. So the larger expanse of the view appears cramped into a smaller picture. To get the effect more natural, wide-angle shots should be enlarged really big and viewed from not too far away so that the eye roams over the picture much as it did over the original view, rather than trying to take it in all at once. When projecting slides, you should similarly have a bigger screen and be fairly near to it. The view then regains its breathtaking width and expanse.

Conversely, tele shots appear flat and compressed. Figures and objects seem to have little or no depth, almost as if they were cardboard cutouts. Distant objects do indeed appear like that, but we are less liable to notice it because we nearly always see nearer items that give the scene depth. It is only when we look at the view through binoculars — or take it with a tele lens — that this depth-giving comparison with a foreground disappears.

You will just have to accept this flattened perspective in tele pictures. To simulate a correct viewing angle by looking at small prints at arms' length just defeats the object of using a tele lens in the first place — to show distant detail large in the picture. This subdued perspective is a small price to pay for the enlarged detail view.

TELE PERSPECTIVE A curious feature of the long focus lens is the apparent compression of subject matter and foreshortening when distant subjects are magnified by it. This can be used to dramatic ends — the cars appear to be nose to tail through this 200 mm telephoto on 35 mm. Photograph by *Ed Buziak, Britain.*

DIFFERENT LENSES AT DIFFERENT DISTANCES

You can get an object large in a picture by going closer to it, or smaller by backing away. You can also get it larger from the same camera viewpoint by using a tele lens, or smaller with a wide-angle lens. What difference does it make? Let us look at an example in detail.

Suppose you are on holiday, having breakfast on the wide terrace of an Alpine hotel with an impressive mountain background. You want to photograph Betty at the breakfast table against the mountains. If you have a camera with interchangeable lenses, you can go about it in one of several ways.

The first is to go close enough to Betty — say to about 1.5 metres or 5 feet — with the camera and a normal lens to get Betty in the picture from head to waist. The mountains in the background will look comparatively small.

The second is to go further back, to say 6 metres or 20 feet away. This won't make much difference to the size of the mountains in the picture — after all, what is 20 feet for mountains miles away? But at 20 feet Betty is much smaller in the picture which includes the whole breakfast table and a bit of terrace and in fact places her more in proportion to the setting.

If you now fit a 4 x tele lens on the camera, a picture from the same viewpoint 20 feet away from Betty, again shows her at half length filling the frame as in the first picture. But the tele lens has also magnified the mountain background which still looms over Betty.

By varying the distance and focal length you can thus control the relative importance of near and more distant objects in the picture. This is one of the most powerful means of using interchangeable lenses creatively.

PROPORTIONS NEARBY

The perspective effect works of course, on things less far apart than people and mountains. If Betty at her table 5 feet away stretches out one hand towards the camera, that may loom up in the foreground at less than half the distance, and therefore twice the size, of the head. From 20 feet away the difference is much less marked and a stretched-out hand still largely retains its correct proportion.

If you are close enough to the head even the relative proportions of the nose and the ears may become slightly exaggerated. To get a closeup of Betty's head you would (with the standard camera lens) have to go as near as 0.5 metres or some 20 inches, if the camera focuses that near. If you don't spend all your time

WIDE-ANGLE PANORAMA A wide-angle lens, in this case a 24 mm or 35 mm format, takes in the great sweep of Monument Valley, Arizona. Although people more often use a wide-angle lens in tight corners by deepening the perspective it can make a distant view more impressive. Photograph by *Geri Della Rocca de Candal, Italy.*

looking at Betty that close, you would find her face apparently distorted in the picture. The proportions look more normal if you shoot from 1.5 to 2 metres or 5 to 6 feet away. If you can change the camera lens for a 3 x tele, you get the face in the picture as big as before but now without the exaggerated perspective.

That is, incidentally, why you often read that close-up portraits should be made with a long-focus or tele lens for natural perspective. You get the natural perspective by going further away; the tele lens merely forces you to keep your distance even for a large view.

Conversely, you can exaggerate near/distant perspective; mount a wide-angle lens on the camera and go really close to the subject. With such a lens you still get the whole subject into the picture.

WHICH LENSES TO CHOOSE

When you buy a camera taking interchangeable lenses the first item of literature you will come across after the instruction book is a lens brochure. Invariably that urges you to buy as many of the accessory lenses as you can afford. As no camera maker worth his salt would dream of offering less than about a dozen interchangeable lenses (and some offer two or three times as many), the prospect is financially daunting.

Obviously you would never have occasion to use them all. Less obvious: which are the most useful?

Having alternative lenses makes most sense if they take in quite a lot more than the standard lens or show objects at a significantly larger scale. So it's hardly worth getting a tele lens with much less than about 1.8 to 2 x magnification (up to twice the focal length of the normal lens) or a wide-angle lens covering much less than twice the normal lens' view. With a 35 mm reflex camera (standard focal length usually 50 mm) the most useful wide-angle lens would be one of 25 to 28 mm. This covers all the occasions when you want to take in substantially more of the view: broad landscapes and views, big buildings, confined interiors.

By the same token a useful first tele lens would be one of 90 to 100 mm. That is fine for portraits, brings distant detail significantly closer yet is usually still a reasonably compact lens.

With a 6 x 6 cm roll film reflex of 75 to 80 mm standard focal length the corresponding alternative lenses would be a 40 to 50 mm wide-angle and a 150 mm tele.

Don't buy more lenses than that to start with. Once you have got used to working with alternative lenses, you will begin to see also where you might want additional focal lengths for

DETAIL AT A DISTANCE A long focus lens can pick out inaccessible details at long range. You can make pictures by selecting parts of the subjects if you look for patterns of shapes that are interesting in themselves. Photograph by *Horace Ward, Britain.*

your particular field of favourite subjects: longer tele lenses for really distant views, for example.

ZOOM LENSES

With normal interchangeable lenses you have to switch the field of view and image scale you cover in quite large and distinct steps. On so-called zoom lenses you can adjust the focal length and hence the image in the finder continuously.

In many ways that is even more convenient. As you look through the reflex camera finder you adjust the zoom ring or control, getting more or less of the subject into the picture — all without moving from the spot. That is handy if you shoot on colour slide film where the picture should be framed as exactly as possible when you take it. Then it certainly makes filling the frame much easier all round.

Against these advantages, zoom lenses tend to be more expensive, bulky and of smaller maximum aperture than equivalent lenses of fixed focal length. And zooming is usually restricted to a 2:1 or 3:1 range.

Many zoom lenses cover a range to each side of the standard focal length, for instance 35 or 40 to 70 or 80 mm with a 35 mm miniature reflex. Others mainly cover longer focal lengths, for instance 70 or 80 to about 200 or 220 mm.

This latter lens is a good though bulky alternative to a medium tele such as the 100 mm mentioned above.

Zoom lenses make sense only with a single-lens reflex camera. For only with that can you directly judge the exact effect on the picture of slight variation in the focal length setting.

HINTS AND TIPS

MAGNIFICATION

The power of long focus and tele lenses is occasionally quoted in terms of magnification, e.g. a lens may be listed as a 4 x tele. This factor simply indicates by how much the lens magnifies the image scale compared with the standard lens. Numerically it is the focal length of the tele lens divided by that of the most usual standard lens for that format.

For instance, the usual standard lens for a 35 mm reflex camera has a focal length of 50 mm. Hence a 200 mm tele lens would be a 200/50 = 4 x tele. This terminology is similar (though optically not calculated in the same way) as with binoculars or telescopes.

180

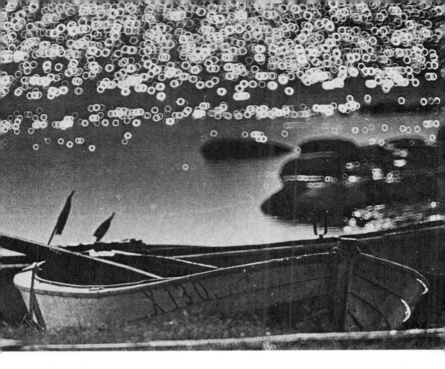

EXTREME LONG FOCUS This picture was taken through a high power catadioptric lens, a lens using mirrors to bend the light instead of glass. Apart from flattening the perspective any small bright highlights are recorded as a telltale doughnut instead of the usual point of light. Photograph by *Peeter Tooming, USSR.*

THE RIGHT LENS

When you buy additional lenses you must be sure that they fit your camera, correctly couple with the various aperture control and exposure automation systems, and perform well.

The safest way is to get lenses specifically marketed or recommended by the camera maker. They almost always meet all three of the above conditions. Lenses produced by independent manufacturers are often less expensive. However you must carefully check that the lens really matches your camera.

Interchangeable lens attachment fittings are different on almost every make of camera. Most models take a bayonet fitting of one kind or another. That is usually quick to attach and remove, yet fits securely. A bayonet mount for camera A however very rarely fits camera B or any other model – and vice versa.

A screw lens mount is more universal and a number of 35 mm reflexes use a 42 mm screw fitting. The aperture linkage elements must however still match. Apart from that, nearly all cameras taking this fitting can use nearly all lenses in a 42 mm screw mount. Not even this vestige of standardisation however exists in roll film reflex camera lenses. So always check carefully that a lens you intend to buy fits your camera – preferably try it on in the shop.

CARE OF YOUR LENSES

Interchangeable lenses need the same careful handling as the built in optics of a fixed-lens camera (page 29). With lens changing there is, however, a greater risk of getting fingermarks on the lens which may be laborious to clean off. Better still, avoid them by placing the lens cap on the lens before you remove it from the camera and fitting the rear cap over the removed lens immediately afterwards. Similarly take off the rear cap of a new lens only immediately before mounting it on the camera. Keep the front cap on whenever you are not taking pictures.

The ideal place to carry spare lenses is in suitable compartments of a hold-all bag or in lens cases or pouches. Carry lenses in your pocket only as a last resort, and even then carefully clean all fluff, debris and dust out of the pockets beforehand.

FISH EYE AND TELE-EXTENDERS

The fish eye lens is a special ultra wide-angle lens that covers an angle of around 180°. To get all this into the picture area, the image is deliberately distorted and resembles what you see in a convex driving mirror or in a silvered Christmas tree ball. That is, the subject appears reasonably big in the centre while everything

away from the centre gets progressively smaller and squashed up. Straight lines going through any part of the picture other than the centre appear curved towards the centre.

Fish eye lenses were originally designed for very specialised scientific recording purposes. They can yield amusing pictorial effects, though they are often used much more for a gimmick.

Tele-extenders are an inexpensive way of doubling your tele lens range. The extenders are optical units that fit between the camera and the lens and they double – or sometimes triple – the effective focal length of the lens. So a 100 mm tele lens used with a 2 x tele extender becomes equivalent to a 200 mm lens – with very little extra bulk.

You don't of course get something for nothing: in doubling the focal length the tele-extender also doubles the f number of the largest lens aperture. Thus a 100 mm f4 tele lens with the tele-extender becomes a 200 mm f8 – quite slow for such a lens. Usually you have to stop down further still for good overall sharpness as the tele-extender makes lens performance poorer.

AFOCAL LENS ATTACHMENTS

Interchangeable lens effects are sometimes possible even with fixed-lens cameras. There exist various afocal attachments that fit into the front of the camera lens and turn it into a tele or wide angle lens.

The range is somewhat limited, at the best to 0.6 x for wide angle and 1.5 x (in extreme cases 2 x) for tele. Even that is something. Again with such attachments you may have to stop down the camera lens to ensure good sharpness.

DEPTH OF FIELD

With alternative lenses depth of field at first sight appears to be greatly modified. Wide angle lenses yield much more depth of field and tele lenses much less than the standard lens, You read off the actual depth of field from the depth indicator on the lens.

You might for instance find that at stop f4 the standard lens focused on 5 metres covers a depth zone from about 4 to 6.8 metres. The 4 x tele lens under similar conditions might cover a zone ranging from only 4.9 to 5.1 metres and from 18.8 to 21.6 metres at 20 metres. However, with the 4 x tele lens a subject at 20 metres is as big on the film as it was at 5 metres with the standard lens. And in both cases the actual depth of the subject space is about the same – 2.8 metres. Hence using a tele lens to bring the subject nearer instead of going nearer to it yourself with the camera does not make a great deal of difference to the zone of sharpness in front of and behind the subject itself.

Close-ups and Copying

Among the more fascinating photographic subjects are close up shots of innumerable natural and hand made objects: flowers, butterflies, the whole microcosm of a corner in your garden, antique knick-knacks, figurines that grandmother brought back from God-knows-where, artistically decorated plates, engraved medallions, jewellery — the list is endless. All have in common the need for a really close look, almost under a magnifying glass, to appreciate the wealth of meticulous detail that makes up the subject.

It is no accident that the most elaborate accessory systems of more advanced cameras are concerned with close-ups and macrophotography. For these fields also have important scientific and industrial applications. However you can easily extend the scope of your camera to close-up photography even if you have quite a simple model.

GOING CLOSE WITH CLOSE-UP LENSES

The simplest way of letting the camera take a nearer look at things is similar to what we ourselves use for close observation: a magnifying glass. That works even if the camera has only a limited or no distance adjustment.

These magnifying glasses for the camera, also known as close-up lenses, are available in various sizes and strengths. We touched on them briefly on page 76 for going nearer than the near depth of field limit with cameras that have no distance adjustment. Now however we are concerned with going quite a lot nearer.

Usually these lenses are marked in diopters, an optician's way of expressing converging power. Preferably you should get close-up lenses specially designed for your camera or, at least, lenses for photographic use. Usually they come in various standard screw-in or push-on mounts that fit the front of your camera lens.

The distance at which a supplementary lens records objects sharply depends on the power of the close-up lens and the distance setting of the camera lens but, curiously, not really on the camera lens itself. If you have set the latter at infinity and for instance placed a 2 diopter close-up lens over it, the camera sharply records objects 50 cm from the front of the lens. If the lens can focus at a closer point, the close-up range also gets shorter with the supplementary lens. Thus, the same 2 diopter lens combined with camera lens focused on 1 metre (3.3 feet) records things sharply at about 33 cm. The table on page 187 gives selected settings and distances with different close-up lenses.

SET THE DISTANCE ACCURATELY

At this near range you must set up the camera at the exact subject distance. Measure this with a tape measure, going from the front of the close-up lens to the main part of the subject.

This is a little cumbersome as you have to mount the camera on a tripod or table tripod and then carefully adjust its distance from the subject.

Depth of field in close-up photography is also limited, so you will have to use a small stop to cover the depth of the subject. But don't count on covering more than about an inch altogether even at stop *f*8. On the other hand you will need to close down the lens to this kind of stop to eliminate optical faults introduced by the close-up lens to ensure adequate overall sharpness.

Focusing aids exist for certain cameras in the form of either close-up rangefinders or distance gauges. The former clip on the camera and you approach the subject until a double image seen in the rangefinder window fuses to a single one. Distance gauges screw to the camera base and consist of a rod protruding in front

185

of the camera with a frame at the end. The latter defines the size of the subject field and also the subject plane. If you approach the subject with this device on the camera, you only have to get the subject within the plane of the frame to be sure of sharp pictures. These rangefinders and gauges work only for the specific camera for which they are designed. They also provide a more accurate view of what the camera takes in at close range than is possible with the camera viewfinder, for with close-up lenses that viewfinder becomes rather inaccurate.

You will have no such problems with a single-lens reflex as you there directly observe the sharpness and coverage of the image on the camera's finder screen.

WHAT LIGHT?

The ideal lighting is daylight. This is also easiest with outdoor close-ups, especially if you keep a sheet of white or silvered cardboard handy to reflect some light fron the sun into the shadow parts of the subject.

Next best is tungsten or other lamplight indoors. For colour shots in that case use tungsten type film.

Lamps are easy to set up at home and for close-up subjects you can easily manage with a pair of desk or reading lamps. Gooseneck type lamps with reflectors or with internally silvered reflector-type bulbs are easy to set up to concentrate the light where you want it.

With inanimate subjects you can work at leisure and the light is intense enough to permit quite short exposures. Check these by the exposure meter. Don't, however, keep plants for too long too near the lamps or they may wilt.

Electronic flash can also be used but take it off the camera and point the flash separately at the subject. Otherwise at close range the flash on the camera might light up an area next to the subject leaving most of the latter in the dark. Preferably use a computer flash unit (but watch its near distance limit), for guide number exposure calculations do not quite apply at close range.

CLOSE-UPS WITH INTERCHANGEABLE LENSES

Close-up photography is supremely simple with a single-lens reflex that takes interchangeable lenses. The easiest way is with a macro focusing lens. Apart from the focusing travel necessary for normal subject distances, this has a specially extended focusing range that permits close-ups down to around half natural size and — with an extension tube that fits between the lens and the

camera — even to full natural size. Thus a diamond ring or a postage stamp can fill the frame on the film.

The best way of focusing with these macro lenses is to mount the camera on a table tripod or even on a full-size tripod, approach the subject to about the required distance and adjust the lens to get the image sharp on the camera's reflex screen. Alternatively, set the lens to the required scale of reproduction — usually marked on the distance adjustment in figures such as 1:2, 1:3, 1:4 and so on — and come up to the subject with the camera until the image appears sharpest. A microprism focusing spot in the viewfinder (page 78) is most convenient here.

Close focusing is also possible with the standard camera lens and extension tubes. These again fit between the camera and the lens and in conjunction with the lens focusing range provide a range of near distances. Each tube has a mounting to fit the camera at the rear and a flange to take the lens at the front. You can combine several tubes to get a longer extension and thus permit closer focusing.

Even more sophisticated are close-up bellows units that take the camera at one end and the lens at the other. The bellows length is adjustable by a precision focusing movement and usually provides a close-up range to macrophotography, i.e. magnified images on the film. This is useful for specially large pictures of tiny objects, for instance jewellery or small parts of postage stamps. Such macro subjects however need particularly careful focusing and special lighting.

CLOSE-UP LENSES AND DISTANCES

Lens setting		Object distance with lens of diopters:					
m	*ft*	*+0.5*	*+1*	*+1.5*	*+2*	*+3* (1+2)	*+4* (2+2)
∞	∞	200 cm	100 cm	67 cm	50 cm	33.3 cm	25 cm
3	10	120 cm	75 cm	54.4 cm	43 cm	30 cm	23 cm
1.5	5	86 cm	60 cm	46 cm	37.5 cm	27.3 cm	21.4 cm
1	3.3	67 cm	50 cm	40 cm	33.3 cm	25 cm	20 cm

You may have to use quite a small lens stop for adequate overall sharpness with the more powerful combinations. When combining two close-up lenses, fit the stronger lens on the camera lens first.

CLOSE-UP EXPOSURES

You are most likely to take close-ups with extension tubes or

187

macro lenses if you have a single-lens reflex camera. Most of these measure the exposure through the lens and such readings directly yield correct exposures.

If you have to measure the exposure with a separate meter that reads the light reflected from the subject, close-up exposures made with extension tubes or macro lenses need an exposure compensation. This depends on the magnification and is given in the table below. Remember that this applies neither to close-ups with supplementary close-up lenses nor to exposure readings through the camera lens.

CLOSE-UP EXPOSURE CORRECTION

Magnification	0.2 1:5	0.3 1:3.3	0.4 1:2.5	0.5 1:2	0.6	0.8	1 1:1
Exposure factor	1.5x	1.7x	2x	2.2x	2.5x	3.2x	4x
No. of lens stops larger	½	$^2/_3$	1	1⅓	1⅓	1$^2/_3$	2

These corrections do not apply to close-up lenses. Cameras with through-the-lens metering automatically allow for them.

COPYING

An easy application of close-up photography is in copying illustrations, documents etc. It is an easy way also of copying a few pages from a book or periodical in a library when you cannot take the original with you, for instance for study purposes. You can also copy paintings and other works of art, photographs etc. (subject to permission of the copyright owner). With old photographs it is a way of making new prints if you have no negative.

COPYING SETUPS

Most originals to be copied are fairly large and the reduction on the film is of the order of 1:8 or more. That you can normally cover with a supplementary lens. With smaller book pages you may have to face the fact that the page does not fully fill the film area. This is not usually serious, as you can re-enlarge the reproduction to fill the print format.

For this kind of casual copying you should have a compact but adjustable camera support on which the camera can point

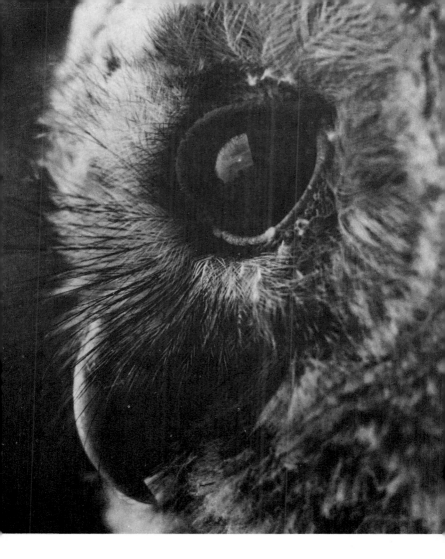

CLOSE-UP WITH ANOTHER LENS Interchangeable lenses allow you to get really close shots of a subject you dare not actually approach yourself. Photograph by *Zdzislaw Zielinski, Poland.*

vertically downwards. You set this up over the page or material to be copied. Check that the lens axis is exactly square to the surface of the picture or page you are copying and focus accurately — if necessary by carefully measuring the distance from the surface to the close-up lens on the camera. If you can focus with the camera's reflex screen, so much the better.

Lighting for copying should be as even as possible. Professional copying setups use up to four lamps shining at the original from the four corners. If you are copying odd pages in a library, a much simpler setup is however adequate. Take your camera and original to a desk near a window and place a white card more or less upright along the side of the original away from the window, to reflect light on to that side as well.

You may get involved with three kinds of copying that need three different film materials. With line work (for instance text and drawings of pure black matter against a white background) use a low-speed fine grain film. This fairly contrasty material yields negatives with strong differentiation between text and background, capable of giving high-contrast legible enlargements.

For copying photographs, use a normal black-and-white film. The same applies to black-and-white copies of colour originals. For copying in colour, usually a colour slide film is best; colour print film tends to falsify colours more under these conditions. However, do not expect too faithful colour reproduction; colour films rarely reproduce very accurately the pigments used in paintings.

If you want to copy paintings in museums you usually need permission. However, if you can on the spot buy colour slides of the more famous exhibits, this is often a better proposition. Such slides are produced by professionals working with special facilities for lighting etc. of the exhibits.

Camera Care and Outfit Sense

Whether comparatively simple and inexpensive or costly and sophisticated, your camera is something of a precision instrument. It was carefully produced and tested to be in perfect working order when it left the camera factory. You, too, have to devote a certain amount of attention to it to keep it in this working order. We have summarised obvious points already on page 29: don't knock the camera about, don't drop it, avoid prolonged exposure to the sun, to heat and of course to moisture, sand or even fumes. (The latter can affect the film.)

All this is straightforward common sense. Here are a few further points for keeping your photo equipment in best possible trim for as long as possible.

KEEP THE CAMERA CLEAN

You may not always manage to handle the camera with absolutely clean hands. But avoid touching viewfinder windows or finder eyepieces, and take special care not to touch the lens surface. You can clean eyepieces and windows with a clean fluffless cloth or well-washed handkerchief (well washed to get rid of all size). Wipe dust off the lens with a particularly clean handkerchief — fold it open and use the inside folds. Finger marks can also be cleaned off this way by carefully dabbing or wiping them away. Lens cleaning brushes are suspect; unless you have taken very great care to keep them clean, they may deposit more soiling on the lens than they take away. Finally avoid spectacle-cleaning tissues and lens-cleaning fluids. And never breathe on the lens for cleaning the way you would with spectacles.

Clean the rest of the camera exterior periodically too. Remove dust by brushing it away with a small stiff brush — but do not let that touch glass surfaces.

Periodically — for instance after every three or four films — clean the camera interior, too. Brush out dust with a clean brush or blow it out with a rubber ball blower brush. Check that you get rid of all bits of film debris. Never touch the reflex mirror of a single-lens reflex camera either with your fingers or with the brush. If you should get slight marks on the mirror, leave them

there; trying to clean the mirror often makes such marks worse.

When using your camera on the beach or wherever dust or sand might penetrate into the mechanism, pack the camera with its case into a polyethylene or other container to keep out such flying dust. This applies particularly when putting it down on a sandy beach. If your camera has got sand or water into its mechanism, get it cleaned only by an expert.

STORAGE

Factory-new cameras are often packed in plastic bags containing a small bag of silica gel as drying agent. If you propose to store the camera without use for longer periods, wrap it up again in such a plastic bag with a silica gel bag added. (Keep the silica gel bags of the new camera and heat them in a medium-hot oven for two to three hours to dehydrate the silica for optimum activity.) Needless to say, store the camera in not too hot or too cold a place. Normal room temperature is usually fine.

Before storing the camera check that you have left no film in it. Further, remove all batteries used in the camera — for the exposure meter system or possibly a flash unit — to prevent possible leakage. The same (removal of batteries) applies to electronic flash units, motor drives and other electrically powered components that you want to store for longer periods.

EXERCISE

Cameras (like many mechanical instruments) need a little regular exercise to keep them in good condition. Store your camera where you can get at it easily and put it through its normal operations at least once a month:
1. Tension the shutter (usually by operating the film transport) and release several times.
2. Check at the same time the film transport movement.
3. Set a slow shutter speed and again tension and release the shutter repeatedly. Also test the self-timer or delayed-action device.
4. Examine the exposure meter for correct operation.
5. Check the distance setting and aperture setting rings or controls.

These exercises keep the mechanism in good order, retaining the natural qualities of the lubricant. That way your camera is ready for immediate use when required.

Before going on holiday with the camera, or on an important assignment, make a few trial exposures. This is especially advisable if you had stored the camera for an extended period. In that

case also test the camera at least four weeks before departure to permit a test film to be exposed and processed. This might save you a possibly spoilt holiday record.

ELECTRONIC FLASH

Keep electronic flash units as dry as possible. Moist surfaces become good conductors of electricity and can cause dangerous short-circuits.

If a flash is not in use for long periods, switch the unit on, allow it to reach the triggering voltage and leave it switched on for about five minutes, fire a flash (with the manual flash button if provided), let the flash unit recharge in the manual operation mode and switch off without firing a further flash. This keeps the electronic circuit and especially the power capacitors in good trim.

ANIMALS A problem with photographing large animals is that from a normal range the head appears too large in proportion to the rest of the body. One way round this is to take the picture from much further away, another is to concentrate on the head only. A side-on-view prevents over-enlargement of the nostrils which is a danger with the head-on viewpoint. Photograph by *Horace Ward, Britain.*

PHOTOSUBJECTS A–Z

Hints and techniques for dealing with anything you might want to photograph

ANIMALS *Pets:* Just watch them at play or at rest to get not one but a whole series of pictures. Preferably preset the camera for a focusing zone (page 58). Get down to the level of the animal: looking down almost invariably dwarfs it. For close-up heads preset the camera to a fixed distance, attract the attention of the animal and expose as it turns its head or comes towards the camera. Aim at photographing animals by daylight; artificial light or flash shots tend to look unnatural. However fill-in flash (page 148) can be useful for lightening dark fur. With dark fur, increase the exposure somewhat to ensure full detail. Wherever possible focus on the eyes. Catchlights in the eyes make a great deal of difference to whether the animal picture looks dull or alive.

In the zoo photograph animals behind bars and coarse mesh netting by putting the lens right into the space between the bars. But watch out for animals likely to grab or peck at the lens. To eliminate distracting and ugly backgrounds choose or wait for side lighting. Ideally this should light the animal but keep the background in the shade.

Wild life photography is, in effect, hunting with the camera, whether that is in the African bush or on the Scottish moors. Nature reserves are richest in potential subjects but this needs at least a single-lens reflex camera with a long tele lens to capture animals from a distance. Small animals such as frogs, lizards etc. are difficult to approach unless you photograph them confined in a terrarium. Try to get as much natural background as possible. When photographing through glass have any lamps (even flash) behind the glass rather than in front to avoid reflections.

Fish in aquaria are handled similarly: you may need flash lighting shining down on the aquarium from above. As fish dart to and fro, a trick – if it is your own aquarium – is to insert a glass plate behind the fish and keep them in a fairly narrow zone in the front of the aquarium.

ARCHITECTURE You can buy picture postcard views or slides of the best known buildings but not of the small architectural discovery, so instead of simply trying to take in the whole of a famous building, concentrate on detail. Normally hold the camera straight to avoid the effect of vertical structures appearing to topple over. If you have to get a lot into the picture, either stand well back from the building or use a wide-angle lens (if your camera takes interchangeable lenses). Similarly, a tele lens allows you to get distant inaccessible detail large in the picture: decorations, design detail, sculptures, etc. Intentionally distorted

196

ARCHITECTURE With architecture photography you would seek excellent definition to render the hard edges and decoration as accurately as possible. Ideally you should work with fine grain film, a large format and small aperture, with the camera on a tripod for complete steadiness. You may have to compromise on the format, but you should still get good quality. Photograph by *Raymond Lea, Britain.*

views can also be effective. For those, go quite close to the building and take it looking up sharply from a low viewpoint. You may have to use quite a small lens stop for adequate depth of field. Direct front lighting on architecture tends to give flat and uninteresting photographs with little texture detail, justified in a colour picture only if the building carries elaborate or attractive coloured decoration. For a good rendering of depth select a time of the day when the light comes from the front and in part to one side of the building. Extreme side lighting produces strong shadows and texture effects which may however disturbingly break up lines and shapes. In black-and-white shots aim at sufficient contrast between the sky and the building, often best achieved with an orange or possibly red filter. Sculptures and sculptural detail are better photographed from reasonably near to ensure three-dimensional depth. But avoid very oblique low-angle or high-angle views with their violent foreshortening. Base the exposure − especially if large patches of shadow are included − on the darkest part in which you want to preserve detail.

CHILDREN Children are the most rewarding of all photographic subjects provided you can take them as they are, unconscious of the camera. Never ask them to pose, to look into the camera or dress them up for the occasion. Preferably prepare the camera beforehand with a suitable zone focus setting, and aperture and shutter speed preselected by separate measurements − unless you are using an automatic camera. Then watch the children at play or other activity until you are sure that the camera does not attract attention, and shoot quickly. Do not worry unduly if you cannot use the fastest shutter speeds to stop movement; slightly blurred outlines due to sudden movement of say the hands are not too disturbing and may even make the picture more alive. As children's actions and reactions tend to be unpredictable, the best approach is to shoot and keep shooting as long as the film in the camera lasts. Preferably photograph children from their own level with the camera at the height of the child's head. Or, better still, take them from a lower angle, say the height of your knees; this gives a more natural and pleasing impression. Natural daylight, even indoors, is generally the most pleasing lighting for child photography. The nearest match with artificial sources is bounce flash (page 146). Otherwise follow the notes on lighting and general technique with portraiture (pages 218-220).

198

ARCHITECTURE INDOORS Canterbury Cathedral choir from the East. To make the uprights look upright you must have the camera level and parallel with the verticals in the picture. This may mean that the subject is too severely cut at the top. Use a wide-angle lens and omit the floor from the bottom of the picture in printing. Photograph by *Clive Hicks, Britain.*

CLOSE-UP STILL LIFE Small and medium-size inanimate objects depend on correct lighting and correct focusing for much of their impact. Close-up lenses extend the camera's near focusing range (page 76) for reproduction scales up to about 1/5 or 1/4 natural size. Still larger scales need more sophisticated close-up equipment such as a macro-focusing lens and/or extension tubes on a 35 mm reflec camera taking interchangeable lenses. Measure the subject distance carefully for accurate focusing or focus on the screen of a reflex camera. The camera will nearly always have to be supported on a suitable stand or table tripod. As depth of field at close range is limited, you will usually have to use a small stop.

Arrange the illumination to avoid deep shadows. The light should not however come predominantly from the front; use lamps (or flash) from the side to provide modelling and texture. Continuous lighting (tungsten lamps) is easier to assess for its effect than flash. Judge the effect of lighting always from the viewpoint of the camera lens or − where feasible − on a reflex camera's finder screen. Use glancing low-angle lighting to accentuate surface texture and low relief, for instance of coins or medallions. With very shiny objects − china, silverware etc. − shadowless lighting eliminates disturbing catchlights: swing the lamp from behind the camera in a large semi-circle, with the camera position as centre. With smaller objects arrange shadowless lighting by placing a 'tent' of translucent paper or plastic over the object, with the camera looking down through a hole in the apex of this tent. Then illuminate the tent from the outside with at least two lamps. Avoid excessive lighting contrast, especially for colour shots.

A useful way of measuring exposures is to place a mid-grey card in the location of the subject, facing the camera, with the lighting to be used turned on. Then read the exposure on this card. For colour shots on colour slide film use the correct film type − artificial light film with tungsten lighting or daylight film with electronic flash or flash cubes. In black-and-white photography a filter of the colour of the main subject − for instance orange or red for brown leather or stained woodwork − helps to bring out texture in detail in these objects.

COPYING Also a field of close-up photography though in most cases supplementary close-up lenses cover the necessary near focusing range. Place the original to be copied on the floor or on a table, fix the camera on a tripod with a ball-and-socket head turned downwards and carefully adjust it so that the film

FISH (*above*) Avoid reflections from the light source and camera by placing the flash to one side and the camera up against the glass, checking for reflections through the range-finder. Photograph by *Hervé Chaumerton, France*.

PETS (*opposite*) You may have to place him where you want him and then act quickly before he disappears. Preset flash and focus and a remote release enables you to shoot immediately your hands leave the picture area. Photograph by *Peter Stiles, Britain*.

GLAMOUR (*page 201*) A light, cheerful location with a background free from ugly intrusions lends the right mood to successful glamour shots. Photograph by *Colin Ramsay, Britain*.

LANDSCAPE (*above*) The simplest camera can tackle this type of subject. The picture depends not on technique but in a pleasing arrangement of the scene within the picture area. Photograph by *Raymond Lea, Britain.*

GARDENS (*opposite*) Everyone wants a photograph of the garden in full bloom. Try to fill the whole picture with real subject matter and avoid empty foregrounds or shapeless compositions. Photograph by *Peter Stiles, Britain.*

PEOPLE (*page 204*) The climber pauses for breath but the picture suggests movement. The subject is aware of the camera but he does not look wooden. Don't take too long over taking pictures of people. Photograph by *Peter Stiles, Britain.*

CHILDREN (*page 205*) They soon forget about the camera and stop playing up to it. After a while you can get pictures that look as natural as if there were no camera present at all. Photograph by *Peter Stiles, Britain.*

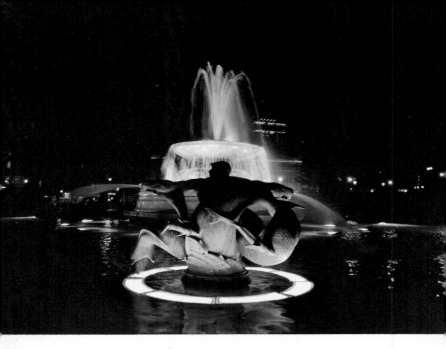

NIGHT Fountains in Trafalgar Square, London. Exposure was based on the highlight areas so most of the surroundings were plunged into darkness. Photograph by *Peter Stiles, Britain*.

plane is parallel with that of the original. Set the correct distance between the camera (with close-up lens) and the original by suitably extending and straddling the tripod legs. To prevent the tripod and camera from toppling over, suspend a heavy weight by a string from the tripod head. Copying requires even illumination of the original without reflecting direct light into the camera lens. In daylight the centre of a bay window is ideal; for artificial light set up two lamps in reflectors to either side of the camera, shining down on the subject. For copying on colour slide film use the correct film type for the prevailing lighting. With black-and-white film, appropriate filters may be used to emphasise the colour contrast between tones of similar brightness value but different colour − for instance red and green (see page 130). A reflex camera with interchangeable lenses is versatile for this kind of work, especially as the reflex finder shows the precise subject field covered and permits accurate focusing, see also page 170.

FIREWORKS Set up the camera on a tripod or firm support, pointing at the area of the sky where the firework display is to take place. Avoid including moving sources of light such as motor cars. Set the shutter to B, the lens aperture to about $f8$ and mount a cable release on the camera. Then open the shutter and keep it open while a few rockets go up and burst. Close the shutter again, advance the film and record a few more rockets or fireworks. If your camera has provision for retensioning the shutter without advancing the film (circumventing the usual double-exposure lock) you can also open the shutter as one rocket goes up and close it again afterwards, then open once more for the next rocket and so on. Either way you collect half a dozen or more single bursts in one picture for an impressive display. Fireworks are particularly attractive on colour film, but use a high-speed material. Artificial light type colour slide film tends to record more varied colours of fireworks, but daylight type film can also be used.

FLOWERS AND PLANTS For close-up studies a simple camera needs a close-up lens (see page 76); you also need a tripod, table tripod or similar support. For a leisurely procedure it is easiest to set up the camera on its stand at the right distance from the flower − either outdoors or in. As in other near-range photography, focusing and viewing is easier still with a single-lens reflex camera; there you may in good light even dispense with a tripod and take the picture by approaching the flower at a fixed

distance setting (for instance of a macro-focusing lens) until the image appears sharpest on the screen. There is rarely much point in photographing flowers and plants in black-and-white; all their interest lies in the hues and contrasts of petals, foliage and detail. Flowers and plants should preferably be photographed where they grow, but they may have to be isolated from the surroundings, for instance by choosing a suitable viewpoint and clearing the ground near the subject. Watch both foreground and background, as blurred parts of other plants included in the picture may spoil the effect. A sheet of light grey paper attached to two sticks may be used as a neutral restful background. Set it in a slight curve around the flower to serve at the same time as a wind shield. Avoid hard midday sunlight; diffused hazy sun is usually best. A hand mirror may be useful to reflect light into shadow areas. Keep exposure times short to avoid possible blurring from the movement of the plant in the wind. Sometimes flowers look particularly attractive when photographed against the light, with the lighting transilluminating the petals and leaves with a soft glow.

GROUPS Organise people in small and casual groups rather than large formal arrangements (football team style). Some sort of occupation serves to join a number of people together in the garden, around the tea table, at sports. Or group them roughly together, let them talk to each other but do not let them look into the camera. Pretend that you have taken the picture, then expose when the group actually relaxes again. To avoid nearer people hiding those behind them, a higher viewpoint (chair etc.) may be useful − provided it is not so high as to make the view unnatural. Avoid taking too large groups with a small-format camera. Equally avoid covering big groups from nearby with a wide-angle lens (if your camera takes alternative lenses). In both cases individual faces enlarged out of the group are likely to appear too grainy. In addition, wide-angle views of groups tend to show peoples' heads distorted near the extreme edges of the picture. Professional group photographers use special big cameras for this kind of work. Diffused lighting outdoors, preferably in shade, is ideal. A weak fill-in flash may improve rendering of the faces. Indoors the easiest lighting for groups is bounce flash (page 146).

INTERIORS Views of the interiors of rooms, halls and buildings should aim to convey something of the architectural style, decoration and the taste of whoever arranged the place. The

210

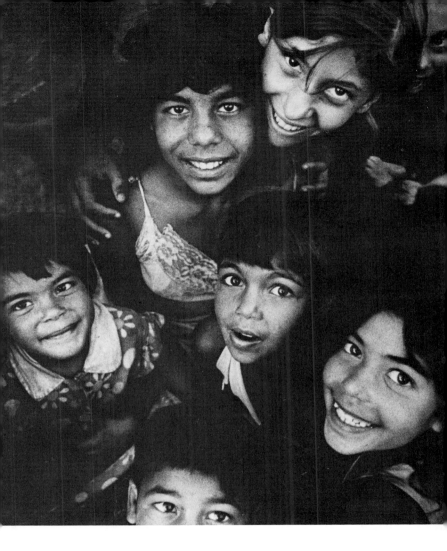

CHILDREN In the best pictures, children display a natural liveliness with spontaneous expressions. Do not ask them to pose but just keep shooting and catch their responses to you even if you need to sacrifice a little sharpness. Photograph by *Jiri Horak, Czechoslovakia.*

subjects can range from small rooms, nooks and corners to big salons, halls and interiors of a whole building such as a church.

With most cameras the best way to go about this is to select small sections and corners of the room with furniture to show the latter and the setting to best advantage. For the normal lens cannot cover more than about a quarter of what we believe we can take in by gazing around a room – without even turning our heads. The scope is greater with an interchangeable-lens camera; there you can fit a wide-angle or even ultra wide-angle lens to take in more of the place. Keep the camera level (film plane vertical) for all such shots to avoid the appearance of walls toppling over (converging verticals). This becomes particularly important with a wide-angle lens where irregular perspective emphasis is much more noticeable. The camera will nearly always have to be supported on a tripod as exposure times are likely to run into several seconds at least. This is not normally a problem with stationary indoor settings.

As indoor lighting tends to be weak, you will usually have to arrange supplementary lighting. Soft diffused outdoor light coming in through windows is ideal, as it brings out details more clearly without too heavy shadows. In public buildings, churches etc. you can sometimes get striking pictorial patterns by making use of sunlight streaming through windows. Such pictures can however look very patchy with large areas of unrelieved deep shadows. A fill-in flash often greatly helps. Flash is also useful when the scene includes a wall with a window through which an outdoor scene is visible. Treat this in the same way as an outdoor sunshine subject with fill-in flash, applying the rules described on page 148 for balancing the daylight and fill-in flash. With this combination you can use daylight type colour film. Avoid however tungsten illumination for filling in, combined with daylight; with any kind of colour film this produces incompatible casts.

General views of interiors will mostly need small lens stops for adequate depth of field – another reason why a tripod is indispensable. Allow also for the reciprocity failure effect with long exposure times (page 166). A good way of lighting large interiors with flash, for instance in a church, is to set up the camera on a tripod, open the shutter at the B setting and lock it open. Then fire flashes from various locations, well hidden from the camera position, to light up details of walls, architectural features, decorations etc. In the absence of daylight you can also do that with a lamp, though here you may have problems with the power supply cables. When photographing in colour use an

artificial light type film with lamplight. A simple way to get even, shadowless illumination with one lamp only is to hold the lamp in the hand and swing it slowly in large circles on either side of the camera towards the part of the area to be photographed.

LANDSCAPES Distant landscapes rich in small detail generally tend to be disappointing in black-and-white. So are those consisting mainly of green tones e.g. meadows with woods in the background. In fact, unless you want to create specially dramatic light and shade effects, landscapes in black-and-white are invariably very dull compared with views in colour.

Broadly, we can group landscapes in three kinds: (1) Views of wide expanse conveying the breadth of a scene; (2) landscapes with prominent foreground objects, trees, buildings etc. receding into the background; and (3) views of predominantly near items, trees, bushes, forest glades etc. The first kind is typical of a view from a hilltop. It should however still have some foreground objects of known size, for instance trees, to provide a measure of distance and create an impression of depth. This type of view often looks particularly impressive if taken with a camera that takes a wide-angle lens. But you should then view the picture either as a really big enlargement or projected on a big screen (see page 174). As such views depend a lot on delicate detail, they are rarely successful with very small camera formats (e.g. pocket cameras).

Landscapes with prominent foreground — of the second kind above — are the commonest and also the easiest to take. The foreground may be a few buildings, trees, a bridge or a road leading to perhaps a village, castle etc. in the middle distance. Such views have solid depth enhanced by the geometrical relationship of near and distant objects. By choosing a high viewpoint you may be able to disentangle an otherwise confused view; a low viewpoint on the other hand increases the importance of things near the camera. The skyline, too, may be raised or lowered according to whether you want a low or high camera position. Even tilting up or down is permissible as long as you keep the camera otherwise level and no buildings are included in the view to give you away. Tilting upwards emphasises the foreground and diminishes the background; a downward tilt — necessarily from a higher viewpoint — gives more of a bird's eye view. This type of view is at its best in full sunshine, especially in colour, and looks best in front or sidelighting. This also provides the most brilliant colours. An overcast sky yields more degraded and duller colours. Landscapes in black-and-white look better with more contrasty

lighting, either from the side or even from behind the subject. Use a lens hood with such against-the-light views and expose accordingly (page 113). Small-scale landscapes of type (3) above rely much more on lighting effects and mood. In both colour and black-and-white you can create that with side or back lighting, making for instance a branch of pale green leaves luminous against a shadow area or sky. Clouds in bigger landscapes can be made to stand out in black-and-white with a yellow filter; a deeper orange or even red filter emphasises clouds even more and cuts through haze. With colour shots a polarising filter can sometimes darken the blue sky (page 132). Landscape photography also includes shots in mist or fog conditions; there black-and-white pictures are often more effective.

MOONLIGHT You can take views by moonlight in much the same way as by daylight, but as the light intensity provided, even by a full moon, is about half a million times lower than of sunlight, the exposures required tend to get rather long. A landscape in bright moonlight without deep foreground would probably need about 10 minutes at $f5.6$ to get a properly exposed moonlight effect. Do not include the moon itself in the picture, as it moves noticeably through the sky during such a period and would thus appear distorted.

You can fake moonlight pictures in black-and-white by giving a very short exposure in sunlight and then printing the negative very dark so that only the highlights stand out. A red filter enhances the effect by rendering the sky almost black. Moonlight pictures on colour film, whether genuine or faked, show very little colour unless fully exposed. In theory at least, the colours should then look reasonably natural but the moonlight effect is lost.

MOUNTAINS Impressive distant peaks tend to appear miserably small with most normal cameras. You may be impressed by the towering majesty of a mountain seen across or behind an Alpine valley; the camera takes in the whole valley and cannot give the mountain the same importance. If you have a camera taking interchangeable lenses, use a medium tele lens to bring the peak back to its impressive size. Otherwise aim to show it in a setting that nicely frames it, for instance a few trees. A foreground object in a mountain view nearly always provides depth to make the picture more impressive. If the worst comes to the worst — with negative film (colour print or black-and-white) you can enlarge just a section of the picture to get a more concentrated

effect. If you go mountain walking or climbing you may have some opportunity for choosing different viewpoints. Generally, a mountain looks least impressive from its foot where you have to point the camera up to take in the peak. That tends to dwarf it, partly because you have a backward leaning effect similar to what you get when you point the camera up at a building. A mountain looks most impressive if you can get a shot of it from half-way up the hillside across the valley, preferably at about half the height of the mountain. At least that is a point to note on your maps as a suitable picture taking viewpoint if you are likely to pass that way.

Use a UV or skylight filter with colour film (colour print as well as colour slide) to reduce the excessive blueness of distant mountain views. In Alpine regions this filter even darkens the blue sky in black-and-white shots. Deeper filters (yellow, orange etc.) in high mountains make the sky very dark indeed on black-and-white shots. Whether you like that dramatic effect is a matter of taste. Such filters also cut through any remaining haze, making even distant peaks look very clear, but with less differentiation in depth. The darkness of the sky can be particularly impressive against glaciers. To darken the sky in colour shots use a polarising filter (page 132). This is most effective if the sun shines at right angles to the camera direction, for instance from the Southwest if you are pointing the camera Southeast.

MUSEUMS Museums, ranging from famous national to small, specialised or local ones, often contain immensely interesting items and exhibits. Many may be of interest to experts in specific fields but often exhibits are fascinating in their own right.

Three main points of museum photography are: firstly, that you usually need permission to photograph (and in some museums you won't get it); secondly, you have to take items as they are displayed and usually with the prevailing lighting (though you may sometimes be able to use flash); and thirdly, as lighting levels are often comparatively low, you need a tripod or at least a table tripod. Many items shown in museums are comparatively small pieces, and for such subjects a single-lens reflex camera preferably with a macro-focusing lens (with extended focusing range) is ideal.

Concentrate on single items rather than whole showcases. However interesting the items may be, a display case looks dull in a picture, You have ideal conditions if items are displayed singly in specially lit showcases, as is often the case with special exhibitions organised by a museum. For such shots mount the

reflex camera on a table tripod and hold the latter against the front of the show case for steadiness. Exposures may run up to a second or two. Focus carefully on the reflex camera screen. Measure the exposure with the camera's through-the-lens metering system. Use artificial light type colour film when taking slides. Items in ordinary glass cases are more difficult both to isolate and to light individually. Your best bet is often an electronic flash — if permitted by the museum — shining at the object a little from one side. Wherever possible, point the camera straight through the glass of the case and the flash at a 45° angle to avoid reflections into the camera lens.

Single larger items displayed in the open are often easiest to photograph even with a simpler camera. Use the prevailing natural lighting if possible, mounting the camera on a tripod (again subject to permission) for what may sometimes be a longish exposure. If the main lighting is from above, use a small flash as a fill-in light for the shadows. This can even be combined with a time exposure. Pictures in museums are nearly always record shots of the items shown and there is rarely much scope for or point in dramatic lighting effects. On the other hand use colour film whenever possible, as decorations, even in only one or two colours, greatly add to the interest of the picture if rendered in colour.

NATURE PHOTOGRAPHY To *photograph birds* the best place and time is at the nest and early in the morning or before 3 o'clock in the afternoon. For such pictures the camera and photographer usually have to be hidden from sight in order not to scare the bird away. To photograph, for instance, a song bird at a nest in a bush, set up the camera at a suitable position for the lighting during the time you propose to wait for the bird. Tie back any branches that might obstruct the view, set up the camera with its tripod and focus on the nest. A camera with a tele lens or tele attachment is useful as you can keep it further away from the nest and still get a close-up view. Then hide the camera and yourself behind an efficient and camouflaged screen and wait for the bird to arrive. This may need considerable patience. Some birds, such as buzzards, kites or crows may be attracted by a bait. Good sites are small pools in woods where birds bath, and the seashore and mud flats at low tide. Most of the successful work is done from hides which may have to vary according to the surroundings. If you cannot use a hide, a remote-controlled release may be useful. This is easy if the camera takes a motor drive or winder as you can then release the camera and advance the film by just pressing a switch 10 metres or more away.

Getting birds in flight is largely a matter of luck and persistence. Larger birds with a slow wing beat are easier to photograph than small ones. As the movement, even then, is relatively fast and the distance mostly short, use the fastest possible shutter speed, for instance 1/500 second. This is sufficient if you are not too close and the birds are approaching the camera; otherwise use 1/1000 or even 1/2000 second. A good hunting ground is the seashore where sea birds can be attracted by bait. For good results you need the fastest film and bright weather. To sight and keep flying birds within the viewfinder an open frame finder is often better than either a normal or a reflex finder. Such frame finders show what goes on outside the camera's field of view as well; they are produced for a number of cameras and fit in the accessory shoe.

Mammals such as otter, badger, fox, pole-cat, stoat, weasel, squirrel, mouse, watervole, hare, rabbit, deer etc. have a strong sense of smell and are shy. Study their habitats to find the best position for the camera. As many mammals rest during the day, the early moring and evening hours are the most likely times to catch them. Always photograph from down wind. If bait is used, any kind of flesh will attract the fox, honey the badger and fresh fish the otter. Tele lenses are a great help in getting sufficiently close as you can rarely photograph at less than 5 metres or 15 feet. The exposure time for animals in normal movement (if not chased) varies between 1/60 and 1/500 second at about 5 metres. Use the fastest colour film or high speed black-and-white, as most exposures will have to be taken in the early or late hours of the day.

NIGHTLIFE This normally needs a camera with an extra fast lens — maximum aperture $f2$ at least. As your subject is mainly snapshots in completely unpredictable light conditions, measure the exposure with a meter. With an automatic camera use the largest aperture and check that the shutter speed is not too slow for a hand-held shot. If the meter's field of view includes much dark area, decrease the exposure reading shown — by one stop if deepest shadows occupy about one-quarter to one-half of the field of view or by one and a half stops if more. Take such nightlife subjects without attracting more notice than necessary; subjects in the streets may resent being photographed, while in restaurants and other locations the proprietors may object. Preset camera settings as far as possible so that you only have to lift the camera and shoot in an instant.

NIGHT OUTDOORS For static night subjects out of doors any

camera is suitable but you need a tripod or suitable stand. With a small aperture (ƒ16) and a high speed (400 ASA) film the exposure will be around 1-3 minutes depending on the available light. The small aperture with its relatively long exposure time will not record occasional passers-by. However, cover the lens while cars or buses are passing the field of view. The total exposure may thus be made up of a number of partial exposures. Use a lens hood to shield the lens against stray light. Floodlit buildings, lighted shop windows, brilliantly lit shopping centres need even shorter exposures. See also page 154 and table on page 168.

PANORAMAS You can cover a panorama view by making a number of exposures with the camera turned through an angle about its axis every time. This angle should be about 80 per cent of the horizontal angle of view of the camera lens. This yields slightly overlapping views which can then be joined up as a continuous round-the-horizon print. Generally, about ten to twelve pictures cover a 360° panorama. You can, however, do with less if your camera takes interchangeable lenses and you use a wide-angle lens. A useful accessory for panorama photography is a panoramic head mounted between the camera and the tripod. The camera easily turns on this head while a degree scale shows the extent of turning. The camera must be absolutely level to enable the individual shots to be linked up as a straight panorama. Do not attempt panoramas with excessively small picture formats such as that of a pocket camera.

PORTRAITURE For portraits of people do not be afraid of going close. A photograph that is half landscape with a figure placed halfheartedly somewhere in it is not a portrait. With most cameras about 1.2 to 1.5 metres or 4 to 5 feet is the most useful portrait distance; it still brings the head reasonably large in the picture yet is not so close as to exaggerate the perspective. If your camera takes interchangeable lenses or a tele attachment — or even has just a switch-over tele setting — a distance of 2.5 to 3 metres or 8 to 10 feet is better still. Note also that most viewfinders other than the screen of a single-lens reflex show a little more than you get on the film. So keep the more important parts of the picture that must be included away from the edges of the finder view. The background to a portrait should be comparatively plain — the sky or a neutral wall without too prominent a pattern are ideal. Keep the wall or similar backgrounds well behind the subject and set the lens carefully to the correct

subject distance. With a large aperture you then keep the background unsharp — one of the few occasions when you do not want depth of field.

One major problem in portraiture is that people being photographed tend to be self-conscious about it, especially when asked to smile or to hold certain expressions. A good way of making the sitter relax is to give him or her something to do — read, smoke, play or work — and then watch for the opportunity to capture characteristic expressions. For this candid approach to portraiture do not try to economise on film. You may need to go through a dozen or so exposures before the sitter even begins to relax. On cameras that take it, a motor drive or motorised winder allows you to take snapshot after snapshot without paying much attention to the mechanics of camera operation.

Out of doors the perfect light is hazy sunlight, strong enough to give modelling to the face yet soft enough to avoid harsh shadows. In particular avoid strong midday sunshine; if you cannot avoid it, use a fill-in flash to lighten the hard shadows (page 148). You can also take portraits in the shade of a building, though there the light is duller. In colour portraiture watch for coloured reflections from walls and other areas not actually included in the picture. Morning and afternoon sunlight are useful, particularly when the sun shines from the side and slightly in front of the subject. If you have no fill-in flash, a large white sheet of cardboard can also serve to lighten deep shadows.

For indoor portraits by daylight keep as near the window as possible. A bay window is ideal as it provides light from more than one side. Point the camera from a direction where about three-quarters of the face is in the light. In good daylight the lighting level is then also adequate for a reasonably short exposure. With a normal window the somewhat one-sided lighting casts heavy shadows; light these with either a large white reflector on the shadow side or with fill-in flash. Alternatively place the sitter facing the window, with the camera in front of or to one side of the window. If two windows are available in one wall, place the person between them to be lit from both the front and the back. Again a reflector or fill-in flash should lighten the shadow side. Set up the camera either parallel with the windows or pointing slightly away from them into the room. If you have two windows at an angle to each other, place the sitter in the corner between them and looking into the room. In this case place a reflector facing the corner (or again use fill-in flash).

For flash on its own you should have at least two flash units

or bulbs; one coming from slightly above and to one side of the face and the other on the camera as fill-in lighting.

Indoor portrait setups with one or two lamps allow more choice in location and background as you are no longer dependent on the position of windows. The background can be a plain wall, a sheet of light or dark fabric stretched taut or simply the frame of an open door leading into an unlighted room. Keep the head at least 1 metre or 3 feet in front of the background. If you use only one lamp, point this from above and slightly to one side of the face, with a reflector close by on the shadow side to fill in the latter. With two lamps use one as the main light source and the other, further away, to lighten the shadows. Different lamp positions can give different effects, so do not be afraid of moving your lights, or the subjects or the camera. For home portraiture high-power tungsten-halogen lamps are ideal and are available in various forms for this purpose. They not only yield sufficiently intense light for short exposure times but also match the colour balance of artificial light type colour slide film. For colour portraits do not however mix tungsten lighting and electronic flash or flash cubes, nor tungsten lighting with daylight. With these light sources exposure times of around 1/30 second are often possible at a large to medium aperture. To hold the camera still, support your elbows on the back of a chair that you are straddling. This is less formal and hence more relaxing for the sitter than a camera on a tripod.

SEASIDE Use a low viewpoint for impressive waves or near views of sea grass against a background of water and sky. A high viewpoint, the top of a cliff, shows the stretch of a coastline photographed against the light, with the water glittering and shining. You may tilt the camera down to get a lively impression of the pattern produced by the back-flowing water in the sand. But do not bother about the steamer coming up over the horizon; it will appear as a mere pinpoint on the film. Snapshots of anything alive with 1/125 second and f11 with 125 ASA film should give well-exposed pictures in sunshine. For close-ups make use of zone focusing. Use a UV filter with colour film to avoid excessively blue results. With black-and-white film a light yellow filter makes the sand lighter against a darker sky while an orange filter gives more dramatic cloud effects. Always use a lens hood to protect the lens against glare and reflections from the water as well as from the sun. Keep the camera well clear of sand which easily creeps into shutters and other parts of the mechanism. The safest bet is to keep the camera always in a tightly closed plastic bag

and remove it for picture taking only away from the sand after you have thoroughly wiped all sand off your fingers. Change films away from sand, too, and in the darkest spot available. The preponderance of light tones areas on the beach may mislead the meter cell into indicating too short an exposure; generally you need half to one stop more (next larger lens aperture or next slower shutter speed) — see page 111.

SELF-PORTRAITS Some cameras have a so-called self-timer or delayed-action release. This is a small clockwork mechanism (sometimes an electronic circuit) that you set before releasing the shutter. If the camera is set up on tripod or stand, you can then press the release and the camera on its own makes the exposure about 10 seconds later — giving you plenty of time to rush in front of the camera and sit down in a prepared spot. Primarily this self-timer is useful for photographing groups, for instance the family at a picnic where after these preparations you can take your own place in the group.

For self-portraits proper, waiting for the self-timer to run down often prevents you from relaxing. A better method is to use a pneumatic release consisting of a small device like a cable release that screws into the camera's release button. This is connected by a thin plastic tube that might be 3 to 5 metres (10 to 15 feet) long, to a small rubber bulb. When you press the latter it operates the cable release plunger to take the picture. This way, you can yourself operate the camera at the moment you think best. It is an easy matter to run the plastic tubing so that it is hidden from the camera lens. If your camera takes an electric remote release, that is better still. As a refinement you can set up a large mirror next to the camera to watch and control your own expressions. Use lighting setups similar for normal portraiture but be sure to preset the camera to the right distance. Measure this accurately beforehand, possibly with a stand-in in the chair or spot you are going to sit or stand.

SHOWS Photography at the theatre, ballet, circus and to some extent floor shows at night clubs can be photographed with 400 ASA film and a camera with lens of $f2.8$ or faster. The technique varies with the type of show, the lighting conditions available and the camera position. Coloured lighting is particularly tricky as it tends to be too dim for successful exposures. Permission to photograph is required at all shows — often freely given in circuses but frequently refused in commercial theatres.

For theatre photography (where permitted) it is useful to sit

through the show once to assess potentially interesting moments for photography. That applies especially to ballet. A seat in the front circle, not too near the centre, or in a box reasonably near to the stage is ideal. A tele lens of sufficient speed is also useful if your camera takes interchangeable lenses. If the stage does not fill the whole film area but leaves a proportion of darkness, adjust exposure meter readings accordingly: give half a stop extra if about one-quarter or one-third of the finder area is black; give one stop extra if half of the area is black surround. (You are usually wasting your time taking pictures if the stage is smaller than half the image area on the film.)

Photography from the auditorium is usually more successful with music hall or ballet — you get colourful groupings and costumes — than with straight plays where the view may take in two or three small people on a big stage. As shutter speeds usually have to be slow, capture moments of relative rest on the stage, for instance the climax of an aria in an opera. Smaller groups of actors are more easily taken during photo calls, which you are more likely to be able to attend with an amateur show. If you have some stage lighting available, you can illuminate such groups with two or three lamps. When photographing with colour slide film use an artificial light type film.

Ballet involves a similar technique for big groupings on the stage. Exposures are particularly difficult for high spots of a duo of the leading ballerina and her partner for this is often tightly spotlit and the small spot of light against a large black stage completely upsets the exposure meter. Instead, measure the exposure beforehand when the whole stage is lit up and work with the same settings for the spotlit turn. Again a tele lens brings the figures a little larger within the huge stage area. Try to capture dead points (page 60) and fairly stationary poses rather than wild leaps. The latter would need electronic flash to show the figures sharp, something you can, again, only do during a photo call.

At the circus a seat in about the fourth or fifth row from the ringside and at 90° to the main entrance to the ring generally offers the best viewpoints. The clowns, single animal turns, ground level balancing acts are reasonably straightforward subjects; trick riding turns need faster shutter speeds than you can afford in the available lighting. A ring too full of animals tends to be too busy pictorially. Highwire turns and trapeze artistes are often too far away to be impressive in snapshots.

Ice shows are often very well lit but more difficult to photograph as the almost continuous movement is likely to show at least part of the action unsharp.

In nightclubs and for floor shows try to get a seat as near to the stage or floor as possible, but not in the centre. A single-lens reflex camera with a fast lens — preferably of medium-long focus — is ideal. Correct the exposure indicated or set by the meter according to the amount of dark space in the picture — as for stage photography above. Use fastest film, artificial light type for colour slides.

SNOW AND ICE Snow and ice, which might seem to be colourless, are not so to photographic material. That is especially so in the Alps where the snow reflects a great deal of UV radiation. Snow pictures in colour thus easily tend to become too blue, especially if the sky is blue and cloudless. A skylight filter gives a better result, and should be used with colour print as well as colour slide film. Unless you have a few brilliant coloured elements, for instance colourful clothing of skiers, snow is however a subject that is often at least as successful in black-and-white. Here a yellow filter is usually advisable to improve the contrast between white snow and bluish snow shadows.

Wide open snow views are usually disappointing in the picture (see also landscapes, page 213), especially with the small picture format of pocket cameras. Near distance and close-up shots are more satisfying. The cold glittering brilliance of snow and ice, particularly close up, is best brought out in strong side light or, better still, backlight. Meter readings in snow need some correction as the meter thinks that you want the scene to average out to a mid tone. So give about one stop more exposure than the meter indicates. With a fully automatic camera use the +1 stop backlight correction or override.

SPORTS Sports photography is mostly action photography, frequently involving fast movement and requiring short exposure times. From the photographic approach, sports events may be team sports (e.g. football, ice-hockey), fixed-location contests (for instance tennis where players move within a well defined area), races of various kinds (individual speed events like ski-ing as well as horse, car and track events) and athletic displays.

In most massed team sports you are as a spectator located at some distance from the action on the field. In a stadium you can only hope to get telling action shots with a tele lens on a camera that takes interchangeable lenses. With less formal matches, for instance soccer, where you can stand on the sidelines, preselect a suitable sharpness zone at say 6 metres or 20 feet with a large aperture (usually necessary to permit a fast enough shutter speed)

and shoot only when the action becomes sufficiently interesting at about the right distance. Similar considerations apply to hockey and ice-hockey. With cricket or baseball you can concen-centrate on the batsman at the wicket or on the plate. Focus on that spot and try to capture the instant of a hit. That usually menas pressing the shutter release a little earlier (see page 60).

In tennis and similar games the location of much of the action is reasonably predictable. You can again select a specific focusing distance in a zone where a player appears to spend most of his time. This you find after watching play for a while. Needless to say, intimate aquaintance with the sport or game is essential if you want to photograph it.

Races, from athletics to ski-ing, also involve competitors passing well defined spots along a route or track. Take up a position near a spot that promises interesting action, for instance the gate of a slalom race. Focus on the spot where most of the skiers do their turns and wait for the competitors to run past. Again anticipate the moment of exposure. Photographed against the light, where the location allows it, the shower of snow thrown up can be very impressive. When shooting racing contestants passing a given spot, preferably choose a viewpoint where the racers are coming towards you at an oblique angle. That usually gives more interesting pictures than contestants running or driving across the camera's field of view and also permits slower shutter speeds. Note also that arms and legs move at least twice as fast as the athlete's body as a whole. At more important spectator sports races, including major athletics, motor races etc. you are unlikely to be admitted to the best viewpoints for action shooting, as these are generally reserved for press photographers. A tele lens on an interchangeable-lens camera again brings you close to the action from more distant spectator stands. Use a monopod to steady the camera, as pictures taken with tele lenses are more liable to show the effects of even slight camera shake.

Athletic displays, either singly or in teams, are easier still to focus as the athletes hardly move from the spot. Many sports displays, for instance gymnastics, have prominent dead points in their movement cycles. By capturing those points you can work with a slower shutter speed if light conditions are tricky.

With many sports, capturing effective pictures depends on hitting the right moment, which even with trained anticipation can be a matter of luck. If your camera takes a motor drive and you don't mind using up a lot of film, picture sequences of the action, for instance a gymnastic display or an attack on the football

field, multiply your chances of obtaining an ideal shot of a telling or dramatic moment.

STORY SEQUENCES It's surprising how a set of pictures of an occasion, for instance a family picnic, always attracts more interest than a single shot. Part of the reason is, of course, that it presents more aspects of the event and more faces of the same and of different people – which always makes them appear more alive. You can make picture sets or sequences of innumerable subjects, presenting different moods and variations or create a natural or sometimes even contrived story line. If you take numerous pictures of a person during a portraiture session while talking and arguing with your sitter, the resulting film is likely to include quite a few good natural poses and expressions. Assembled together, these give a kind of photo interview. A natural sequence might be the progress of a sandcastle being built on a beach or the cat investigating a mysterious parcel that has arrived on the doorstep. (You can contrive that one by wrapping a piece of fish inside.)

TRAVELLING WITH THE CAMERA Decide beforehand what you are really likely to need and travel as light as possible. That applies especially if you have an extensive camera outfit with several lenses and other accessories. Generally a wide-angle lens of about or just over half the focal length of the standard lens and a tele lens of 2 to 2½ times that focal length are the most useful ones. You may however have specific preferences for other lenses to tackle particular subjects (for instance a macro-focusing lens for close-ups of plants or butterflies). Take a good supply of your favourite film with you, unless you know that it is easily obtainable at your destination. Carry also spare batteries for the camera's exposure meter system, for the flash unit and other ancillary gear.

Carry your camera where it is reasonably free from vibration or heat. Not recommended places in a car are the glove compartment or rear window ledge. Pack the camera and its outfit into a hold-all case of the appropriate size – the smallest that will take what you are carrying with you. That way you can pick up the whole outfit at once, for instance if you leave your car parked. When travelling by air keep your films – both exposed and unexposed – in your pockets rather than your luggage, especially at airports where security examination of luggage includes X-ray irradiation, as this is liable to fog films. But be sure you know which of your films are exposed and which are unexposed. This

is fairly obvious on cartridge and roll films; a useful way to mark 35 mm cartridges is to wind the film leader fully into the cartridge. Check your insurance, if any, and see that it covers the full value of your equipment, the duration of your journey and the area where you are going.

Take plenty of pictures, looking out for local features or peculiarities, even if they are not exceptionally pictorial. You will find them intriguing in future years when the journey is almost forgotten. Finally, take notes of what subjects you are photographing where, as it is difficult to identify anonymous locations or buildings weeks or even months later. A miniature cassette recorder is sometimes less cumbersome for this purpose than a note book.

TROPICAL PHOTOGRAPHY The lighting in the tropics tends to be more contrasty than in the temperate zones, especially in the middle of the day when the sun is directly overhead and shadows are deep and harsh. Allow for these shadows in exposure readings by suitably increasing the exposure (see page 111).

Tropical climates also call for special care in handling equipment and materials. Both heat and humidity adversely affect films. Even in airtight (tropical) packing, films should not be kept longer than 6 months in the tropics. Where feasible, store films in a refrigerator. Once a film package is opened, it should be exposed and processed within a week or two. After exposure in the camera, films should be processed within a day or two if the climate is very hot and humid. Films should stay in the camera for as short a time as possible. While waiting to process them, keep films in an airtight container with a moisture-absorbing material such as silica gel.

Keep the camera dry and clean, protect it against sand, dust and insects. Leather parts should be wax-polished, metal parts lightly greased. Never leave the camera unnecessarily exposed to heat; keep it in its case whenever possible, with the lens covered with a lens cap. When not actually in use, store photographic equipment in an airtight metal box or tin also containing a bag or two of silica gel, and seal the tin with adhesive linen tape.

Film processing in the tropics needs special developers and hardening baths to protect the film layers.

WOODS As in landscape photography, concentrate on detail; select for instance a small group of trees standing out against a background of cloudy sky. That will suggest more than a whole wood. More worthwhile but technically more difficult are scenes in woods: a few tall tree trunks, between which the rays of the

sun cast interesting light patches on the undergrowth, the slowly clearing morning mist etc. Such pictures greatly depend on light coming through the trees, often photographed against the light which shows up the rays of the sun against the dark background and eliminates irritating detail. Woods and particularly undergrowth are comparatively dark even on a bright day, and the predominating brown and green tones swallow most of the incoming light. Such subjects therefore need comparatively long exposure. With colour print or with black-and-white negative film correct exposure readings as for contrasty subjects, or read the brightness of darker subject detail to obtain a correct exposure. For pictures on colour slide film take a close-up reading of a bright patch of sunshine and multiply this exposure by about 4 to 6 (2 to 2½ lens stops larger).

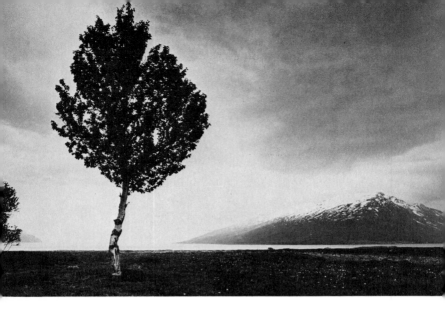

THE FINAL PRINT It may be easy to produce a well-finished picture from a particular negative. But even this can often be improved. Sometimes it calls for a little shading here, or printing in there, to balance up the tones. This 'juggling' of the enlarger light is the art of making fine prints and the well-executed result will seem almost to glow on the paper. Photograph by *Pentti Paschinsky, Finland.*

THE FINISHED PICTURE

The rest of the story after the film leaves the camera

Getting Your Pictures Processed

The painstaking manipulation of images of light with complex equipment and elaborate techniques has so far in fact only produced a potential and not an actual picture. The film carries invisibly this latent image; further effort and other skills are needed to turn these fleeting impressions of light into visible negative and positive pictures.

These skills are in fact so different that it makes some sense to leave this job to specialists – laboratories that spend all their time developing films to bring out the images we have recorded with light, and in making prints and enlargements. After all, once the picture is taken, its appearance is largely determined. Indeed, in the beginning it is easiest to let others process your films while you get used to the technical side of photography and to recording and capturing events and life around you. Eventually you may be tempted to do yourself part or all of the job of turning the exposure on the film into a finished picture. Even if you are not, it is worth knowing what goes on during processing. That knowledge may help you also in specifying precisely what you want when you order prints or enlargements.

COMMERCIAL PHOTOFINISHING

The simplest way of getting your films processed is to take them to a photo dealer who in turn usually sends them to a photo-finishing laboratory. This operates like a tightly organised industrial factory. The films, identified by order numbers, are run through automatic processing machines in which various chemical solutions act on the sensitive layer or layers to make the image visible. After fixing (to make the picture permanent), washing and drying the films run through automatic or semi-automatic enlargers where photocell systems determine the printing exposure for each negative and set the colour correction to yield a reasonably neutral balanced colour print. The prints are processed in continuous paper rolls, cut up to single pictures and come back to you via the photo dealer, together with the film negatives. Colour and black-and-white films differ in the chemical treat-

ment they receive but not in the basic handling in the photo-finishing organisation.

This treatment is very standardised and does not allow for individual variations. Thus you get back enlargements of a standard format, possibly about 9 cm or 3½ inches wide and anything between 10.5 and 12.5 cm or up to 5 inches long, depending on the original negative format. Also the prints are from almost the whole negative; you cannot select just part of the picture. And you are expected to order prints when you take your film to be developed, because the operations are more economically handled that way. If you have the film developed first, and only then select which negatives you want printed, it costs you more per print. (However the photofinishing laboratory does not normally print negatives that are completely under or over-exposed and could never yield a recognisable picture).

These prints are mass produced, usually of reasonable quality, though occasionally not as good as they could be – because with the large-scale production operation involved it is impossible to make allowances for individual deviations from a broad standard.

Such mass-produced prints are primarily a guide by which you can assess whether the negatives are worth enlarging to bigger prints. And you can order such enlargements, too, and at that time specify more precisely how much of the picture you want included. These better quality enlargements are necessarily more expensive and this is the point where doing the job yourself will begin to look attractive and interesting.

Colour slide films are handled somewhat differently. With some makes of film the cost of processing is already included in the price you pay when you buy the film. There you send the exposed film back to the processing laboratory – often run by the manufacturer of the film himself – and eventually receive back the processed colour slides. Usually they are already mounted in card or plastic frames ready for projection. With other films where processing is not included in the purchase price, you take the film to a photo dealer in much the same way as a print film – but again you get framed transparencies back and not prints.

MORE FUN THIS WAY

Taking films to a photo dealer for processing is acceptable if you are too busy to do it yourself or if you only get the camera out of the bottom of a drawer to bring back a few snaps from your holiday. Once you become more engaged in photography, you will soon find the limitations of mass-produced prints irksome:

the fact that you are stuck with one or two standard sizes, that you cannot select part of a negative or that the colour rendering isn't quite what you feel it should be.

Well, you can get a great deal of satisfaction out of hours spent in developing and enlarging your own films. For there the pictures are really your own all the way. And you will find that you can still do quite a lot to control the effect of a picture by the way in which you enlarge it. The enjoyment you get from this more than compensates for any failures. What do a few fuzzy negatives, a few dull prints matter if they are all your own work? The method may be laborious but it is much more fun.

THE USUAL PROCEDURE

Handbooks on photography that teach the beginner how to process the results tend to adopt a very similar approach. First you are shown how to obtain a negative from the exposed film and then how to make enlargements from the negative. Now this is a nice logical procedure, because of course you must have a negative before you can get a positive from it. But even so, it is not necessarily the best way of going about things if you are just starting.

For if there is anything risky about photography it is above all the developing of the film. The sensitive layer on the film is very delicate; that of papers is much tougher. And if in the course of development there is a little too much here and not quite enough there, the negative is already damaged if not spoilt. And a lost negative means that everything else is lost, too. A spoilt print on the other hand is by no means the end of everything, for you can easily make another one from the negative, this time without mistakes.

A NEW SUGGESTION

From the above consideration comes the somewhat unusual suggestion to turn the logical sequence of events back to front. By all means let a photographic dealer develop your films, and possibly even make standard prints. Begin your own part of the business by making your own enlargements. And when you are an old hand at this, you can even develop your films yourself.

This method, the opposite of the one usually recommended, is indoubtedly the safest. It leads you step by step from the easier to the more difficult operations and arranges things so that mistakes and failures inevitable at the beginning do not affect the negative, which is often irreplaceable, but only the print.

START WITH BLACK-AND-WHITE

One other suggestion is that you should start by making enlargements from black-and-white negatives. You may be using virtually only colour film but in making enlargements from colour negatives you have to cope with two quite different sets of techniques: projecting a negative on a sheet of printing paper and exposing this correctly — and manipulating filters and colour tests to get the colour balance correct. You can do the first without the second, but not the other way round. It is easier to learn the job by tackling the stages separately. And if this teaches you something about seeing subjects in terms of just light and dark tones, it will also add to your grasp of creative photography.

Two aspects of processing you should leave to photofinishing laboratories altogether; these are colour slide films and pocket format or ultraminiature films. The processing procedure for colour slide film can be very lengthy and cumbersome, involving perhaps half a dozen different chemical baths and numerous intermediate stages all of which have to be accurately timed and take place at very precisely controlled temperatures. That, frankly, is where the fun of it may well become a chore. And if you have already paid for processing, anyway, why bother?

The problem with pocket camera films is that the tiny negatives are particularly fiddly to handle. First results are liable to be more disappointing than with larger film sizes. Some processing laboratories use specialised enlarging equipment to get better results with this very small format. At least you should have a practised hand in dealing with bigger negatives before you plunge head first into ultraminiature film handling.

THE ART OF STARTING MODESTLY

Photography in our age has become not only a major world industry but also part of almost every science and technology, associated with immensely complicated and expensive equipment considered necessary to produce prints and enlargements. In fact, the basic processes of film developing and printing are surprisingly simple. True, you may need automated machinery if as a photofinisher you churn out hundreds of thousands of prints every week. If on the other hand you just want to spend an evening to enjoy yourself with making your own enlargements, you don't need any of this — even if you could afford it.

For black-and-white enlarging you can start with very simple gear. The few items that you do need will carry you through for a long time — even into the first steps of colour enlarging. There is no need to spend a fortune on equipment.

233

Making Black-and-White Enlargements

WHAT YOU NEED

As we are going to start with basics, let's do it with the minimum of equipment. Essential items are:

an enlarger;
a darkroom lamp;
developing dishes;
processing solutions;
enlarging paper.

These items you cannot do without if you want to make enlargements. Not quite so indispensable but highly desirable for a minimum of working comfort are the following:

a masking frame;
a timer;
a thermometer;
print forceps.

THE ENLARGER

This is virtually the only costly item of equipment. It is essentially a projector held on a vertical column to project down onto a baseboard to which the column is attached. The projection system of the enlarger head consists of a lighting setup (usually a lamp and condenser), a negative carrier to hold the film negative and a lens in a fitting to focus the projected image on the baseboard. The bigger the enlargement you want, the higher

up you move the enlarger head on its column; for smaller enlargements you bring it down lower.

That, despite all the refinements available on some enlargers, is really it. If you are buying an enlarger you will of course need one that takes at least negatives as big as your camera uses: up to

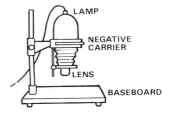

24 x 36 mm for miniature camera users, up to 6 x 6 cm for roll film and so on. An enlarger for a bigger format can always enlarge from smaller film sizes as well, but is likely to be slightly bulkier than one designed just for 35 mm film. Some enlargers you can easily take apart. They usually separate into enlarger head, baseboard and column. This is useful if you haven't enough space to keep the enlarger permanently set up and want to store it in a small space.

Two important recommendations: first, get the best enlarging lens you can afford. An enlargement can be no sharper than the enlarging lens allows. And if you have a high quality camera lens, it is a pity to waste its performance with a poor enlarging lens. If you eventually switch to a better quality or more versatile enlarger, you can always continue using a high class lens you bought in the first place. Second, get an enlarger that you can convert to colour work later on – for instance by adding a colour head. Such enlargers don't cost much more than simple black-and-white models, and you save money when you want to try colour enlarging.

ENLARGING PAPER AND DARKROOM LAMP

To make the enlargements you project the film with its negative pictures in the enlarger on to a light-sensitive enlarging paper. This records the image in much the way that the film recorded the picture in the first place, and turns the tone values round again: after development the negative image becomes a normal-looking positive picture.

Enlarging papers come in various makes, sizes, surface finishes and grades. The makes differ in some picture characteristics. For instance, one may give a neutral black image, another a slightly

warmer one. For quality, you cannot go wrong with the leading brands, so start with one of those and stick to it until you have become expert in making your enlargements. Then you can try other papers and see how prints look on them.

It is more fun to make enlargements reasonably big, for instance, 13 x 18 cm (or 5 x 7 inches). If you are more ambitious — and can afford it — you can buy your paper stock in 20 x 25 cm (or 8 x 10 inch) size. That you can cut down to half size, 12.5 x 20 cm (or 5 x 8 inches) or even to quarter size, 10 x 12.5 cm (or 4 x ·5 inches). But if you do that, buy a guillotine print trimmer. It cuts sheets much more neatly than scissors.

To start with, stick to one paper surface. Glossy or lustre paper (sometimes called semi-matt, velvet etc.) are easiest to handle. Buy resin-coated or plastic-coated paper — this again, is easier to handle in the beginning than old fashioned plain enlarging paper. Finally, buy 'normal' or No. 2 grade paper as well as 'soft' or No. 1 and 'hard' or No. 3. We'll come back to the need for these grades.

Enlarging paper is sensitive to light, but not equally sensitive to all colours. You have to expose and develop it in a darkroom so that only the light of the projected image reaches the paper to record a picture; any other normal light would ruin the picture.

You can see what you are doing and handle the paper by the weak light of a darkroom lamp. This may be a specially coloured light bulb or a lamp housing with a safelight filter — generally orange or olive green — in front of it. The paper manufacturer's instructions will tell you what kind of safelight filter you need. But never handle papers or prints directly under such a lamp — always keep a distance of at least 1.2 to 1.5 metres (or 4 to 5 feet).

DISHES AND CHEMICALS

Processing a print involves treating it succesively in three solutions: a developer to make visible the exposed image in the print, a stop bath to neutralise the developer and a fixing bath to remove residual light-sensitive salts to ensure print permanence. The

treatment takes place in dishes. You will need a separate dish for each solution and it is always best to keep each dish for the same solution. You can get processing dishes in colour-coded sets for easy distinction. Get dishes one size larger than the biggest prints you will normally make — for example 25 x 30 cm (10 x 12 inches) if you intend to make a lot of 20 x 25 cm (8 x 10 inch) enlargements. Dishes should be at least 4.5 cm (or 1½ to 2 inches) deep.

The best way to buy processing chemicals is in concentrated stock solutions. The instructions with the enlarging paper usually recommend specific developers, stop baths and fixers, but most standard enlarging papers can be processed in most standard developers etc. Dilute the solutions as indicated on the bottles, using a measure. Avoid powdered chemicals at least at first; they may be trickier and messier to handle.

OTHER AIDS

A masking frame simplifies location of the enlarging paper on the baseboard, holds the paper flat and masks down the image to exactly the area you want.

A timer helps to time exposures as well as processing. Simplest and cheapest is a loudly ticking clock; you time exposures by the tick. (It doesn't matter whether they are exact seconds or not — as long as you always use a 'tick' as an exposure timing unit.) Keep the clock near the darkroom lamp to watch development times. More elaborate timers may be wired into the enlarger switch: you select the number of seconds and the timer switches the enlarger on, and then off again at the end of that time.

A thermometer is useful to check that solutions are not too cold or too warm. Black-and-white print developer should be at about 20° C or 68° F. Get a thermometer graduated from about 10 to 50° C or 50 to 120° F.

Print forceps allow you to transfer prints from one dish to the next without getting your fingers wet. Keep one set of forceps (of different colour) in each dish. To avoid solution contamination never dip the forceps into a solution other than its own.

SETTING UP

For enlarging you need a room that can be efficiently blacked out and which, preferably, has running water. A bedroom or guest room with a basin is ideal; a bathroom will do if the rest of the household puts up with the place being occupied for a whole evening. Naturally, if you use a bathroom you should observe

the usual safety precautions where water and electricity are concerned. Evening is a good time for enlarging, a room is easier to darken then and heavy curtains over the window will quite efficiently keep out street lighting. But many other darkroom locations have been used successfully, even broom cupboards.

Set up your equipment to reach everything easily, separated into a dry and a wet section. The dry section (bench, table etc.) carries the enlarger, paper packets and enlarging accessories; the wet section holds the solution bottles and the processing trays and accessories. Cover this bench or surface with waterproof plastic etc or, better still, stand the dishes in a large shallow drip-tray to catch drops of spilt solution.

Make up the developer, stop bath and fixer as instructed and check the temperature. In cold weather dilute the solution concentrates with lukewarm water. First, prewarm the room to around 20^{o} C or 68^{o} F — solution temperatures will then stay constant. Set up the darkroom lamp to shine mainly on the processing dishes — but at least 1.2 to 1.5 metres (4 to 5 feet) away.

FIRST TRIAL

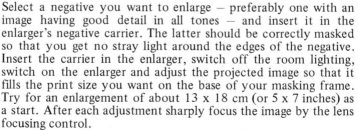

Select a negative you want to enlarge — preferably one with an image having good detail in all tones — and insert it in the enlarger's negative carrier. The latter should be correctly masked so that you get no stray light around the edges of the negative. Insert the carrier in the enlarger, switch off the room lighting, switch on the enlarger and adjust the projected image so that it fills the print size you want on the base of your masking frame. Try for an enlargement of about 13 x 18 cm (or 5 x 7 inches) as a start. After each adjustment sharply focus the image by the lens focusing control.

In enlarging you can of course arrange for any selected part only of the full image to come within the print area on the masking frame. Being able to crop the picture in this way is one of the big advantages of making your own enlargements.

First make an exposure test.

Take a sheet of 13 x 18 cm (5 x 7 inch) enlarging paper, cut it in half lengthways and place it across the centre of the image in the masking frame on the enlarger baseboard. (Do this with the enlarger lamp switched off and only the darkroom safelight on.) If the negative looks fairly brilliant, use a normal (No. 2) paper grade; if the negative appears soft, use a harder (No. 3) grade. Have ready a sheet of opaque card at least 15 x 10 cm (6 x 8 inches) or larger, and prepare to count seconds (or 'ticks' of your darkroom clock). Set the enlarger lens to about f 5.6 or f 8.

Switch on the enlarger and start counting. After 4 seconds cover up about 1 inch of the paper strip from the end with the opaque card. After 6 seconds cover up a further inch, then another inch each time after 8, 12, 16 and 24 seconds. Switch off the enlarger after 32 seconds. That gives you a test strip of approximately 1 inch steps, each of which has received, on average, 40 per cent more exposure than the previous one.

DEVELOPING THE TEST

Push the exposed test strip, emulsion side up, into the developer in the developing dish. Move the strip about with the developer forceps or by gently rocking the dish. The image will appear at one end of the test strip after about half a minute and gradually get darker. Continue development for at least 2½ to 3 minutes at around 20° C (68° F), then lift out the strip with the developer forceps, allow the developer to drain off for a few seconds, and drop the strip into the stop bath. Do not immerse the developer forceps in this bath; instead handle the print now with the stop bath forceps, swishing it round for about 10 seconds. Lift out, allow to drain and drop into the fixing bath dish — again without immersing the stop bath forceps.

Move the strip about in the fixing bath with the fixer forceps. After about a minute you can turn on the white light to look at the result. (Before switching on the light check that you have no unexposed paper lying about open).

If the image across the strip covers a reasonably representative part of the picture, one of the steps will appear to be more or less correct. By counting from either end you can establish the exposure time you used for this step.

Make another trial exposure on the other half of the paper strip, this time with what seemed the best exposure on the test strip. Develop as before and look at the print in the fixer by white light. If the test appears too light or too dark, you can then adjust the exposure for the final print.

If all the steps on the original test were too light, try another test with all exposures multiplied by 6 (e.g. starting at 24, 32, 48, 64 seconds). If all steps are too dark, stop down the lens by 2 stops for a further test strip.

THE FINAL PRINT

Having established the correct enlarging exposure you can now make the final enlargements. Recheck the sharpness of the image projected on the masking frame, switch off the enlarger, place the enlarging paper in position and switch on the enlarger for the required time. Immerse the exposed print in turn in the developer, stop bath and fixer, as with the test strip. Be sure to move the print about in each solution all the time. Keep it in the fixer — if you are using a high-speed fixer — for about 2 minutes, then wash for about 5 minutes.

This applies to resin-coated papers. A useful way is to do it in a handbasin full of water with the outflow partly closed and water flowing in at the top at the right rate to balance the drain at the bottom. At the end of the washing time lift out the print, wipe off surplus water and lay the print down face up to dry on a clean sheet, table cloth etc.

The fixing and washing times are not critical, and you can expose and develop a fresh print while the previous one is in the fixer or rinse.

Ordinary (not resin coated) papers need a longer final rinse — an hour won't do any harm. But you can then collect the prints after fixing in a large dish or even bucket of clean water until you are ready to wash a batch. This is less advisable with resin coated papers which should not be subjected to prolonged wet treatment.

WHAT IS THE PRINT LIKE?

If all has gone well, you should have obtained a good enlargement. That means, it should show a full range of tones from just short

of pure white to almost, but not quite, full black. In particular, you should recognise detail in the very light as well as the very dark areas.

The most obvious faults — apart from unsharpness (due to inaccurate focusing of the enlarger, shaking the enlarger during exposure or an unsharp negative) — are wrong exposure and wrong gradation.

To judge whether the exposure was right, check the light tones. If these are white and chalky, the shadows medium grey without any full black, the exposure was too short. If, on the other hand, the highlights are veiled over and appear grey, and the shadow details too dark to be seen, the exposure was too long. (If you hold up such a print to a bright light you often see more detail in the shadows.)

For gradation, check both highlights and shadows of a correctly exposed print. If the image shows full detail in the lightest and darkest tones, yet looks brilliant, the gradation is right. If you see full detail in all tones but no really light highlights nor really dark shadows, the print is too soft. You then need a harder paper grade. And if the tones, from almost white to full black, are there but the picture lacks tone detail in the light and/or dark tones, the contrast is too great — you need a softer paper grade.

When you have obtained what you think is a reasonably good enlargement, it is instructive to make a range of similar prints with different exposures (15, 30, 40 and 50 per cent less than the correct exposure — and 20, 40, 70 and 100 per cent more). Also make a set of enlargements on the different paper grades — at least one grade softer and one grade harder than the best enlargement, and in each case with 20 and 40 per cent less and also more exposure than correct.

This sounds like wasting a lot of good enlarging paper, but it gives you once and for all a set of prints on which you can follow the changes in the picture appearance from under to over exposure and from soft to hard gradation. With that you can establish at a glace how near subsequent test strips or prints are to being correct — and in what direction you have to correct exposure and/or contrast.

After a while you won't even need this aid any more and you will learn to assess the quality of a print or any required correction at a glance.

NEGATIVE SELECTION AND CONTACT SHEETS

An enlargement cannot be better than the negative from which it is made. So you should carefully select the negatives you are

going to enlarge and ruthlessly eliminate all unsuitable ones. That does not mean cutting them out of the strips of 3, 5 or 6 exposures that were returned to you after development. For those films should remain in their complete strips — they are easier to handle that way. However, mark your negative in some way (eg: with a small notch in the film edge) so that you know which you want to print and which you don't.

Select your negative by two criteria.

Firstly, eliminate technically poor ones. That means looking at every frame of film through a magnifying glass to check whether it is sharp. Also at this stage weed out badly underexposed (too thin) or overexposed (excessively dense) negatives — they very rarely make satisfactory prints and are worth keeping only if they represent absolutely vital and unrepeatable shots.

Secondly, you may want to eliminate exposures with pictorial faults: a self-conscious smirk on Johnny's face or a picture with a telegraph pole growing out of his head. Often such aspects, especially facial expressions, can be judged only by looking at a positive print. If you are still getting your films developed by a photo dealer, the standard 7 x 10 cm mass-produced enlargements are useful for such an assessment. Less expensive for the same purpose are contact sheets or contact strip prints of the negatives, often also available as a service from the photofinisher.

Alternatively, you can make such contact sheets yourself. Place the strips of negatives with emulsion side down on a sheet of 20 x 25 cm or 8 x 10 inches enlarging paper on the enlarger baseboard (not the masking frame this time) and cover with a clean sheet of flat plate glass. This of course you do in the dark. Then switch on the erlarger — without the negative in the carrier — so that the 'cone' of light covers the whole of this paper with its negatives on top. An exposure of about 10 to 20 seconds with the lens at $f5.6$ or $f8$ should be about right for an average enlarger. Then process the print in the usual way.

A 20 x 25 cm sheet of paper will accommodate six strips of

six 24 x 36 mm negatives or, crosswise, five strips of five exposures; alternatively, you can cover the sheet with three strips of four (or five of three) 6 x 6 cm (2¼ x 2¼ inch) negatives.

Such a contact sheet will not of course show every positive as a perfectly exposed miniature print (unless all negatives are absolutely similar in density and graduation). But you will usually see enough detail to check expressions, pictorial arrangements etc. If some negatives print much lighter than the others, you may want to make two contact sheets with different exposures and check out the best shots on each. Look at the contact prints with a magnifying glass and mark on the sheet which negatives you want to print. You can identify these later on the strip by the edge numbers, which also print through on the contact sheet. But don't rely on checking the sharpness from contact prints (or even mass-produced enlargements); do that directly on the negative with a good magnifying glass.

WHAT OF MORE ADVANCED AIDS?

For this summary of enlarging practice we have assumed that you are working with minimum essential equipment, and that is precisely what it is. There are numerous aids that make the operations of enlarging more convenient and that you may acquire when you feel you need them and can afford them. Here is a quick run-down of the more useful ones:

A focusing magnifier is valuable to check exact focus of the projected image. The best types focus at about 20 x magnification on the actual negative grain.

Enlarging exposure meters measure the projected image brightness on the paper or masking frame to indicate or control a correct exposure. They work in various ways, but with all you must first make a perfectly exposed print from a standard negative by trial and error methods to calibrate the system.

Print washers handle papers in the final rinse, ensure efficient water circulation and stop prints from sticking together.

Print dryers speed up drying of the washed prints, usually from overnight to about 15 minutes. There are different types for resin-coated and ordinary papers.

Roller processors are more expensive units that automatically run the exposed print through the developer, stop bath and fixer for the required time. That saves messing about with solution trays. But the prints must still be washed and dried in the normal way.

An automatically focusing enlarger keeps the image in sharp focus on the baseboard as you raise or lower the enlarger for

bigger or smaller prints. This speeds up operation if you make many prints. But the automatic system must be in very good adjustment and also allow for the thickness of masking frames etc.

HINTS AND TIPS

ENLARGING AND EXPOSURE TECHNIQUE

For precise focusing of the enlarged image you need a sharp negative. You can buy focusing negatives of fine line patterns, but you can also make one yourself from a spoilt very dense or all-black negative: with a fine needle, scratch a crisscross pattern of lines into the emulsion surface, then focus the enlarger with the aid of this focusing negative. When the sharpness is correctly set, replace by the negative you want to enlarge.

Even the sharpest negative and most careful focusing yields unsharp enlargements if you allow the enlarger to vibrate during the exposure. So don't walk about in the darkroom while exposing. Also, switch the enlarger on and off with a separate switch and not one mounted on the instrument. An electric exposure timer also gets over this problem.

Before you decide on the format of the final enlargement, try cutting down the projected image area with a pair of black L-shaped cards to concentrate just on the important picture elements. Such cropping can greatly improve the picture by eliminating distracting detail. When you think you have what you want, adjust the magnification to bring that part of the picture within your planned print size.

Nor do you have to crop straight. A gentle skiing slope can become a breakneck descent by taking an oblique section of the picture. But perpendicular objects may give the trick away. Don't overdo it, gravity has a knack of giving objects a certain pose that indicates at once what really is vertical.

DODGING AND OTHER CONTROLS

Even when you have done your best in selecting the optimum paper grade and exposure, there may be portions in a picture that appear too light or too dark compared with the rest. (Increasing or decreasing the exposure would in turn make the rest too dark or too light, respectively.) A useful solution is selective exposure control, also known as dodging, shading, spot printing, burning in etc. Suppose a foreground shadow portion prints too dark when the rest of the picture is right. Here is how dodging works:

Establish by test strips the correct exposure for the dark

244

shadow portion and for the rest of the picture. Say this is 12 and 20 seconds, respectively. Start the enlarging exposure and after 12 seconds move your hand (or a piece of card) into the projected light beam so as to throw a shadow onto the portion that came out too dark before. Keep this shadow going until the full 20 seconds are up, then switch off the enlarger. This 'holds back' the exposure for the too-dark area, lightening that part of the print to match the rest. Keep the hand or cardboard shading aid gently moving during the exposure to avoid an obvious outline to the dodged area.

Where small image portions are too light, for instance an extra bright catchlight, you may have to shade most of the picture with a large opaque card that has a hole just big enough to let through the light to this area which needs more exposure.

During enlarging you can also correct to some extent pictures of buildings that appear to fall over backwards because the camera pointed upwards when you took the shot. The falling-over effect arises from the convergence of vertical lines in the image. The simplest way of correcting that is to raise the masking frame with the paper at the side of the image where the lines diverge until these verticals appear parallel again and the building straight. The best way, if the enlarger allows it, is to tilt the negative carrier at the same time in the opposite direction. Match the negative and the paper tilts till the image is evenly sharp all over the masking frame surface. (If you cannot tilt the negative carrier, stop down the lens to a small stop, otherwise the image won't be evenly sharp.) Such a corrected print needs more exposure at the end that is further away from the lens than at the other end, so you may have to dodge it gradually from one end to the other.

PAPER CHOICE

Negatives – like subjects –vary a lot in tone range: a harshly lit scene may have brilliant catchlights (very dark on the film) and deep shadows (faint in the negative); a slightly underexposed shot may cover little more than a few just distinguishable greys. Yet in a print we expect both to cover tones from nearly white to nearly black. We can do it by printing such different negatives on different grades of enlarging paper. The very-thin-to-very-dense negative needs a so-called soft paper grade, the grey-and-grey one a 'hard' paper. Most paper brands have numbered grades, and average negatives yield good prints on No. 2 or No. 3 paper. No. 1 is a soft grade for very contrasty negatives, No. 4 or 5 are hard to extra-hard for really thin and ethereal ones (unless you deliberately want ethereal effects). In the beginning it helps to sort negatives

by the grade of paper they are likely to need; after some experience you will be able to tell at a glance by just looking at the film.

Apart from enlarging papers available in separate grades there are also variable-contrast papers that yield higher-contrast prints when you use a yellow filter in the enlarger and softer prints with a blue filter (or vice versa). By splitting the exposure between blue-filter and yellow-filter periods this permits almost unlimited fine control of print gradation.

Further, papers are available with various surfaces. Commonest is glossy which best shows up the full tone range of a picture and is therefore preferred for enlargements destined for reproduction in newspapers, books etc. For prints to be looked at directly, a semi-matt or lustre surface is often more pleasant. Alternatively there are various texture surfaces (silk, grained rough paper etc.) for more artistic effects. The choice of paper surface is largely a matter of taste.

You can also create a texture photographically by combining the negative with a so-called texture screen – a negative of a texture pattern, available from photo dealers – and enlarging this combination together.

PRINT PROCESSING

Do not overwork the processing solutions. If the tones of the developed print become warmer brown or even greenish, the developer is getting exhausted.

An overworked fixing bath no longer fixes prints fully, even when acting for a long time, so that prints may after some time discolour or acquire stains. Check the processing capacity of your developer and fixer from the instructions packed with it.

Do not overwash resin-coated papers, as otherwise the water penetrates into the edge of the paper and may cause blistering. Ordinary papers without resin or plastic coating however need long washing to remove all chemicals from the paper fibre as well as from the emulsion. Here a soak, after fixing, in a 2 per cent solution of sodium carbonate aids subsequent washing.

Ordinary papers (without resin coating) tend to curl up strongly during drying on their own and you have to straighten them by carefully pulling them backwards over a table edge. A print dryer, different types are needed for ordinary and for resin-coated paper, greatly speeds up this process and yields flat prints.

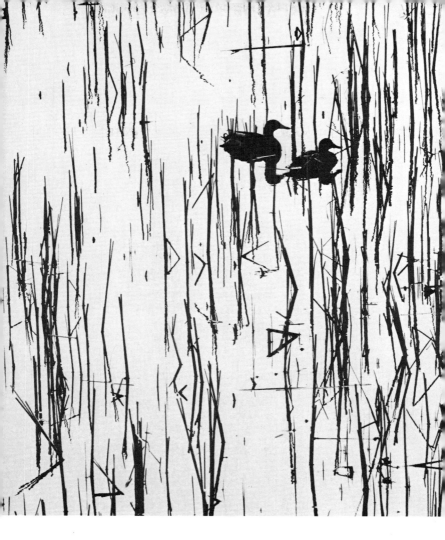

CONTRAST High contrast printing sometimes suits the subject. In this case the sharp silhouettes were strengthened in density by printing on a hard grade of paper. Tone in the water was virtually eliminated by the paper's inability to cope with wide variations in negative contrast. Photograph by *Raymond Lea, Britain.*

Making Colour Enlargements

HOW COLOUR DIFFERS

The mechanics of making a colour enlargement from a colour negative are much the same as for a black-and-white enlargement from a black-and-white negative. You again project the negative in an enlarger onto a printing paper — a colour printing paper this time — focus it accurately, determine the correct exposure and expose, then develop the print and pass it through the rest of the processing sequence. There are however a few differences in the optics and the chemistry.

The optical difference is that the colour of the enlarger light determines what the colour print will look like. So we have to control this light colour with filters placed in the light path. This is a versatile way not only of correcting the colour rendering of the picture but also of obtaining deliberate special colour effects.

The chemistry of colour processing is a little more complex in theory than that of black-and-white, but with modern colour processing kits the procedure is hardly more difficult. The chemicals must, however, be specifically matched to the colour paper you employ, and manufacturers issue individual processing kits for this purpose. Temperature and handling may need to be more precisely controlled and it is therefore advisable to process colour prints in drums rather than dishes (page 250).

COLOUR ENLARGERS

Nearly all present-day black-and-white enlargers have a filter drawer; this is a compartment located somewhere between the light source and the negative, into which you can place gelatine or acetate colour printing filter sheets. This provides a simple way of colour control in making colour enlargements. The filters are available in sets in three colours — yellow, magenta and cyan and in six or seven depths or densities in each colour, making some 21 filters in all. The densities are labelled with numbers such as 05, 10, 20 etc. The light of the colour enlarger is modified by inserting one or more filters of one or two (but never all three) colours and the filtration designated for reference by letter and number combinations. For instance, if for a colour enlargement

you needed a filter density of 40 in yellow and 15 in magenta, this is written as 40Y + 15M. Note that the 15M is in this case obtained by combining a 10M and a 05M filter; similarly you can get higher filter densities with higher combinations, for instance a 50Y and a 40Y filter give a 90Y filtration value.

The numbers themselves are a rough guide to filter depth, but are consistent only within any one make. A 40M filter of one brand is not necessarily comparable with a 40M filter of another. If you stick to filters of one set, this need not worry you.

Switching different filter pack combinations in a drawer is slow and inconvenient. The more modern way is therefore to use a colour enlarger that has three filters built in — very dense yellow, magenta and cyan — and achieves different filter values by moving one or two of these filters progressively into the light path. This filtered light is thoroughly mixed in a diffusing or mixing box and reaches the colour negative as a flood of more or less yellowish, magentaish etc. light.

The enlarger components that differ for black-and-white and colour work are virtually all in the lamphouse, i.e. the section involved in illuminating the negative for projection. So you can with quite a few modern enlargers convert a black-and-white version to colour by replacing the black-and-white lamphouse by a colour head. This has the mixing box and filters all built in.

For more than the very occasional colour printing, such a colour head is a worthwhile investment. It saves the cost of a comprehensive filter set and takes a lot of the chore out of manipulating filters in the enlarger. You just turn three dials to obtain a continuous range of filter values from 01 or 05 to 100 or more in each colour. Also, the filters used in colour heads depend on so-called interference effects and not on dyes; hence these filters

are fade-proof. (Ordinary gelatine or acetate printing filters gradually fade and have to be replaced periodically.)

DRUM PROCESSING

Colour prints take rather longer to develop than black-and-white ones and the results are more easily affected by variations in temperature, solution exhaustion etc. This makes the black-and-white method of developing prints in three dishes both tedious and not very consistent. A much more reliable way uses a processing drum. This is a light-tight tubular container that takes the exposed print rolled up against the inside wall. You pour a small amount of solution into the drum, set the latter rolling to and fro on a table while the solution washes over the paper surface inside. After the necessary time the solution is replaced by the next one. Drum development not only saves chemicals (which are not cheap) but also can take place in ordinary lighting — apart from the insertion of the paper. The chemical solutions are used once and then thrown away, which further ensures consistent action. Colour processing is entirely controlled by time and temperature, which is just as well, as you cannot judge the effect of a print until it has passed through all the chemical processing stages. So watching the print in a dish in the darkroom would not help you. And the darkroom illumination that colour paper can stand is much more critical than the illumination you can use for black-and-white print materials.

Kits for colour enlargements from colour negatives consist of chemicals for a colour developer, a stop bath, a bleacher and a fixing bath; the latter two may sometimes be combined as a bleach-fix bath. Kits for various materials are produced by the paper manufacturers as well as by independent firms. With the first kind you are always sure that the chemistry is adapted to the latest type of paper — but independent kits are sometimes easier to make up (for instance by using only concentrated solutions).

Prepare the solutions exactly as indicated in the instructions with the kit and bring them to the recommended temperatures. This is important, especially with the colour developer, for accurately reproducible results.

A TRIAL PRINT: FILTER CORRECTION

The first step – to establish the correct exposure – is very similar to a test exposure series for black-and-white enlarging (page 238). After processing the test strip (see below) make a half-size test print with the correct exposure of a central portion of the picture, including as many easily identifiable colour areas (e.g. flesh tones, neutral greys and so on) as possible. Examine this print by daylight or daylight-quality artificial light (e.g. certain types of fluorescent tube lighting) to check it for colour balance.

This print is made without any colour filter in the light path (on a colour head, with the filter dials set to 0). It is, however, almost sure to have a colour cast – the colours may be too reddish, too greenish or have some other bias.

According to the cast choose the correction filter, or filter combination, required for a good print. If the test print has:

yellow cast: use yellow filtration

red cast: use yellow and magenta filtration

magenta cast: use magenta filtration

blue cast: use magenta and cyan filtration

cyan (blue-green) cast: use cyan filtration

green cast: use cyan and yellow filtration

The stronger the colour cast or tinge in the test print, the higher must be the filter density. Generally reckon on using a 40 filter to correct a very prominent colour cast, a filter density of about 20 for a medium cast and about 05 or 10 for a slight cast.

Next, make another part-area test print – similar to the first – but with the appropriate filter values in the colour drawer or set on the colour head. You must also increase the exposure to compensate for the filter factors; the actual factors for different filter densities are usually included with the set of filters or with the instructions for the colour head. Generally the exposure factors with yellow filters are negligible.

With every print or test print that you make, mark on the back of the paper the exposure time and the filter combination employed – for instance '15 seconds, 20Y + 10M'.

FURTHER CORRECTION

After processing this new print, again look at it in white daylight-quality light and compare it with the first test. If you were very lucky, the colour rendering may be just right. Usually it is still slightly out – possibly you may have overcorrected for the cast or introduced a new one. Normally the required filter corrections should be rather smaller than the first time.

The principle is as before, but with one difference: if you already have two filter colours in use and further correction appears to need a third colour, reduce two filter colours instead. For you should never have filters of all three colours in the enlarger — that only introduces a neutral grey density and increases the exposure without providing useful colour correction.

So here is the alternative way of correcting colour casts: If the print has:

yellow cast: reduce the magenta and cyan filtration

red cast: reduce cyan filtration

magenta cast: reduce yellow and cyan filtration

blue cast: reduce yellow filtration

cyan cast: reduce yellow and magenta filtration

green cast: reduce magenta filtration

The aim, always, is to end up with the lowest filter combination in two colours. For instance, if you arrive at a combination of 10Y + 45M + 15C, you can deduct a density of 10 from all three filter colours (= 35M + 5C) and still have the same correcting effect.

You may now feel confident enough to make the full-size print. If this sequence appears a little tedious, it is so only while you gain experience. With some practice you should soon be able to judge the required correction for a final print from just one intermediate test.

Once you have found the correct filter combination, it is likely to yield good colour balance on other negatives from the same film, at any rate with similar types of subject (for instance with other outdoor exposures if your first print was an enlargement of an outdoor negative).

While it is a little expensive in paper, it is worthwhile to get a good idea just what all the different casts look like. So, once you have as perfect a print as possible, make another six similar enlargements, but each with a deliberate cast of 30 density. Thus for a yellow print increase the filter density by 30M + 30C, to get a red print increase the filter density by 30C, for a magenta print increase by 30Y + 30C, for blue increase by 30Y, for cyan increase by 30Y + 30M and for green increase by 30M. (As you are here creating colour casts, you use opposite filter colours to when you have to correct a cast.) Remember also to eliminate a third filter colour if these combinations produce one, and to allow for the exposure factors.

Such a set of prints or 'ring around' from a subject with a full colour range is a great help in quickly identifying a colour cast and the required correction.

PROCESSING THE COLOUR PRINT

The two stages of colour enlarging that require darkroom illumination (usually the special safelight used is rather dimmer than permissible for black-and-white prints) are those when the colour paper is handled openly – during the exposure itself and during loading into the colour processing drum.

Push the exposed print into the processing drum from the open end, so that the print emulsion side faces inwards and the paper is bent around the inside of the drum wall. Often, the drums take quite large sizes. e.g. 20 x 25 cm or 8 x 10 inches or even larger. To process smaller prints you insert them with the aid of special guides or spacers and the drum may then take four or more such prints. When you expose and process tests you generally, however, want to process such tests one by one.

Once the print or test is in the drum, refit the lid. From this stage you can carry on working by ordinary light.

Be sure that you have a flat surface about 60 cm or 2 feet long and a little wider than the length of a drum available. Also have the processing solutions ready, each measured out in containers holding the correct amount of developer, stop bath, bleach-fix etc. for one drum charge. Depending on the size of the drum, this is likely to be between 60 and 150 ml.

Place the drum upright with the funnel opening on top and pour in the developer, Note the time, lay the drum down on its side and start rolling it back and forth over the table surface. Most processing drums collect the solution in a compartment underneath the lid while you pour in and release the liquid into the drum interior when you lay the drum flat. By rolling it back and forth the liquid then flows over the print surface held against the inside wall. That way, you make a little solution go a long way.

Carefully time the development step as recommended in the instructions with the chemical kit. At the end of the development time (typically about 5 to 6 minutes) immediately pour out the solution by inverting the drum and holding it over a bucket or other container. Pour in rinsing water or the next solution, roll the drum again for the required time, empty it, pour in the next solution and so on to the end of the process. Finally, open the drum and withdraw the print, then wash and dry in the same way as a black-and-white enlargement on resin-coated paper. (Colour papers are virtually all resin-coated.)

The process temperature is important in colour printing to ensure consistent results – for instance to get a final enlargement of the same colour rendering as your test print. With some

processes the required temperature may be quite high (up to about 40ºC) and there you may need a more elaborate setup that allows the drum to rotate in a water bath kept at the right temperature. Solutions are also kept at that temperature by immersing the measures in the same bath water. If you cannot afford an outfit that complex, select a process that runs at a more easily maintained temperature, for instance 20ºC.

Also cultivate a uniform rolling movement. As the amount of solution used is insufficient to cover the whole print surface all at once, the drum must rotate all the time to keep the liquid running over the paper surface.

COLOUR ANALYSERS

An increasingly popular aid to colour enlarging is the colour analyser. This is a photocell system that measures the red, green and blue proportions in the light coming through the colour negative, and on that basis indicates the filter correction required for a balanced colour print. It is based on the assumption that if in most colour pictures you were to scramble all the colours you would get a fairly neutral grey. That is true for about 90 per cent of general colour views taken outdoor and indoors. The 'grey mixture' of light coming through a colour negative in your enlarger is, of course, not really neutral. But if you know to what extent and in what direction it deviates from neutrality, you can compare this deviation with that from other colour negatives and in that way derive a required filter correction.

A colour analyser saves quite a lot of expensive colour paper and so pays for itself in the long run.

The detailed use of a colour analyser varies slightly with the different types available. With all of them you have to start with a perfectly exposed and colour balanced print made from a typical average negative exposed in the manner described above. You then measure the light coming through that negative in the enlarger — usually with a diffuser placed in front of the lens — and adjust the sensitivity of the colour analyser photocells until the analyser gives a zero balance reading. On the analyser you then set the filter values used for the perfect print. That completes the calibration procedure.

Once the analyser is calibrated, you measure a new or unknown negative in the same way and adjust the controls to a balance point. On these controls you can then directly read off the filter densities or setting required for a neutral print. Alternatively, you adjust the filters in the enlarger colour head until the analyser signals a balance point. The filters set in the colour

head are then automatically the right filters for the print.

Colour analysers need recalibrating when used on a different enlarger, with a different make of negative film, and with a different batch of colour enlarging paper. They can also be misled by anomalous subjects that do not correspond on an overall grey mixture. For instance a sunset scene is all reddish and should be so in the print. The colour analyser however reacts as if this redness were an accidental cast and will correct the print, making it look too bluish-green. Similarly, a white kitten on a green rug would in the print become a pink kitten on a greenish-grey rug. With such subjects you have to correct individually and not rely on the colour analyser.

THE COMPROMISE OF COLOUR

With careful enlarging and filter control you get colour prints of attractive effect and acceptably faithful colour rendering. You will not, in every case, manage to reproduce subject colours absolutely exactly — especially when dealing with artificially coloured items such as clothing, interior decoration etc. For colour film and colour prints are compromises: with just three dyes they try to recreate the immense range of natural hues and colours. You can reach a good approximation, but rarely perfection.

In practice that matters less than you might think. How well do you remember what exact shade of green the grass was in a landscape shot? And are you sure that the tree trunk was not just that brown it looks in the picture? So, in general, aim at results that look right rather than those that can be proved to be 100 per cent accurate. Exact colour rendering can be undesirable too: remember the reddish effect you get on daylight type colour film exposed by lamplight.

Colour print making is, however, the starting point of an immense new world of photographic experimentation. You can create innumerable effects by deliberately distorting colour hues with extreme filter settings, by partially overlaying pictures with different tones, by dodging or holding back image portions with pieces of filter foil — and many more. Try experimenting; it's a creative adventure in itself.

<div align="center">

HINTS AND TIPS

</div>

SELECT YOUR COLOUR NEGATIVES

Poor colour negatives cannot yield good prints. Weeding out of your negatives should be even more radical than with black-and-white. For underexposed and grossly overexposed black-and-

white negatives can still produce stylised effects when they are printed; in colour however the results are usually muddy and lifeless. Colour negatives print well only if they show distinct detail in all areas from the lightest to the darkest.

Colour negatives should be of average contrast; with colour papers you don't have a selection of contrast guides, so you must rely on having a suitable negative in the first place. And as negative processing is strictly specified as well, a correctly exposed film should yield the right kind of negative if properly developed (page 258).

BLACK-AND-WHITE PRINTS FROM COLOUR NEGATIVES

Even with colour film you don't always need colour prints. Black-and-white enlargements are as easy to make from colour negatives as from black-and-white ones. If the colour picture is one of predominant bluish and greenish tones, you can often enlarge the negative directly on a regular enlarging paper, then process in the normal way. For best tone rendering however, use a panchromatic enlarging paper (i.e. one sensitive to light of all colours), specially produced for this purpose. However, panchromatic papers need handling in almost total darkness or extremely dim darkroom lighting. The tones – especially skin tones, reds, orange and yellows – look much more natural compared with the rest of the image.

PRINTS FROM COLOUR SLIDES

There are also colour papers on which you can make enlargements from positive colour slides. This process differs from normal colour enlargements in two respects: reversed colour control principles and a different processing sequence. The latter in turn depends on the print material and process you are using; it may involve up to seven processing steps and solutions, including an intermediate exposure to white light. The practical handling in a processing drum is however the same as with normal negative-positive colour papers.

The exposure procedure of materials for enlargements from slides is straightforward. Make a stepped exposure test as already described and correct colour casts with filters during the exposure. The actual filter correction is however the opposite from that in normal negative-positive printing (see table on next page).

Further this type of material needs rather greater filter changes to produce a noticeable colour modification. For instance, with enlargements from colour negatives a filter density change of 05 noticeably affects the print and you usually think in terms of

filter changes of 10. With enlargements from slides you have to change the filter density by at least 20 to correct even a fairly slight excess colour.

Choose colour slides carefully for enlarging. Obviously they should be sharp. Avoid very contrasty slides with brilliant highlights and deep shadows. They may look glorious when you project them, but yield disappointing colour prints. The best kind of slide is one with soft tones and pastel colours with as few deep shadows as possible. Don't expect enlargements from colour slides to reproduce the brilliance and colour saturation of the original; that is often beyond the scope of colour papers. Such enlargements can, however, compare reasonably well with enlargements from colour negatives.

If you want to make many enlargements from a colour transparency, it is worthwhile having an internegative made (go to a large photo dealer or a professional colour processing laboratory). From that internegative you can then make enlargements in the normal way and often with better quality.

FILTERS FOR PRINTS FROM SLIDES

Cast on print	Increase filter densities of	Or reduce filter densities of
Yellow	Cyan + magenta	Yellow
Red	Cyan	Yellow + magenta
Magenta	Yellow + cyan	Magenta
Blue	Yellow	Cyan + magenta
Blue-green (cyan)	Yellow + magenta	Cyan
Green	Magenta	Cyan + yellow

And Lastly The Negative

EXPERIENCE ALREADY GAINED

As explained before, we have left the development of negatives to the last because a negative can be irreversibly damaged or even ruined by unskilful handling. In fact, film processing is the easiest operation of all, once you have gained a little experience in handling chemical solutions and timing processing steps.

The procedure is very similar for black-and-white and for colour negative films. In each case the sequence involves development, a rinse or (with colour film) a stop bath, and a fixer (with black-and-white) or a bleaching and a fixing stage with colour — often combined as a bleach-fix bath. Black-and-white and colour films differ in the actual solutions employed and also in the precision required in the timing and temperature control, especially of the developer. Further, a black-and-white negative developer suitable for one general-purpose film is almost always suitable for all other such films. Colour negative films need process-specific chemicals, though nowadays quite a number of different negative colour film makes are compatible with the same process kits.

Negative development — both black-and-white and colour — is an operation strictly controlled by time and temperature. The aim is to obtain negatives of reasonably constant inherent contrast where the individual brightness range only varies with subject range.

As in the case of enlarging, we suggest that you first try your hand by developing black-and-white negative films before going on to colour negatives. With black-and-white film slight variations in the development time and/or temperature modify the contrast and density of negatives obtained, but you can easily allow for that by printing on a different paper grade and by modifying the enlarging exposure respectively. Errors in colour development and/or temperature affect the contrast, density and the colour balance of the negative. The contrast you cannot compensate for, as previously mentioned, as colour printing materials are only available in a single contrast grade. Modifications in the colour balance mean that you will have to make more filter tests. Precise

control of the processing time and temperature ensures consistent colour negatives that need less filtration change in enlarging.

DEVELOPING TANKS AND CHEMICALS

The common way of developing negative film is in a film tank – a light-tight container that takes the films in a suitable holder. The tank is loaded in the dark (some tanks with more complex systems permit daylight loading); once the tank lid is closed you can continue in daylight and pour the solutions into the tank in turn for the required processing times.

For black-and-white films you need a developer and a fixing bath. Choose formulae that are available in concentrated liquid form – they are the most convenient as you only dilute the concentrate with water to obtain the working developer and fixer. If the developer you want to use is sold in packed powder form, dissolve the powder containers (there are usually two of them) one after the other in about three-quarters of the final volume of warm water. Stir thoroughly until the first powder is dissolved before adding the second one. With some developers you may have to dissolve the powders in separate lots of water and mix these solutions. Then top up to the final volume with cold water and filter the solution (for instance through a plug of cotton wool in a funnel) into a storage bottle.

The instruction leaflet with the film usually recommends an optimum developer formula and also indicates the required development time. Developers produced by independent manufacturers generally include a listing of the more popular films and required times.

For colour negatives make up the solutions of the processing kit – developer, stop bath, bleach and fix (or bleach-fix) as instructed with the kit.

The developing tank usually consists of a black plastic body, a lid that screws on which is light-tight and reasonably solution-tight but contains a charging funnel, and a push-on cover that closes the funnel opening. The tank body takes a film holder – usually a spiral reel with a groove running from the outside to the centre. Such reels exist with different separations between the flanges to take films of different widths (35 mm, No. 120 etc. roll film). With some tanks the reels are adjustable for different film sizes. Sometimes sheet films may be accommodated in special holders that fit into the tank like the reels. If you have a lot of similar films to develop, a multiple tank taking two, three or more reels at once saves time.

Learn to load film in total darkness. Apart from the loading

operation, all the rest of film processing takes place in normal light. Any permissible darkroom safelighting that is safe for high-speed films would be so dim that you would see nothing by it anyway. But practice loading the tank with a dummy film by ordinary light — use the practice film you got for loading the camera (page 105).

The usual procedure is to open the film cartridge, take out the film, trim off any shaped leader, and push the beginning of the film into the spiral groove of the reel. With roll film unroll the backing paper of the exposed roll until you reach the film itself, then start charging the beginning of the film into the spiral groove in the same way. Continue feeding the film into the reel until it is all spooled in. Often the two halves of the reel can turn slightly back and forth against each other to ease the film evenly into the groove. Then cut off the other end of the film from the cartridge spool or backing paper, insert the loaded reel into the tank and screw down the tank lid tightly.

When practising this, lay out the tank components, reel etc. carefully in front of you so that you can get hold of any part without looking for it. Once you have the knack of the operation try it again with your eyes closed. Once you have that pat, you can start on a 'live' film to be processed.

THE PROCESSING SEQUENCE

Have the right amounts — according to the tank capacity — of the developer, clean rinse water and fixer ready in separate measures. With a thermometer check that the solutions are at the recommended temperature. Pour in the developer, immediately fit the plastic push-on cap over the funnel opening and invert the tank back and forth three or four times. Tap the tank gently on the table to dislodge possible air bubbles from the film, let the tank stand for half a minute, then invert and return to normal at once. Repeat this every half a minute during the development time.

At the end of the development period remove the push-on cap (*not* the tank *lid*), pour out the developer into its container, pour in clean water at the right temperature, refit the cap and invert back and forth a few times. Pour out the water, pour in the fixer and repeat the inversion procedure. After about 10 minutes in the fixer you can open the tank lid and carefully lift out the reel. Check whether the film still appears to have any milkiness on it (don't unwind it from the reel). Keep the film in the fixer, periodically lifting out the reel and putting it back again, for about double the time the milkiness takes to disappear.

Pour back the fixing bath into its container and wash the film.

The easiest way is to stand the tank in a wash basin and run water into the centre opening by a rubber hose, so that the water runs down to the bottom of the tank and up again through the turns of the film on the reel. There are also special film washing accessories that make this stage more efficient.

Normally wash black-and-white films for half an hour, then remove from the reel and attach a film clip to each end. Take care not to scratch the wet film — it is particularly delicate at this stage. Hang the film up to dry in a reasonably dust-free, and undisturbed, room.

COLOUR NEGATIVE PROCESSING

Colour negative processing needs greater temperature and timing precision. The simplest way of getting the temperature right is to fill a medium-size bowl with water of the correct temperature, then stand the loaded film tank (before any solutions are poured in) and the prepared containers with the processing solutions in this bowl. Adjust the water temperature by adding hot or cold water until it is a degree or two above the required process temperature. Check this with a thermometer *in the developer*. Prewarming the tank as well makes sure that the developer temperature does not change when you pour the solution in.

At the start of development pour in the developer fairly rapidly and time development from the instant the tank is full. The end of the development period is the end of the pouring out process, so start pouring off the developer a few seconds before.

Apart from that, proceed in the same way as with black-and-white negative film, allowing of course for the fact that you probably have to handle one or two additional solutions.

THE FINISHED NEGATIVE

The negative cannot be judged accurately until it is quite dry, so don't try to handle it until then as the delicate emulsion surface is easily damaged. Examine the negatives by holding them up against the light. A moderately powerful magnifying glass (3 x to 6 x) allows you to judge sharpness and grain.

In a normal negative the thin parts (shadows) should show detail and should not be completely clear. The dense highlights (as tone values are reversed on the negative) should be sufficiently dense without being solidly black and show every gradation from grey to black. A well-balanced negative of this kind usually produces excellent prints on a normal grade paper. The shadow detail shows adequate exposure, the well-graded highlights correct development.

261

If the negatives are very contrasty with detailless shadows, this indicates underexposure. Such negatives rarely produce good prints. If, on the other hand, there is detail present in the shadows, excessive contrast is due to overdevelopment – either too long a developing time or too high a developer temperature. Such negatives need a soft paper grade to make satisfactory enlargements.

Sometimes a negative may be weak, with little contrast between shadows and highlights. If the shadows are veiled and also heavily covered, the negative was overexposed. Such negatives need long exposure times in enlarging and usually have to be printed on a hard paper grade.

Finally, if a negative image with detail in the shadows appears very light and thin, this indicates underdevelopment (too short a development time or developer being too cold). Such negatives need enlarging on a hard or extra hard (up to No. 5) paper grade and even then the quality is rarely acceptable.

Colour negatives appear similarly when they are incorrectly exposed and/or developed. In judging the negatives do not be misled by the orange tint over the whole film. Check the actual image detail in the thinnest and densest portions. While wrongly exposed or developed black-and-white negatives can occasionally still be salvaged, don't waste your time on poor colour negatives.

NEGATIVE CARE

Even when dry, film negatives easily collect small scratches, fingerprints and other flaws during handling. So cut up the film rolls into strips of negatives – five or six exposures per strip of 35 mm or three or four exposures of 6 x 6 cm. Then store these strips in transparent plastic sleeves or envelopes.

To store negatives systematically, use negative albums that hold film strips in similar sleeves, possibly with space for a contact sheet (page 241) that simplifies selecting and locating any given negative that you may want to enlarge.

HINTS AND TIPS

AGITATION AND TEMPERATURE

For consistent results cultivate a consistent way of inverting the film tank during development: turn it upside down and back again every half minute. But do it gently, don't shake the tank like a cocktail – or you will create air bubbles that might cause uneven action. You can only invert tanks that have a solution-tight lid and push-on cover. With older tanks you can move the

film by inserting a rod (through the funnel) to grip the reel and turn it back and forth.

Keep a check on the temperature: after filling the tank and making the first inversion, remove the push-on cover and insert a thermometer into the tank centre through the funnel opening. Repeat this every two or three minutes to establish an average temperature during the development period; modify the development time accordingly, if necessary.

Exact timing and temperature control is less vital after the development stage since all subsequent operations go to finality — so a minute or so extra won't do any harm. But avoid temperature changes of more than a couple of degrees between solutions. If your running water supply is appreciably colder than the processing temperature, cool down the film gradually by changes of water, each a couple of degrees cooler than the previous one, before you let running water get at the film.

CHEMISTRY CAPACITY

Some developers can be re-used for a number of films; with others you dilute a concentrate with water and throw away the solution after use. The second kind is generally preferable, for at least you start with fresh developer every time. Re-using developers is a more uncertain business because used developer deteriorates on storage, so you are never quite sure where you stand. But note the maker's recommendations for the minimum amount of concentrate needed per film, otherwise your developer gets exhausted before it has done its job.

Fixers, bleach-fix solutions etc. can be reused and you normally notice when they get exhausted from the slowing down in their action. But check the recommended working capacities and don't try to overwork solutions.

DRYING

At the end of the final rinse stop the water flow, lift the reel out of the film tank (still filled with water) and add a few drops of wetting agent to the tank. Return the reel and move it up and down a couple of times before removing the reel from the tank and the film from the reel. This wetting agent treatment makes for more uniform drying without drying marks.

If the water used in the darkroom is very hard, it sometimes leaves a white powdery deposit on negatives. Avoid this by putting the film, after washing, in a 2 per cent solution of acetic acid. If a drop of water falls on the emulsion side of the dry film, re-soak the negative completely in water (preferably again on the developing tank reel) and dry again, otherwise a mark remains.

Looking at Slides

When you get a 35 mm colour slide film processes, you usually receive transparencies ready mounted in 5 x 5 cm (2 x 2 inches) cardboard or plastic frames. It is worth ordering this type of framing even when it is not part of the standard processing service; the frames allow you to hold the transparencies without touching the film itself and they are essential for projection in a slide projector.

Larger colour transparencies, for instance from 6 x 6 cm (2¼ x 2¼ inches) roll film, are often returned unmounted. here, too, it is worth having them mounted in 7 x 7 cm (2¾ x 2¾ inches) frames for projection. If you don't have them mounted, at least keep the transparencies in clear plastic sleeves to avoid handling the film directly. That also applies to larger-format colour transparencies.

The temptation is to look at colour transparencies by holding them up against the sky or against a lamp. It is not a satisfactory way, partly because the detail on small slides is too small to be observed properly and partly because the colour of the lighting (especially blue sky) does not make the transparencies look right.

More useful is an illuminated viewer which, in its simplest form, is battery powered. You insert the slide which automatically switches on the lamp and you see the picture somewhat enlarged in the viewing lens in the front.

Such viewers are available in different sizes for 5 x 5 cm and 7 x 7 cm slides. They are adequate for viewing by one person, or even two, and for sorting out slides when you assemble your pictures for a slide show.

A viewing light box is useful for viewing larger colour transparencies or for looking at a large number of miniature slides at the same time.

The viewing box is a housing with an opal glass (or plastic) front and one or two fluorescent tubes behind to illuminate the opal screen.

The most convenient and effective way of showing colour slides is to project them on a screen. In this case present your pictures really big to an audience of your family or friends – or as illustrations for a lecture or show.

The commonest slide projectors take 5 x 5 cm slides with 24 x 36 mm transparencies. There are also models for 3 x 3 cm ultraminiature slides (transparencies made by No. 110 pocket cameras) and on the other hand for larger 7 x 7 cm slides. Further, projectors range from comparatively simple models to highly sophisticated ones with various remote control and automatic focusing facilities plus other features for professional showmanship effects.

Simple projectors for home shows usually have a 150 watt tungsten-halogen lamp and take slides in long or round magazines or trays that may hold anything from 30 to 100 slides. During projection the magazine advances slide by slide, so that when you press a button on the projector (or on the remote control unit) the machine automatically withdraws the slide being projected and inserts the next one in the projector. While all this goes on you can explain the scenery or location to your friends watching the show.

A projector with remote focusing allows you to readjust the image sharpness on the screen during the show. This is often necessary because colour slides 'pop' in their frames – they curve owing to the warming up in the projector and frequently the curvature abruptly reverses itself. This shifts the location of the image plane in the projector, causing the picture on the screen to become unsharp. You then have to readjust the lens focus. Sophisticated projectors do this completely automatically by optically monitoring the location of the transparency film in the slide frame.

For really professional shows you can record a commentary to

a slide series on magnetic tape and at the same time record signal cues on the second track of the tape. If you link the tape or cassette recorder to the projector via the connecting socket that many modern projectors have for this purpose, the tape takes over the control of the slide show. Your audience hears your commentary while the projector automatically changes slides at the preselected points.

HINTS AND TIPS

PREPARING SLIDE SHOWS

Set up the projector squarely to the screen, otherwise the image appears distorted and becomes difficult to get sharp all over. Set the screen and projector on a higher level if you are presenting a show to a lot of people.

Preferably have the room dark. If this is difficult, at least shield the projection screen so that no light falls on it from windows, lamps in the room etc.

Get people to sit as near the projection axis as feasible; the picture usually looks brightest from there.

A smooth light wall will do as a projection surface; so will a white sheet (but watch out for creases). A proper screen however yields a much more brilliant projected image.

When you sort out your slides to assemble a show, eliminate not only all technically inferior slides but also all repetitive pictures. If you doubt your ability to give a coherent running commentary during a slide presentation, write out the text beforehand and practise reading it. If necessary, record it on tape and use that to control the projector and slide change.

Don't put too much into a slide presentation. People not as familiar with your last holiday location as you are, easily get bored.

INDEX